BRITISH WILDLIFE

PHOTOGRAPHY AWARDS 9

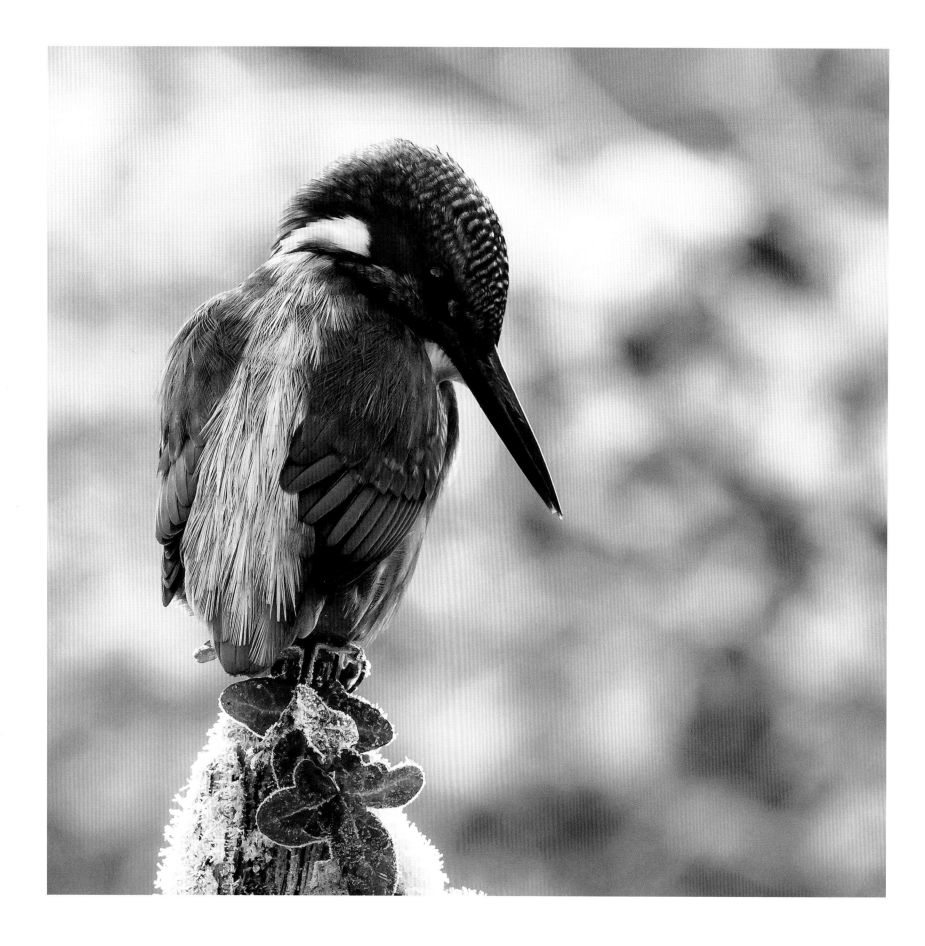

BRITISH
WILDLIFE

PHOTOGRAPHY AWARDS **9**

◀ IAN TODD
ANIMAL PORTRAITS (PAGE 34)

AMMONITE
PRESS

THE BRITISH WILDLIFE PHOTOGRAPHY AWARDS

MAGGIE GOWAN
BWPA DIRECTOR

The British Wildlife Photography Awards were established to recognise the talents of photographers practising in Britain, while at the same time highlighting the great wealth and diversity of Britain's natural history. The driving motivation to set up the Awards evolved through the nation's growing awareness of the local environment and the need for its protection.

With a nationwide touring exhibition of the best entries, the Awards aim to:

• celebrate British wildlife in all its beauty and diversity, through a collection of inspirational photographs

• recognise the talents of photographers (of all nationalities) practising in Britain

• showcase the very best of British nature photography

• engage all ages with evocative and powerful imagery

• raise awareness about British biodiversity, species and habitats

• encourage discovery, exploration, conservation and enjoyment of our natural heritage.

With thanks to the BWPA team:
Matthew Chatfield (Website Manager, Facilitator and Chairman of the Judging Panel)
Ian Winter (Website Lead Developer)
Victoria Skeet (Assistant Judge and Administrator)
Clare Webb (Technical Adviser and Manager)
Adam Sanders (Exhibitions Manager)
Chris Hart (Designer)
Archie Taplin (Social Media)

► CHAITANYA DESHPANDE
OUTDOOR PHOTOGRAPHY EDITOR'S CHOICE
(PAGE 193)

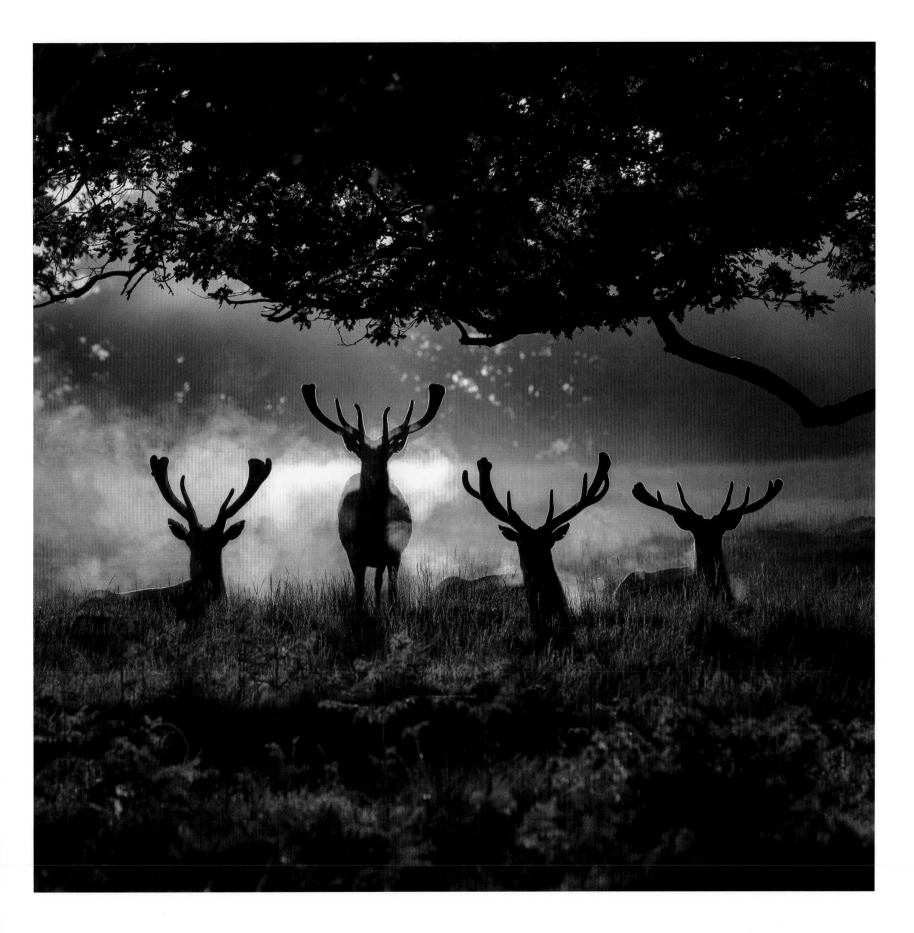

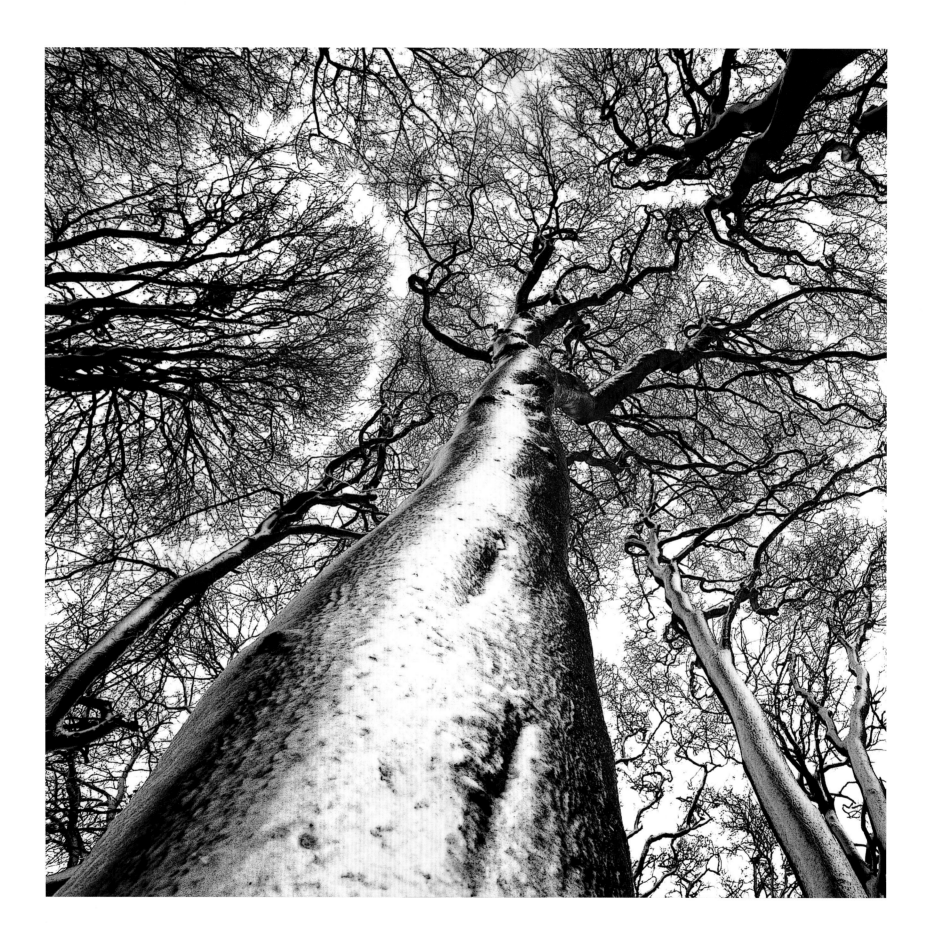

STEPHEN MOSS
NATURALIST, AUTHOR AND
WILDLIFE TV PRODUCER

FOREWORD

Once again, this collection of images from the British Wildlife Photography Awards leaves us in awe of the skill, patience and artistry of the photographers whose work is showcased here.

The extraordinary range of subjects, species and habitats, and the imaginative way they are portrayed, leaves us in no doubt that we in Britain are fortunate to be home to some of the most talented photographers in the world. Every single one of these men and women – whether they have won their chosen category or not – should be immensely proud of what they have achieved.

Another person who deserves the highest praise is Maggie Gowan, whose vision and persistence over the past decade has established the British Wildlife Photography Awards as the most important annual showcase for nature photographers and film-makers, and their subjects.

But stunning though this book is, it is not simply a collection of beautiful images, preserved like museum specimens for us to enjoy. It is also a snapshot of Britain's diverse and beautiful wildlife, at a time when these wild creatures – and the places where they live – are under threat as never before.

As Tanya Steele of WWF-UK noted in her foreword to last year's book, our wildlife is facing an existential crisis on a scale we have never seen before. Climate change, habitat loss, pollution and persecution are conspiring in an unholy alliance to threaten the very future of the plants and animals that appear in these pages. They – and we – are now at a crossroads. If we continue down this path of loss and destruction, the future looks bleak indeed.

This book – and the awards that it celebrates – cannot turn the tide on their own. But they are a crucial part of a growing movement, ranging from professional conservationists to ordinary people who simply love nature, who have had enough.

Enough of the way the natural world is marginalised; enough of the way wildlife is regarded as a luxury, rather than a necessity; and enough of politicians who ignore what is staring them in the face: that wildlife is not an optional extra, but absolutely central to our well-being as individuals and as a nation. If you need proof, just take a look through the pages of this book, and be inspired.

Stephen Moss
Naturalist, Author and Wildlife TV Producer
www.stephenmoss.tv

◀ MAX MORE
WILD WOODS (PAGE 124)

CONTENTS/CATEGORIES

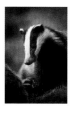

ANIMAL PORTRAITS 20
Images that capture the character or spirit of the subject in an imaginative way, giving a sense of the animal's 'personality'.

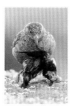

ANIMAL BEHAVIOUR 44
Images showing any aspect of wildlife behaviour or action, or depicting something familiar in a new light. The judges sought images that made them look again at what they thought they knew.

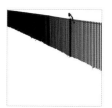

URBAN WILDLIFE 70
Wherever we live, wildlife can be found alongside us, in our towns and cities, parks, gardens and backyards. The judges looked for an original image that shows wild animals or plants within an urban environment.

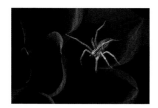

HIDDEN BRITAIN 82
Images in this category reveal the secret universe that is life in the undergrowth – a life that is all around us, but rarely seen.

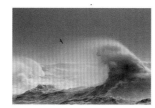

COAST AND MARINE 96
Imaginative photographs that reveal the nature or behaviour of marine life, or create a sense of place or occasion. This includes marine animals near the sea, underwater, on the seashore and within the coastal zone.

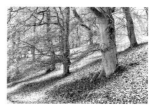

WILD WOODS 114
The judges sought an image celebrating the splendour of British woods. Entries could be portraits of woodland wildlife, wooded landscapes, seasonal scenes or plant details, or show the relationships between species and habitats that occur within our woods and forests.

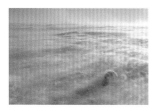

HABITAT 128
Imaginative images that portray the importance of the environment and ecosystems that sustain wildlife. This can include animals, plants and the relationships between them.

BOTANICAL BRITAIN 144
This category focuses on botanical subjects in Britain, including trees, plants, flowers, fungi and algae, whether close up, macro or as part of a wider scene.

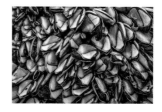

CLOSE TO NATURE 156
A category that explores the beauty of nature close up, and its ability to create extraordinary designs, symmetry, form and patterns.

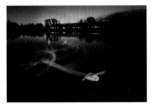

BLACK AND WHITE 164

Any images of British wildlife or landscapes in monochrome. The judges were looking for creativity and innovation in the use of the medium.

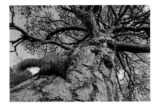

BRITISH SEASONS 172

A portfolio of four images portraying British wildlife in each of the four seasons, or four scenes from just one season. Each image needed to capture the essence of the season and its wildlife subject.

DOCUMENTARY SERIES 178
AND EVERDAY NATURE

A sequence of up to six images on any British wildlife, conservation or environmental issue, displaying innovation in storytelling.

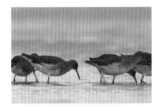

WILDLIFE IN HD VIDEO 182

An inspirational and dynamic sequence (of up to 90 seconds) illustrating the unique power of video as a medium for capturing British wildlife. Stills from the winning entry feature here.

OUTDOOR PHOTOGRAPHY 186
EDITOR'S CHOICE

Each month of the competition, the editor of *Outdoor Photography* magazine chose his favourite image for publication in future issues – these are his top picks.

YOUNG PEOPLE'S AWARDS 194

Striking and memorable images of any British wildlife species taken by under-12s and 12-18-year-olds.

For further information about the annual competition and touring exhibition, please visit: www.bwpawards.co.uk

BRITISH WILDLIFE PHOTOGRAPHY AWARDS

THE SPONSORS

CANON

Canon is once again proud to support the British Wildlife Photography Awards.

The Canon EOS system of cameras and lenses has been helping photographers capture the perfect shot since 1987 with over 90 million EOS interchangeable-lens cameras and 130 million EF-series lenses produced worldwide.

As a world leader in imaging solutions we strive to ensure that our photographers are always story-ready with our wide range of cameras and lenses, camcorders, binoculars, printers and online services.

To learn more, please visit us at **www.canon.co.uk** and **www.canon.co.uk/pro**

RSPB

With over 1.2 million members, the RSPB is the country's largest nature conservation charity, inspiring everyone to give nature a home.
www.rspb.org.uk

RSPB WILDLIFE EXPLORERS

RSPB Wildlife Explorers is the junior membership of the RSPB. With over 260,000 junior members, it is the world's biggest club for young people who love wildlife and want to make a difference.

The RSPB is the country's largest nature conservation charity, inspiring everyone to give nature a home. Together with our partners, we protect threatened birds and wildlife so our towns, coast and countryside will teem with life once again. We also play a leading role in a worldwide partnership of nature conservation organisations.
www.rspb.org.uk/youth

WWF

At WWF, we want a world where people and nature thrive. That's why we're passionate about tackling climate change, finding ways to share our planet's resources more sustainably, and protecting our threatened wildlife.
wwf.org.uk

THE WILDLIFE TRUSTS

No matter where you are in the UK, your Wildlife Trust is protecting and standing up for wildlife and wild places in your area. Supported by 800,000 members, we connect local people to nature on their doorsteps; look after thousands of nature reserves for future generations; and inspire people to take action for wildlife.
www.wildlifetrusts.org

BUGLIFE

Buglife is a registered charity and the only organisation in Europe devoted to the conservation of all invertebrates – everything from bees to beetles, woodlice to worms, and jumping spiders to jellyfish! Invertebrates are vital for the health of the planet. They pollinate our crops and wild flowers, recycle nutrients back into the ground, and are a vital source of food for other animals such as birds and mammals. The food we eat, the fish we catch, the birds we see, the flowers we smell and the hum of life we hear simply would not exist without wonderful, amazing, fascinating bugs.
www.buglife.org.uk

BBC WILDLIFE MAGAZINE

BBC Wildlife Magazine is the UK's bestselling natural history magazine, read each month by around 240,000 people in the UK and abroad. It gives an authoritative view of the natural world using top wildlife photographers and writers, and reflects current scientific thinking from the world's leading academics and naturalists. The magazine and the accompanying website cover a mix of stories and photographic galleries about specific species and wildlife habitats, as well as conservation and travel, news, book and TV reviews and answers to readers' wildlife queries. A percentage of the content springs from the rich natural history documentary programming produced by the BBC.
www.discoverwildlife.com

SHETLAND NATURE

Shetland Nature is a Five Star Accredited wildlife and photo-tour operator. They run a wide range of photographic holidays, tours, workshops and tailored assignments that are inspired by a lifetime of knowledge of the islands and their wildlife. Tours and assignments cater for all levels of photographer, from beginners to professionals. They are especially known for their work on otters. Their responsible and collaborative approach, local knowledge and leadership expertise are unrivalled on the islands. Photo-tours, one-to-one assignments and hides are available all year round.

www.shetlandnature.net

PÁRAMO

Páramo Directional Clothing Systems provide exceptional performance and unrivalled comfort outdoors. Innovative, quiet fabrics that wick away water combined with professionally tested designs help photographers and naturalists stay comfortable outside. Páramo's Fair Trade production and PFC-free, Detox-friendly outdoor clothing further set the company apart.

www.naturallyparamo.co.uk

OUTDOOR PHOTOGRAPHY

Outdoor Photography is the UK's only magazine for photographers who are passionate about being out in wild places, seeing inspiring nature and wildlife and having great adventures. And, of course, these activities also go hand in hand with an interest in conservation and the environment. Each issue features a stunning array of photographs with regular contributions by leading photographers from the UK and beyond. The magazine is renowned for its in-depth technique features, cutting-edge opinion articles and its superb guides to photographic locations.

www.outdoorphotographymagazine.co.uk

www.kristal-photos.com

KRISTAL DIGITAL IMAGING CENTRE

Kristal Digital Imaging Centre is Surrey's premier professional photo-processing laboratory. A family-run independent business established in 2003, its continued investment in the most up-to-date equipment ensures the highest-quality results. With an ever-growing product range, from standard photographic prints through photobooks to acrylic panels, Kristal strives to develop products that will keep existing customers and attract new clientele.
www.kristal-photos.com

COUNTRYSIDE JOBS SERVICE

Countryside Jobs Service is a small, ethically focused company providing information on countryside careers including jobs, volunteering, professional training and more. Established in July 1994, CJS is run by a small, dedicated team of ex-rangers, smallholders and ecologists working on a co-operative basis to ensure they publish the widest range of relevant information for readers.
www.countryside-jobs.com

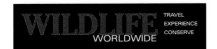

WILDLIFE WORLDWIDE

Established in 1992, Wildlife Worldwide is an award-winning specialist tour operator. Focusing on tailor-made and small group wildlife travel experiences, they offer an unparalleled range of opportunities to see the finest wildlife in the world. The collection of dedicated wildlife photography tours and workshops are designed by photographers for photographers. Each small group trip offers outstanding wildlife viewing, exceptional photographic opportunities and on location tuition from professional experts. Whatever your preferred area of wildlife photography, whether it's capturing images of the smallest insects, the largest mammals or the most magnificent scenery, they have a trip just for you.
www.wildlifeworldwide.com

THE JUDGES

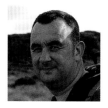

ROB COOK
SEGMENT MANAGER, CANON

Rob is a Segment Manager at Canon UK and is responsible for the UK's wildlife and nature photographers. He works closely with many of the country's leading professionals enabling Canon to be instrumental in the development of British nature photography.

Rob is passionate about landscape photography and Britain's wilderness and will be out with his camera whenever possible. While fortunate to have travelled extensively, he maintains a preference for the UK and its more open spaces, with a specific love for Dartmoor, north-west Scotland and the Outer Hebrides.

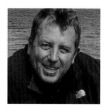

RICHARD EDWARDS
HEAD OF CONTENT, WWF-UK

Richard Edwards is Head of Content for WWF-UK and is responsible for putting powerful storytelling and compelling content at the heart of WWF communications and fundraising. Working with an in-house production unit and external media producers and broadcasters, Richard's aim is to create fascinating stories with compelling narratives and content that capture the attention and imagination of audiences, inspiring participation and action.

Richard has substantial experience working in the wildlife film, photography and digital media space. Prior to joining WWF he spent some 12 years with Wildscreen, leading multi-disciplinary teams of researchers, editors, communications specialists and AV personnel in the creation and on-going development of award-winning natural history events and digital projects; projects included the Wildscreen Film Festival, WildPhotos and ARKive. Richard has an academic background in zoology (Oxford University) and environmental sciences (University College, London) to Masters level.

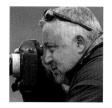

DANNY GREEN
NATURE PHOTOGRAPHER

Danny is an award-winning photographer based in Leicestershire. He became interested in nature at a young age, and would regularly wander in the woods and by rivers looking for wildlife. His late grandfather was a big influence during his childhood, inspiring him with different aspects of nature.

Thirty years on he is still keen to learn more about the natural world, including mammals, birds, insects and reptiles. Although most of his work has been in the UK, he enjoys travelling to exotic locations. He has been commissioned by *National Geographic* magazine and his work has been widely published, as well as being represented by leading picture agencies including RSPB Images and Nature PL. Danny was also one of the 58 nature photographers chosen for the prestigious Wild Wonders of Europe project, which covered every European country and was seen by several hundred million people.

He has won many photographic awards, including Natures Best, British Wildlife Photography Awards and GDT European Nature Photographer. Danny now runs a successful tour business, Natures Images, with fellow photographer Mark Sisson.

JAMIE HALL
WILDLIFE PHOTOGRAPHER

In just four years Jamie has built an innovative and creative portfolio and is now a full-time professional wildlife photographer. His novel approach and technical ability have gained him numerous awards, and recognition within the photographic industry.

He has been a category winner in the British Wildlife Photography Awards (Urban Wildlife 2013), as well as being highly commended several times in the last four years. Jamie has also won the *BBC Wildlife Magazine* Camera Trap competition for the last two years and has been commissioned by Canon for a number of promotional campaigns.

Jamie's love of nature and extensive field-craft skills developed at a young age and he uses this knowledge to seek out elusive and shy species, in order to get unusual images. Based in Suffolk, and hailing from Norfolk, Jamie runs a variety of workshops throughout East Anglia and the London area. He also offers one-to-one tuition throughout the region.

SHEENA HARVEY
EDITOR, BBC WILDLIFE MAGAZINE

Sheena has been the editor of six national magazine titles, including *Bird Watching*, *Wild Travel* and now *BBC Wildlife Magazine*. She has a great love for the natural world and some of her happiest times are when she is wildlife-watching with her husband in the Scottish Highlands, on the north Norfolk coast, or at Rutland Water, close to their Lincolnshire home. She is also a qualified scuba diver and has spent many relaxing hours observing amazing marine life and attempting to photograph it.

Her experiences in the field have given her a fine appreciation of the difficulties of catching the perfect shot of a wild animal, particularly underwater. Working on wildlife magazines and associating with talented photographers has given her an eye for a top-quality image, and she has been a judge of several wildlife photography competitions.

VICTORIA HILLMAN
WILDLIFE RESEARCHER
AND PHOTOGRAPHER

Victoria studied zoology with marine zoology at the University of Wales, Bangor, before going on to study for an MSc in wildlife biology and conservation at Edinburgh Napier University. Nature has been a passion from an early age with photography following closely behind as a way to show people what she was seeing.

Over the years she has developed both her scientific and photographic skills, specialising in macro photography and championing the smaller species we have around us. Victoria is a Manfrotto Ambassador and has contributed photographs, videos and articles to magazines, books and TV series, with awards in multiple competitions, including the British Wildlife Photography Awards.

Victoria has recently published her first book, *Forgotten Little Creatures*, which celebrates local wildlife by bringing together photography with scientific and historical facts. Based in Somerset, Victoria gives talks about her work and runs group workshops and one-to-one tuition across the country, helping people to make the most of their subjects and equipment while getting to grips with tricky habitats and thinking about the importance of being responsible when photographing nature.

LUCY MCROBERT
CAMPAIGNS MANAGER,
THE WILDLIFE TRUSTS

Lucy is a researcher, campaigner, educator, environmental historian and wildlife journalist. She is the Campaigns Manager for The Wildlife Trusts in their central office, on their Communications Team, running engagement campaigns such as My Wild Life, Every Child Wild and the UK's month-long nature challenge, 30 Days Wild.

Lucy has written for many wildlife publications, including *BBC Wildlife Magazine*, and is currently a regular columnist for *Birdwatch* magazine. Lucy is also an experienced broadcaster, appearing on BBC *Breakfast* and BBC *Springwatch Extra*, as well as on BBC R4's *The Today Programme* and BBC Radio Nottingham.

She has worked as an environmental educator in several schools across the Midlands in conjunction with the Rutland Osprey Project, and was the researcher on the recent book by Tony Juniper examining ecosystem services: *What Nature Does for Britain*.

DAVID NOTON
PHOTOGRAPHER

David Noton is a renowned travel and landscape photographer, who runs his own highly successful freelance photography company from his base in Milborne Port, near Sherborne on the Somerset/Dorset border. He also publishes the acclaimed *f11 Photography Magazine*.

David's passion for photography, travel and the world's most beautiful locations are the defining influences that have shaped his life, work and creative approach to photography. In his 33 years as a roving professional photographer, David has travelled to just about every corner of the globe. His images sell all over the world, both as fine art photography and commercially in advertising and publishing, and his clients include Canon, the National Trust, Royal Mail and BBC Enterprises/*Lonely Planet Magazine*. In addition, he has won international awards for his work, including the British Gas/BBC Wildlife Photographer of the Year Award in 1985, 1989 and 1990.

David is also a widely published writer, author, presenter, tutor and film maker, a Canon Ambassador, a Fellow of the Royal Photographic Society, an official Adobe Influencer and a Manfrotto Ambassador.

JASON PETERS
NATURALIST, EDITOR AND PRODUCER
OF WILDLIFE-FILM.COM

Jason has been fascinated by wildlife ever since he grew up on a farm in Sussex. Very early on he developed a deep respect for all that was wild around him, but soon discovered that the natural world was in deep trouble. He studied biological sciences with a specialisation in zoology at university in London, gained work experience at the BBC's Natural History Unit in Bristol and then became involved in various conservation projects around the world. This included working in the rainforests of Northern Vietnam and with cheetah in Southern Africa.

Jason went on to study wildlife film-making in Cape Town and following this worked mainly as a researcher before taking over the helm at wildlife-film.com.

RICHARD SHUCKSMITH
NATURE PHOTOGRAPHER

Richard studied marine biology at the School of Ocean Sciences, University of Wales, Bangor, before moving to the west coast of Scotland to the Scottish Association of Marine Science where he undertook a PhD in marine ecology. During this time he used photography to document many of the animals he studied and in his spare time he would scuba-dive, photographing Scotland's marine life.

Richard's work has been published widely in magazines, journals, books and newspapers; used by advertising agencies around the world; and has won multiple awards. In 2011 Richard was the overall winner in the British Wildlife Photography Awards, and won the animal behaviour category in 2014. He has also had numerous highly commended images since the competition was founded.

Richard is fascinated by the natural world that surrounds us and loves being outside following, watching and observing animal behaviour. One of his favourite places is the coast, as it has a wide variety of habitats, species and dramatic seascapes. Richard now runs Shetland Photo Tours, specialising in nature photography.

MARK WARD
NATURE WRITER AND EDITOR-IN-CHIEF, RSPB NATURE'S HOME

Mark has championed British wildlife through his writing for more than 20 years. His work has appeared in a wide variety of publications, including several magazines, newspapers and books. His latest book, *Wildlife on Your Doorstep*, published by Reed New Holland, was inspired by his passion for the local wildlife in Cambridgeshire.

Mark's love of British wildlife has taken him to all corners of the country where he has seen more than 5,000 species. He has also travelled widely around the world with Brazil, Ecuador, the Philippines, Ghana, South Africa, New Zealand and Australia among his favourite wildlife-watching destinations.

Mark currently heads the publications team at the RSPB, which is responsible for a large portfolio of print and digital communications targeting its supporters and members.

STEVE WATKINS
EDITOR, OUTDOOR PHOTOGRAPHY

Steve Watkins is an award-winning travel photographer and writer, and editor of *Outdoor Photography* magazine. He has worked closely with the BBC in creating travel programmes and has written BBC books including *Unforgettable Journeys to Take Before You Die*. Steve has walked on the wild side for 20 years as an adventurer and travel photographer; in the past eight years he has shot 120,000 images in 65 countries.

The BWPA would like to express their thanks and gratitude to:

All the photographers who participated in the Awards
The sponsors, supporters and judges
Chris Packham
Stephen Moss
Miranda Krestovnikoff
Mark Carwardine
Tanya Steele
Emily Beament
Paul Hetherington
Rory Dimond
Mall Galleries, London
Nature in Art, Gloucestershire
Astley Hall, Lancashire
Towneley Hall Art Gallery, Burnley, Lancashire

Gracefield Arts Centre, Dumfries, Scotland
Wildlife Film Festival, Dumfries, Scotland
Nunnington Hall, Yorkshire
Stockwood Discovery Centre, Luton
Oxfordshire County Museum
Red Brick Building, Glastonbury, Somerset
Beaney House of Art and Knowledge, Canterbury, Kent
Moors Valley Country Park, Dorset
The RSPB's Wildlife Explorers Team (Emma Lacy and Jack Plumb)
Kristal Digital Imaging Centre
Wildlife-Film.com
Wildeye

Pinkeye Graphics
HomePage Media
Minesh Amin
Adam Cormack
Chris Hart
Jennie Hart
Claire Blow
Angus Robinson
Hannah Robinson
Lottie Robinson
Siroun Tarayan
Dympna Marsh
Sally Cross
Roger and Tess Green
Ralph Tribe
Cat James

OVERALL WINNER

BRITISH WILDLIFE PHOTOGRAPHY AWARDS

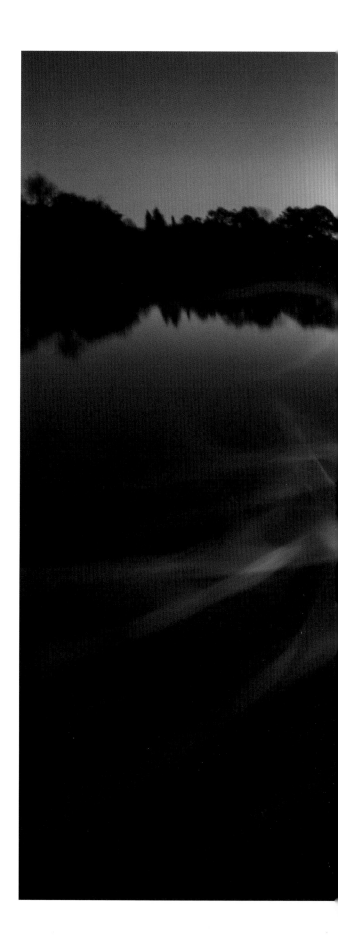

PAUL COLLEY
OVERALL & CATEGORY WINNER

Contrails at Dawn
(Daubenton's bats, *Myotis daubentonii*)
Coate Water Country Park, Wiltshire

Ghostly contrails reveal the flight paths and wingbeats of Daubenton's bats. An infrared camera and lighting system that were 14 months in development overcame the challenge of photographing the high-speed flight of these small mammals in the dark. The in-camera double exposure caught the foreground bat milliseconds before insect intercept. As these bats are a protected species they were photographed in the wild following advice from the Bat Conservation Trust and Natural England.

Camera: Nikon D750 modified to 830nm wavelength infrared | Lens: 12–24mm at 12mm | Shutter speed: 4 sec. | Aperture: f/8 | ISO: 400
Own-design high-speed camera trap using Pluto laser trigger, modified Nikon Speedlights (infrared) and constant infrared floodlight

mpcolley.com

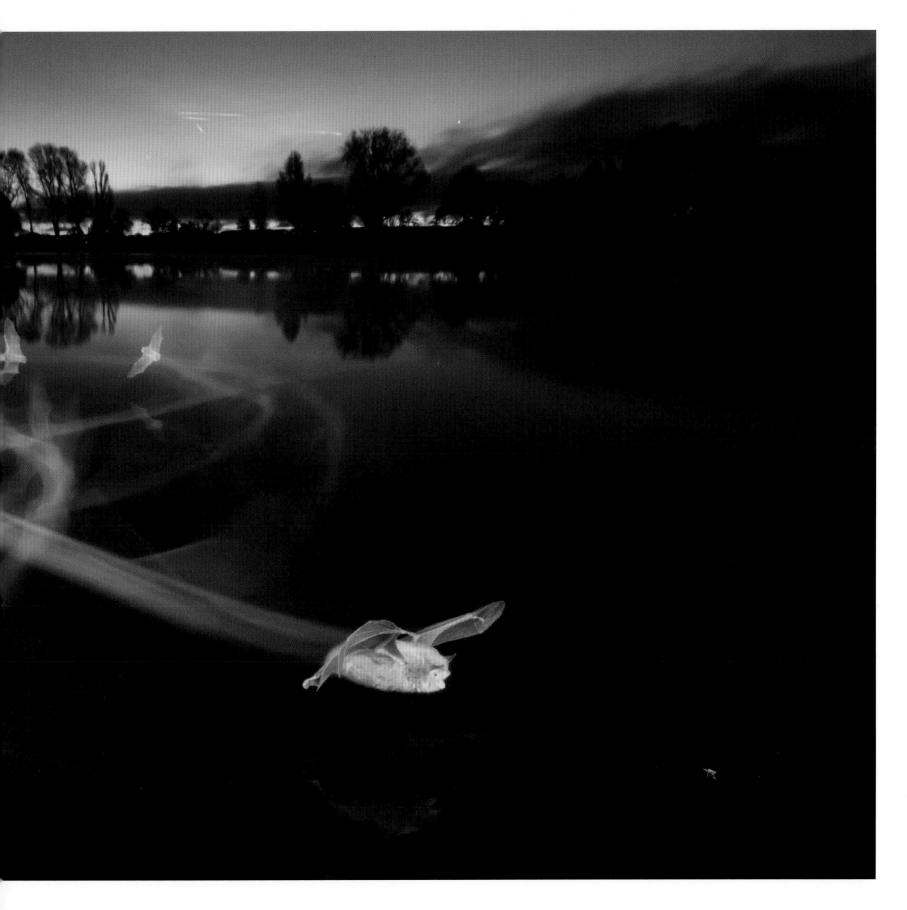

ANIMAL PORTRAITS

BRITISH WILDLIFE
PHOTOGRAPHY AWARDS

SPONSORED BY
BBC WILDLIFE MAGAZINE

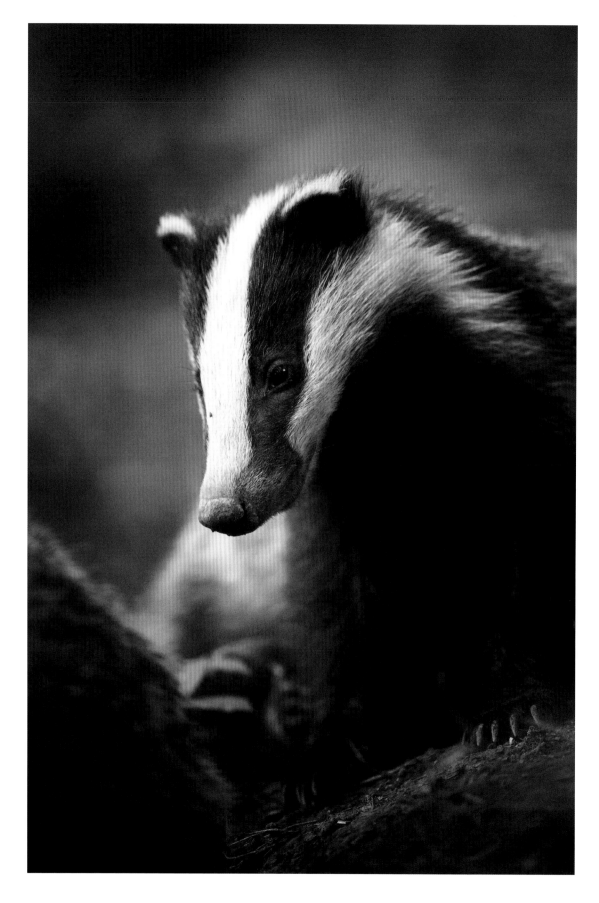

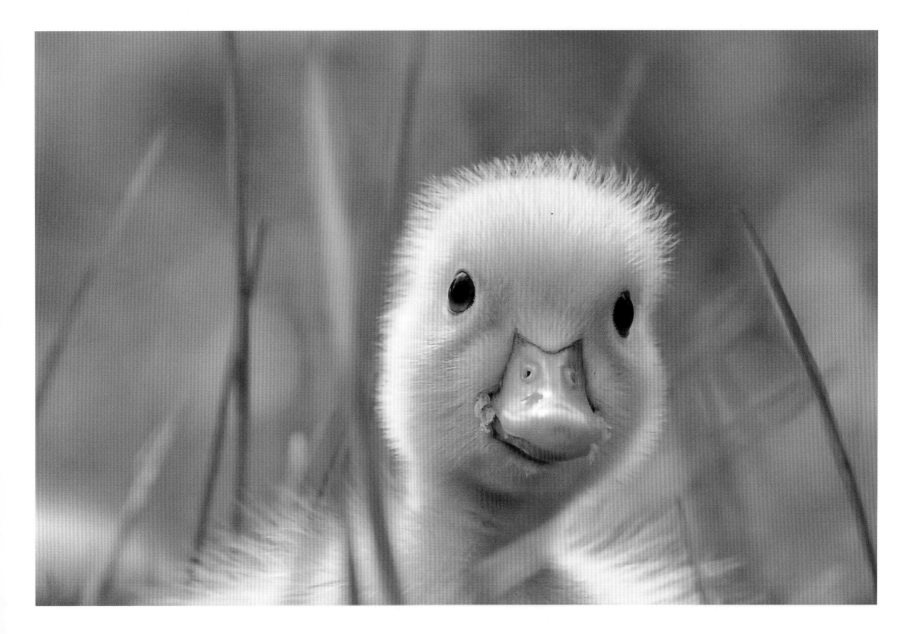

◄ TESNI WARD
CATEGORY WINNER

Bean
(Badger, *Meles meles*)
Peak District National Park, Derbyshire

With muted light leaking through the woodlands, a badger cub emerged from its sett, slowly shuffling into the open before pausing briefly to observe its surroundings. While the light was difficult to work with, the cub stayed still long enough to allow me to capture one frame before it headed into the bushes.

Camera: Canon EOS 5D MkIII | Lens: 500mm | Shutter speed: 1/160 sec. | Aperture: f/4 | ISO: 4000 | Tripod
tesniward.co.uk

▲ DARREN MOSTON
HIGHLY COMMENDED

What Are You Doing Down There Taking My Photo?
(Mallard, *Anas platyrhynchos*)
Stockton Heath, Cheshire

Four one-week-old ducklings had just got out of the water and started wandering around in the grass, so I lay on the floor to get some low-angle shots. It was a lovely sunny day and they didn't seem bothered that I was there. This one stopped suddenly and looked right towards me, so I clicked away and got some unusual shots.

Camera: Nikon D300 | Lens: 80–400mm at 400mm | Shutter speed: 1/800 sec. | Aperture: f/8 | ISO: 640

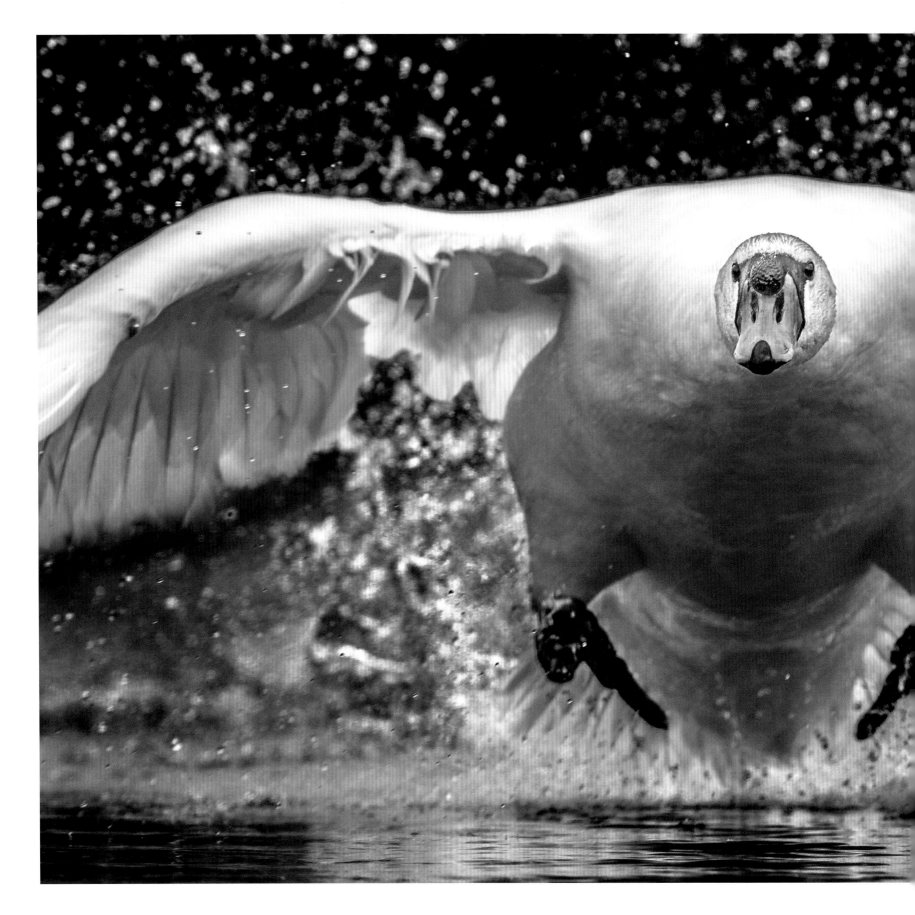

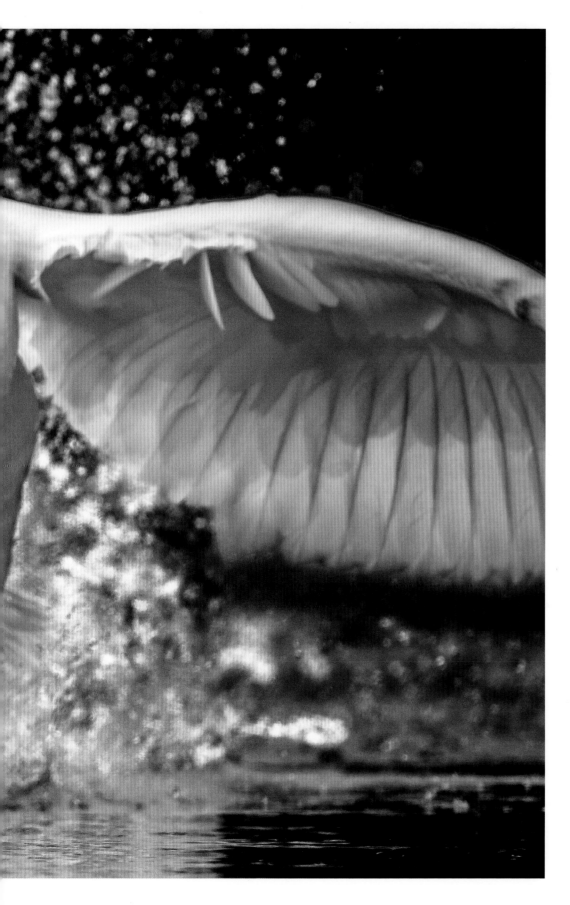

PHILIP SELBY
HIGHLY COMMENDED

Collision Course
(Mute swan, *Cygnus olor*)
Swindon, Wiltshire

Throughout a photography session at a local lake, this mute swan continually chased and harried the resident Canada geese, to the annoyance of all. My opportunity for this shot arose when a gosling settled just a few feet in front of me. Sure enough, the swan locked on to his victim and thundered towards me, rapidly filling the frame. I managed to take several images before I had to pull away, expecting to be collateral damage in the ensuing melee!

Camera: Canon EOS 5D MkIV | Lens: 300mm with 2x teleconverter
Shutter speed: 1/1000 sec. | Aperture: f/8 | ISO: 500 | Tripod
flickr.com/photos/philselby/

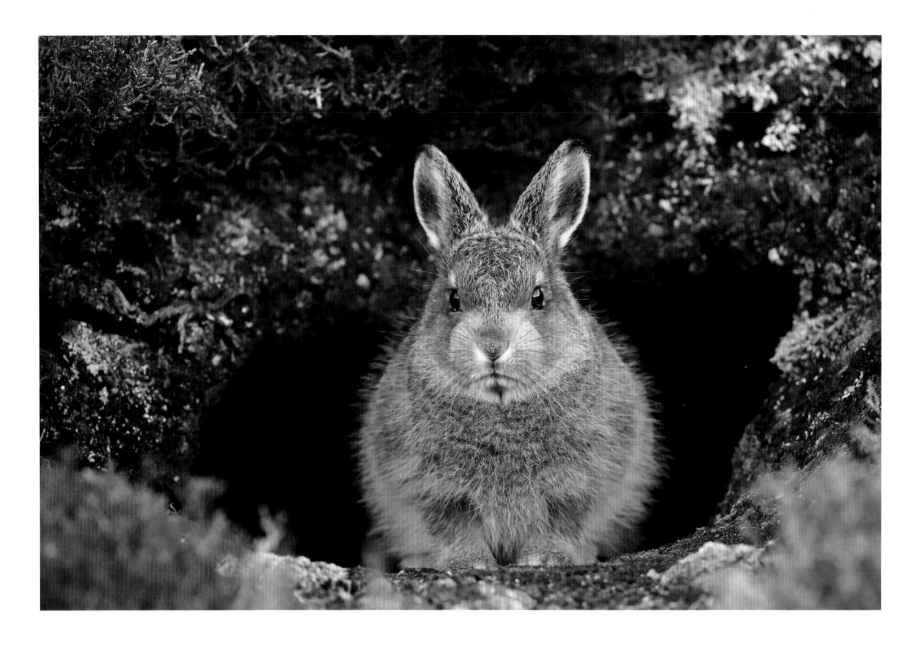

NEIL MCINTYRE

Grumpy Mountain Hare Leveret
(Mountain hare, *Lepus timidus*)
Monadhliath Mountains, Highland

A friend had tipped me off that there were some mountain hare leverets starting to show, so early one morning I set out to an area where I have seen them in the past. At the very first place I looked I found this small fellow sitting perfectly framed at the entrance to its form. The grumpy look is characteristic of all leverets and I just think it adds to their appeal.

Camera: Canon EOS 1DX MkII | Lens: 500mm | Shutter speed: 1/500 sec. | Aperture: f/5.6 | ISO: 3200 | Beanbag
neilmcintyre.com

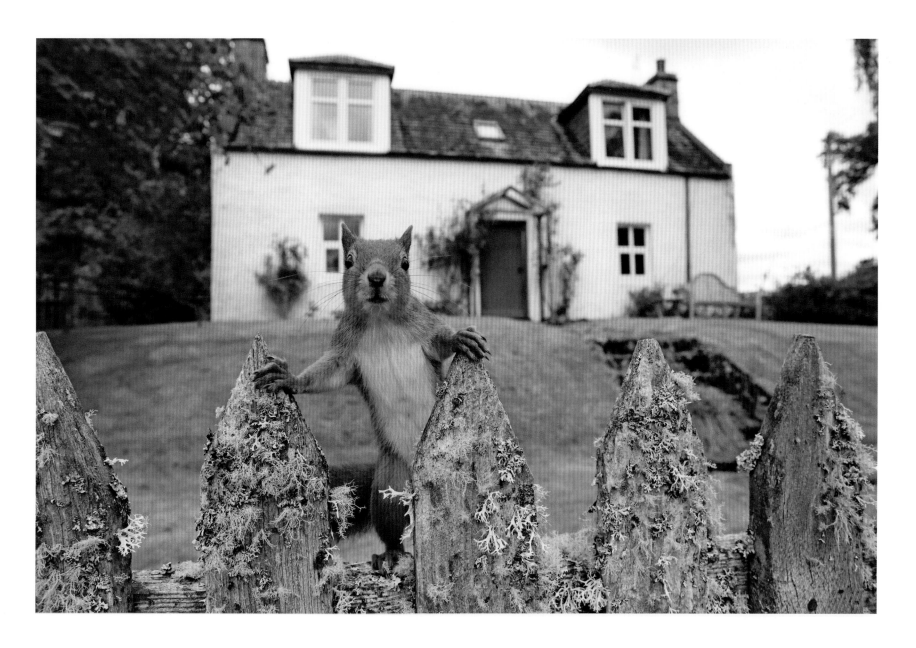

NEIL MCINTYRE
HIGHLY COMMENDED

Inquisitive Red Squirrel
(Red squirrel, *Sciurus vulgaris*)
Cairngorms National Park, Highland

This lichen-covered picket fence was a regular approach route for the red squirrels that visited our garden to feed on the bird feeders. I positioned a remote camera down by the fence and retreated back to the house, watching from the window behind the squirrel's head. A few squirrels passed by, but this one stopped and peered inquisitively into the camera, clearly curious about what was going on.

Camera: Canon EOS 5D MkIII | Lens: 24–105mm at 24mm | Shutter speed: 1/1250 sec. | Aperture: f/8 | ISO: 1000 | Tripod

neilmcintyre.com

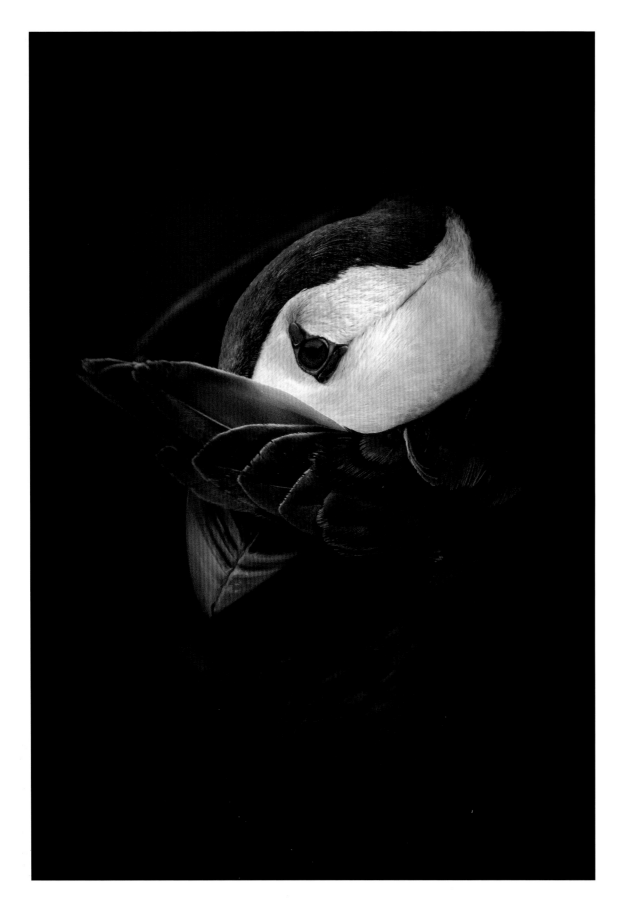

CSABA TOKOLYI
HIGHLY COMMENDED

Shy Puffin
(Atlantic puffin, *Fratercula arctica*)
Skomer, Pembrokeshire

Preening is a very important activity for puffins, second only to feeding. During this process, the bird removes dirt, dust and parasites from its feathers; well maintained, they stay waterproof and provide perfect insulation. As the puffin is a seabird that nests underground, there are a lot of things to do to keep the plumage in top shape. This image was taken on Skomer island in Pembrokeshire, Wales, where I stayed for a few days in July 2017.

Camera: Nikon D7200 | Lens: 70–200mm | Shutter speed: 1/2500 sec.
Aperture: f/4 | ISO: 640
csabatokolyi.com

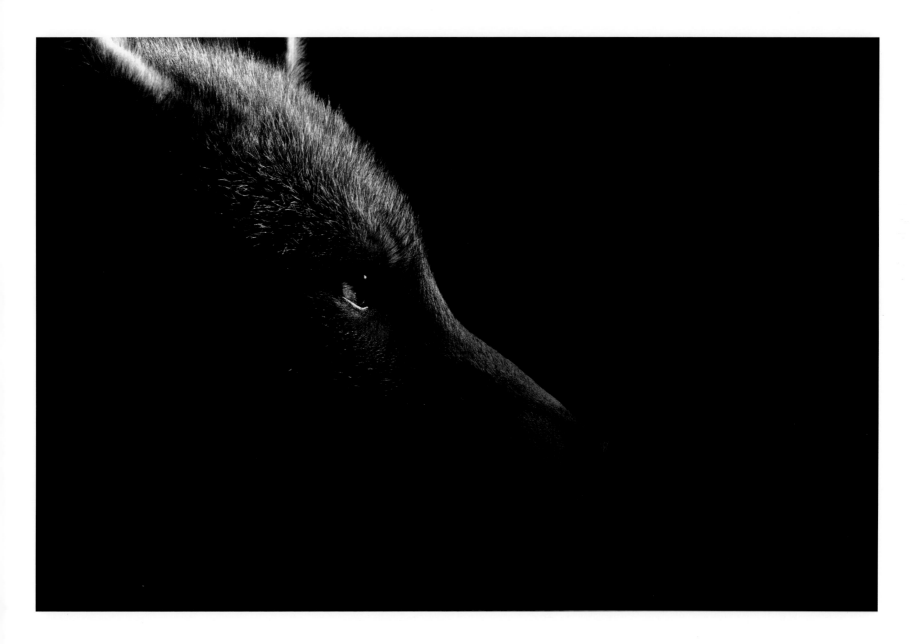

ALANNAH HAWKER
HIGHLY COMMENDED

From the Shadows
(Red fox, *Vulpes vulpes*)
Redhill, Surrey

Foxes are well-photographed animals, so whenever possible I like to try and get something a bit different. With the sun low in the sky there were several patches of light and I decided to make the most of this by deliberately underexposing by four stops. Then I just had to wait for the right moment!

Camera: Canon EOS 7D MkII | Lens: 100–400mm | Shutter speed: 1/250 sec. | Aperture: f/10 | ISO: 800
alannahhawker.com

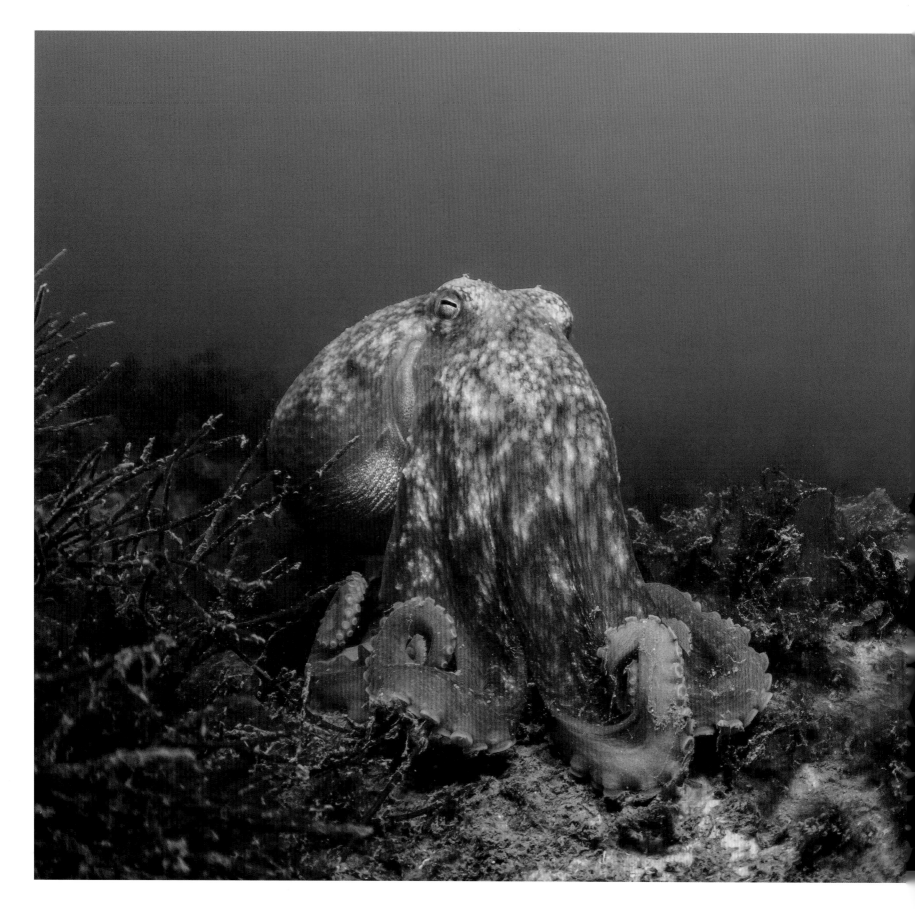

TERRY GRIFFITHS
HIGHLY COMMENDED

At the Den
(Common octopus, *Octopus vulgaris*)
Torquay, Devon

Having come across this octopus sitting on top of its den, a slow approach enabled me to get close, without disturbing it. I then spent more than one hour watching and observing its habits.

Camera: Nikon D500 | Lens: 10–17mm at 14mm | Shutter speed: 1/250 sec. | Aperture: f/11 | ISO: 400 | Inon Z240 underwater strobes

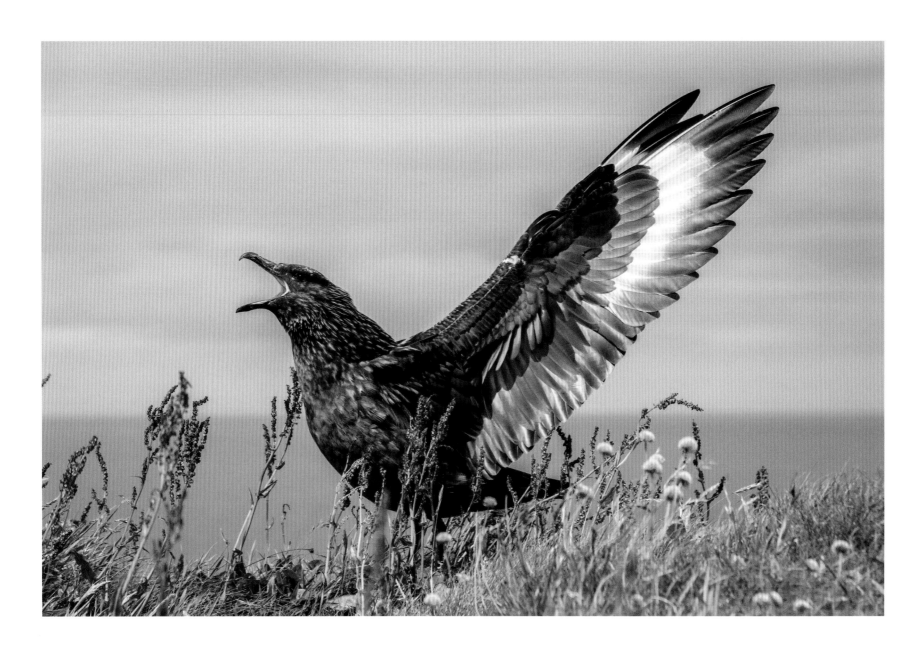

DANNI THOMPSON
HIGHLY COMMENDED

The Long-Call
(Great skua, *Stercorarius skua*)
Handa, Sutherland

While monitoring cliff birds in Scotland, I became aware that I was close to the territory of a great skua. Every time another skua flew overhead, this 'bonxie' performed its long-call display, which I was keen to photograph. On a lunch break I crept slightly closer and lay in wait. Typically, the skies became quiet, but just before I had to admit defeat and get back to work another skua flew by, allowing me the perfect shot.

Camera: Nikon D3300 | Lens: 16–300mm | Shutter speed: 1/640 sec. | Aperture: f/9 | ISO: 200

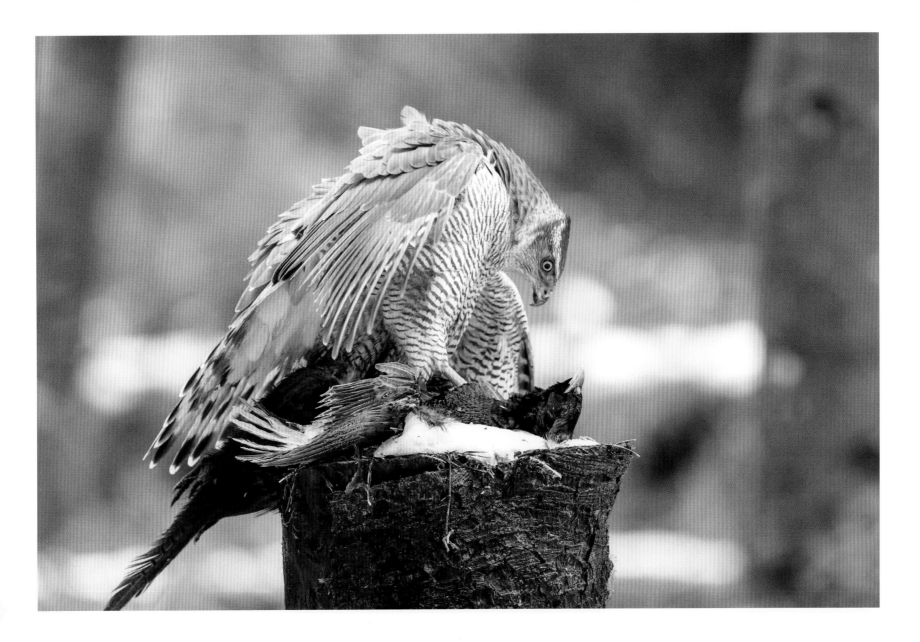

CHAS MOONIE
HIGHLY COMMENDED

Eye Contact
(Northern goshawk, *Accipiter gentilis*)
Galloway Forest, Ayrshire

A wild female goshawk mantling over a pheasant. This project took many months and around 200 hours in a freezing woodland hide. It proved to be extremely challenging, which is to be expected when trying to photograph the unpredictable and nervous 'phantom of the forest'. Very cold conditions are required for a goshawk to eat carrion, as the need for food increases in late winter. The pheasant, which was roadkill, provided a nutritious meal.

Camera: Canon EOS 5D MkIV | Lens: 300mm with 1.4x teleconverter | Shutter speed: 1/320 sec. | Aperture: f/5 | ISO: 2500 | Tripod, camo lens cover
wildfeathers.co.uk

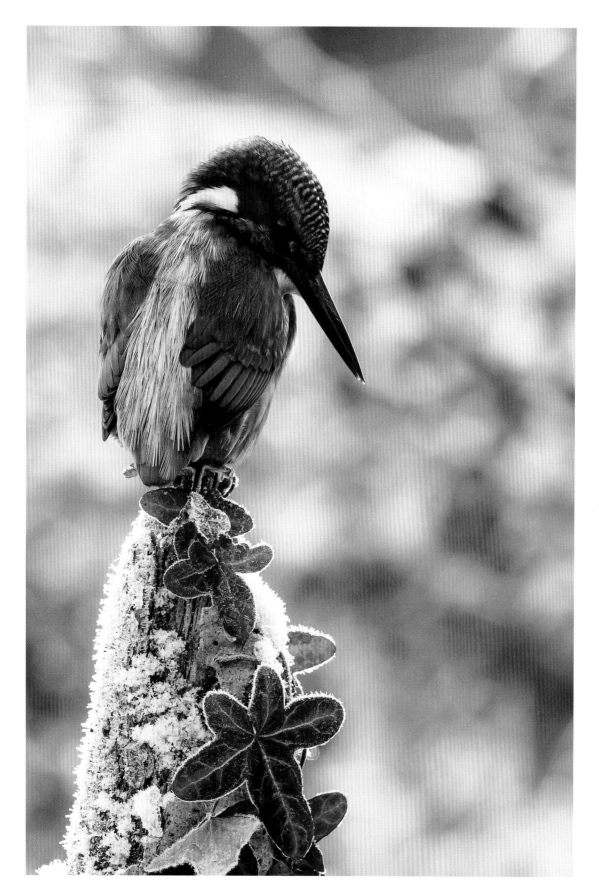

Icy Blue
(Common kingfisher, *Alcedo atthis*)
River Ayr, Catrine, Ayrshire

I had been watching this male kingfisher visit the same quiet spot on the River Ayr on an almost daily basis during the autumn and winter of 2017. I learned its favourite perches and eventually set up my camera with an IR remote control on this particular perch. After a couple of hours he arrived, and after using a few other less photogenic perches he eventually sat here and I could take my shot.

Camera: Canon EOS 7D MkII | Lens: 70–200mm at 149mm
Shutter speed: 1/250 sec. | Aperture: f/7.1 | ISO: 1000 | Tripod

Shadow on the Peaks
(Mountain hare, *Lepus timidus*)
Peak District National Park, Derbyshire

The Peak District in Derbyshire can be a challenging environment in winter. Up on the plateau, having worked a path through the heavy snow, this mountain hare just sat very still, perfectly camouflaged in a wash of white. Mountain hares are very skittish, but he must have felt comfortable as he remained crouching for around 20 minutes, allowing me to take this magical image.

Camera: Nikon D850 | Lens: 600mm | Shutter speed: 1/1000 sec.
Aperture: f/6.3 | ISO: 320
bearprintsphotography.info

LUCY MURGATROYD
HIGHLY COMMENDED

Snake Haven
(Grass Snake, *Natrix natrix*)
Skipwith Common National Nature Reserve, North Yorkshire

Walking along my usual route, I couldn't believe it when right in front of me two grass snakes lay coiled together. Being careful not to disturb them, I quietly crouched down and enjoyed the moment. As I reached for my camera a gust of wind came out of nowhere, blowing leaves up into the air swirling towards the twosome, resulting in a quick retreat into the darkness of the wall.

Camera: Canon EOS 7D | Lens: 100mm | Shutter speed: 1/1250 sec. | Aperture: f/10 | ISO: 800

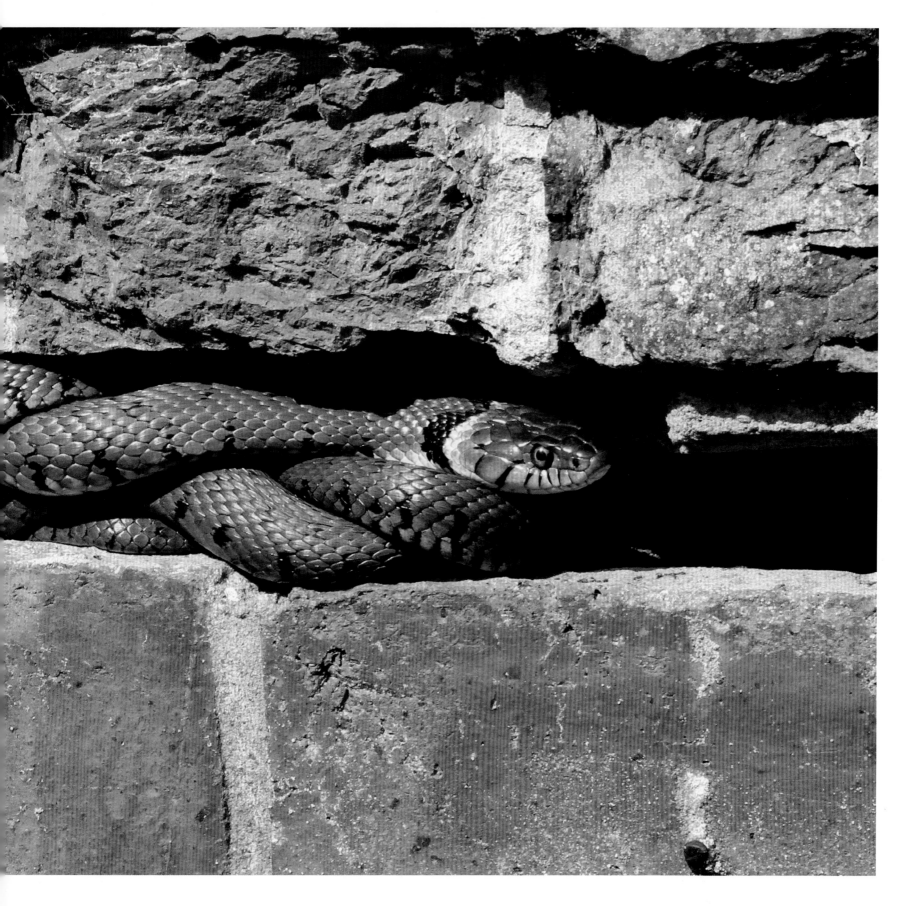

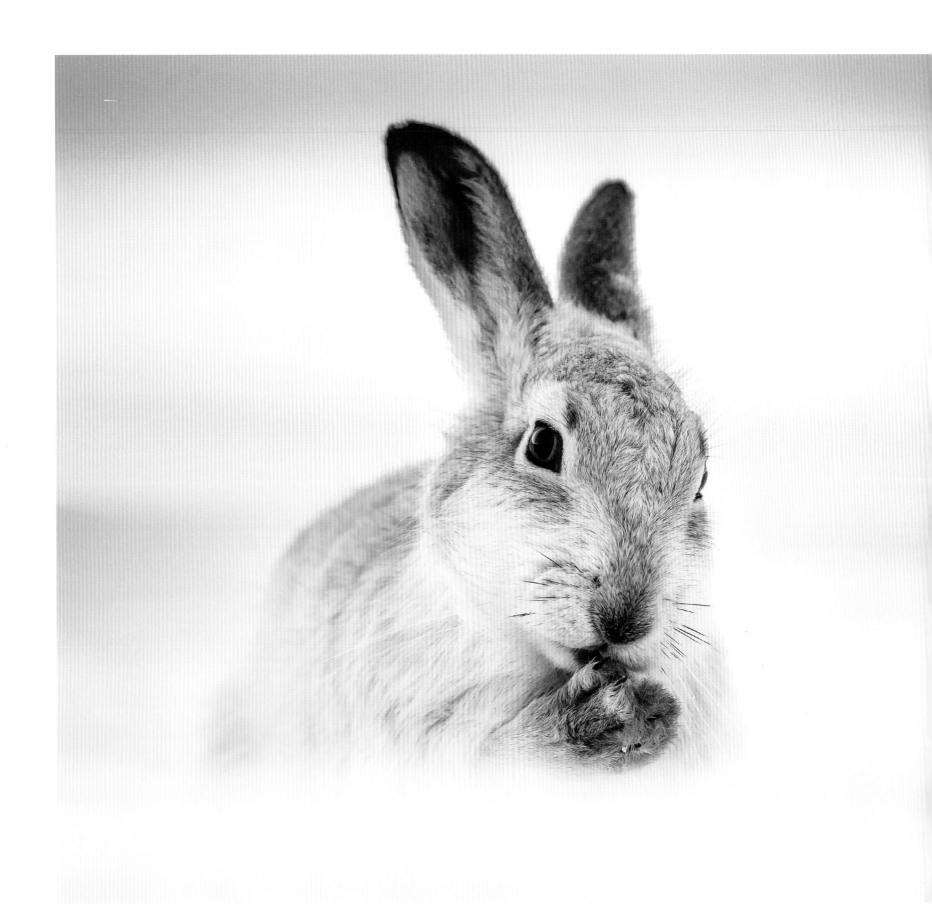

KEVIN MORGANS

Sunset and the Hare
(Mountain hare, *Lepus timidus*)
Cairngorms National Park, Highland

I was photographing mountain hares up on a hillside in the Cairngorms National Park when the hillside I was working on fell into shadow. I decided to head up onto the plateau to see if I could photograph a hare against the setting sun, and was lucky to find this confiding hare, which groomed and posed beautifully as the sun set over the mountains. Over the next few days this hare became a real star and hopefully I'll find him back on the hillside this coming winter.

Camera: Canon EOS 1DX | Lens: 500mm | Shutter speed: 1/200 sec. | Aperture: f/4 | ISO: 1000
kevinmorgans.com

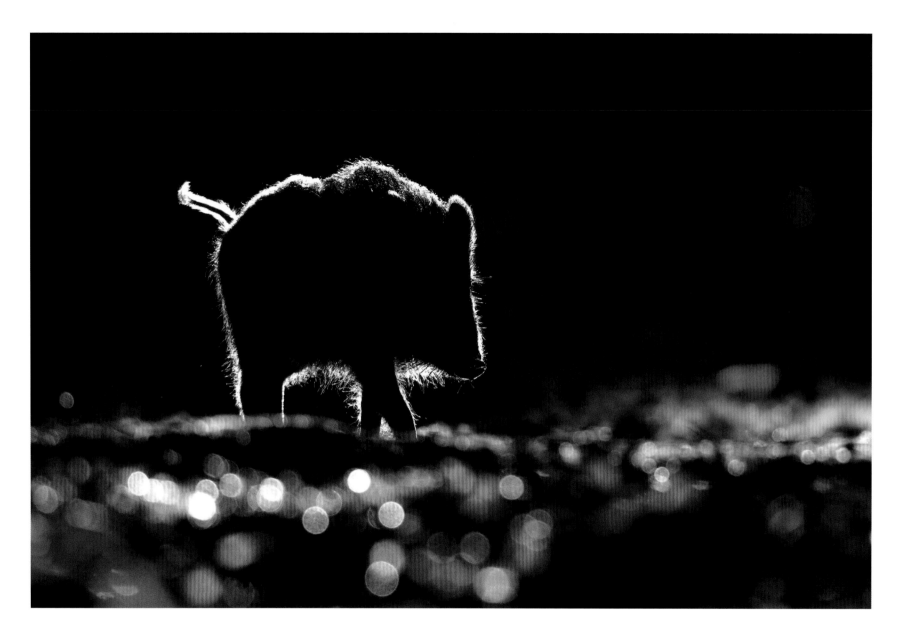

CRAIG CHURCHILL

Backlit Boar
(Wild boar, *Sus scrofa*)
Forest of Dean, Gloucestershire

I'd heard rumours that a wild boar and her young were showing very well down in the Forest of Dean. It's a species I've always failed to see after many visits, so when I arrived early in frosty, overcast conditions my confidence was low. I drove along the road and suddenly they were in front of me, crossing the road. They allowed a close approach, but I stayed back with a longer lens. The sun emerged later on in the afternoon, which allowed good backlit opportunities.

Camera: Nikon D500 | Lens: 500mm | Shutter speed: 1/320 sec. | Aperture: f/4 | ISO: 400
craigchurchill.co.uk

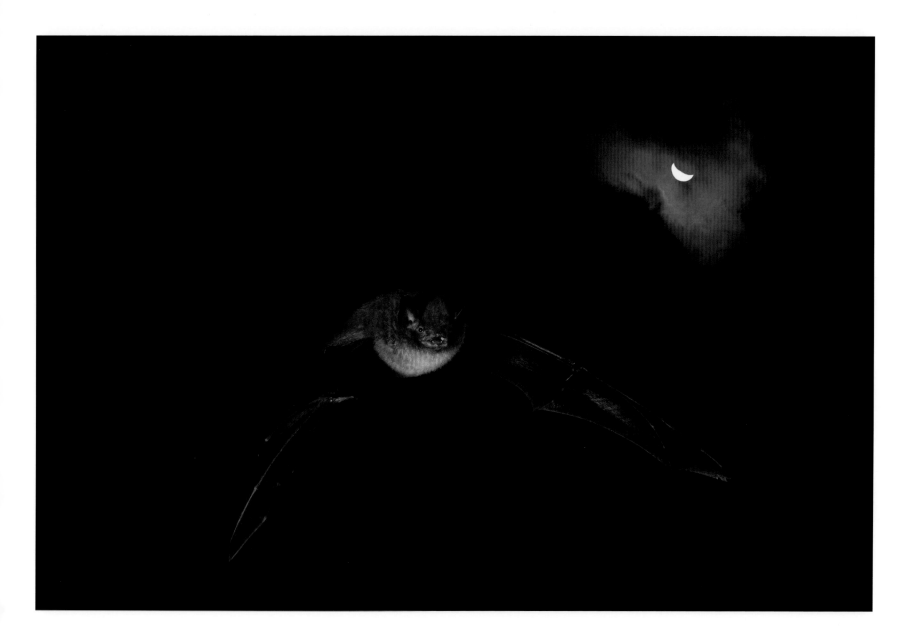

PAUL COLLEY

Hunter's Moon
(Daubenton's bat, *Myotis daubentonii*)
Coate Water Country Park, Wiltshire

To catch this Daubenton's bat hunting in the autumn moonlight I used a low-light camera system. The image is an in-camera double exposure, which enabled me to capture both the bat and the Moon in sharp focus. These protected animals were photographed in the wild following advice from Natural England.

Camera: Nikon D500 | Lens: 12–24mm | Shutter speed: 0.6 sec. | Aperture: f/16 | ISO: 640 | Own-design camera trap using Pluto laser trigger and Nikon Speedlights
mpcolley.com

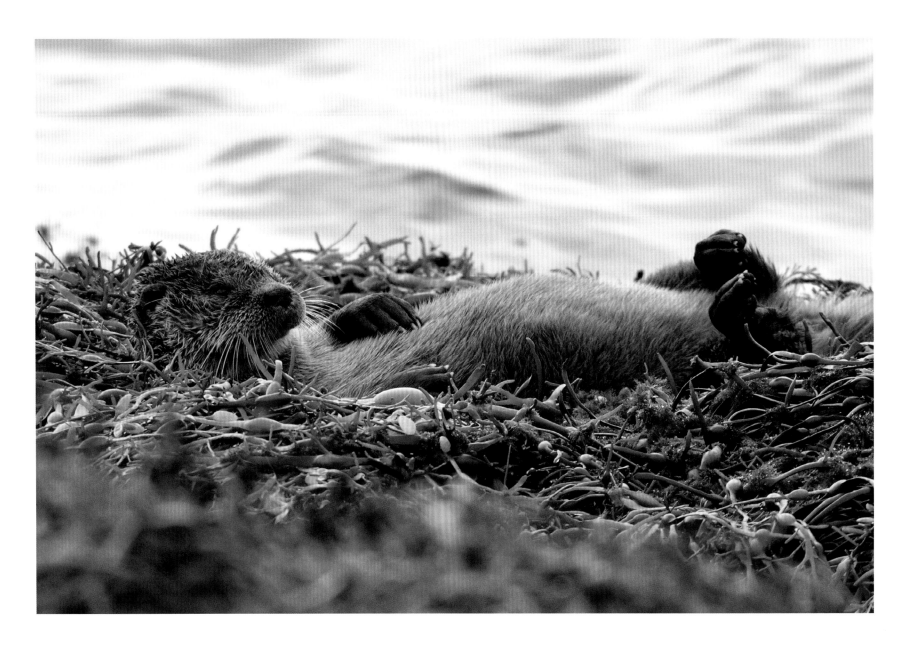

SARAH HANSON

Relaxed Otter
(European otter, *Lutra lutra*)
Isle of Mull, Argyll and Bute

Getting close to otters relies on good fieldcraft, as the slightest noise or scent of a human can cause them to disappear in seconds. This otter was relatively relaxed and as it rolled in the seaweed to dry its fur I was able to keep low and slowly creep towards it among the rocks. A perfect Mull encounter!

Camera: Nikon D500 | Lens: 80-400mm | Shutter speed: 1/1000 sec. | Aperture: f/7.1 | ISO: 500
instagram.com/sarahhanson33/

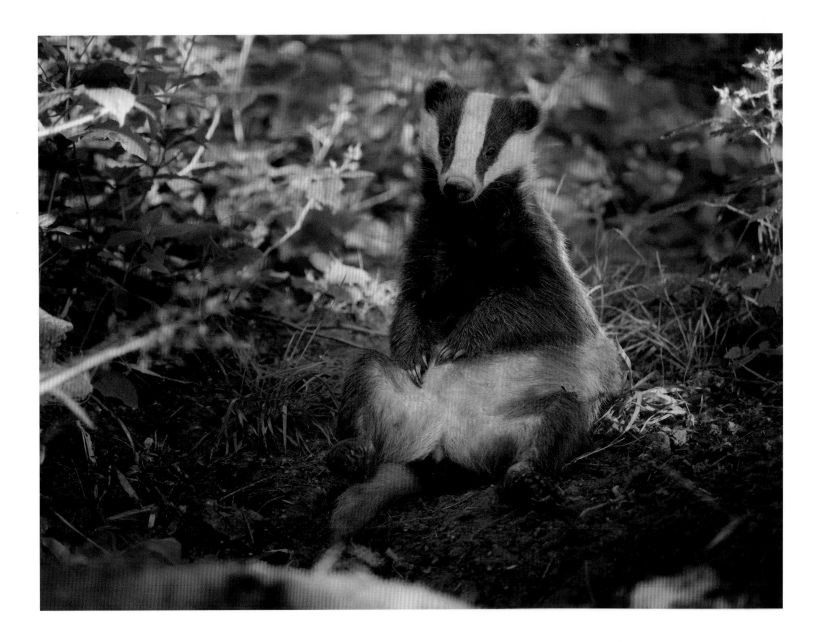

TESNI WARD

Belly Rub
(Badger, *Meles meles*)
Peak District National Park, Derbyshire

Although badgers are nocturnal, during the summer months the shorter nights can force them to emerge while it's still light. With the extended dry period this year, they've been forced to emerge even earlier due to difficulty finding earthworms to eat. After three years and nearly 2,000 hours spent with them, I was finally able to witness this well known behaviour out in the open and with good light, having only seen it once before in the flesh.

Camera: Olympus OM-D E-M1 MkII | Lens: 40–150mm | Shutter speed: 1/60 sec. | Aperture: f/2.8 | ISO: 800
tesniward.co.uk

ANIMAL BEHAVIOUR

BRITISH WILDLIFE
PHOTOGRAPHY AWARDS

SPONSORED BY
SHETLAND NATURE

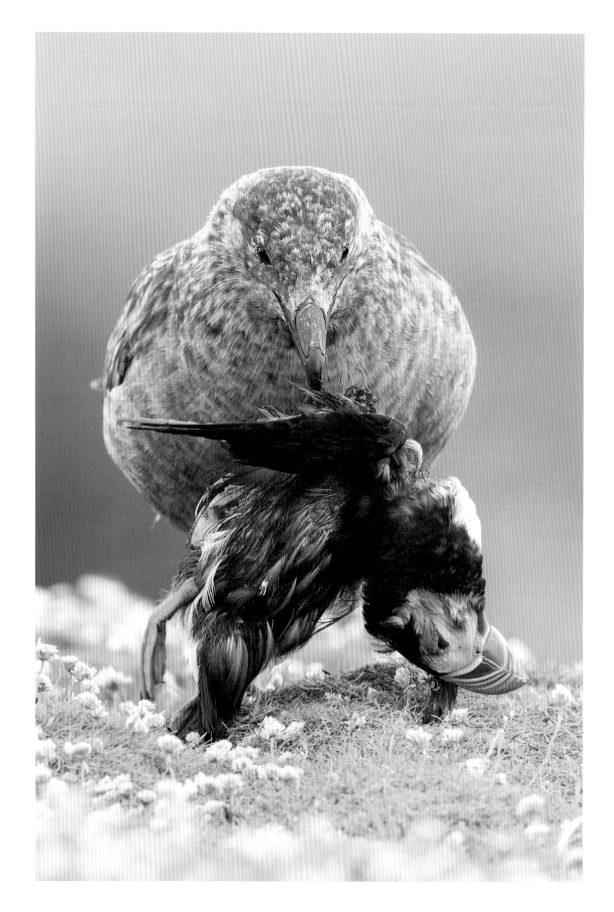

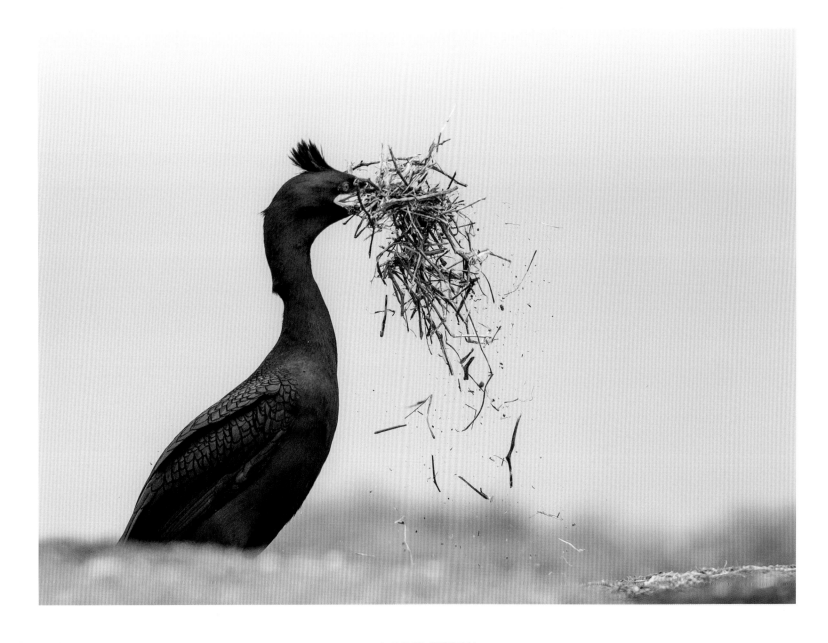

◀ SUNIL GOPALAN
CATEGORY WINNER

Life and Death at the Edge of the World
(Great skua, *Stercorarius skua*; Atlantic puffin, *Fratercula arctica*)
Fair Isle, Shetland

Seabird colonies are among my favourite places. One morning on Fair Isle, I heard a great racket arise from the other side of the cliff. The cliffs are periodically cased by predators, which cause all the puffins to flush. I have never seen any action before, but this 'bonxie' (great skua) closed the loop on the circle of life right in front of my lens.

Camera: Canon EOS 1D MkIV | Lens: 600mm | Shutter speed: 1/400 sec. | Aperture: f/8 | ISO: 1600
sunilsphotos.com

▲ DAVID GIBBON
HIGHLY COMMENDED

Nest Builder
(Shag, *Phalacrocorax aristotelis*)
Farne Islands, Northumberland

Visiting the Farne Islands early in the breeding season, I hoped to capture some interesting behaviour as the seabirds came together to raise their young. As I sat in wait for something special to occur, I noticed this shag gathering straw and other materials. It collected so much it struggled to keep it all in its mouth as it carried it back to continue work on its new nest.

Camera: Canon EOS 1DX | Lens: 500mm with 2x teleconvertor | Shutter speed: 1/1000 sec. | Aperture: f/8 | ISO: 800
davidandlouisephotography.com

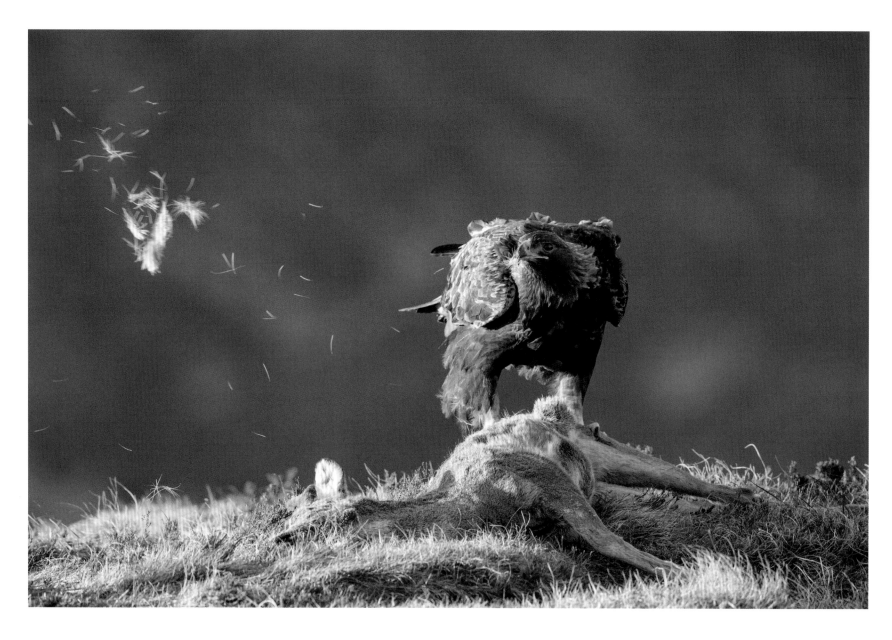

MARK HAMBLIN

Golden Eagle Feeding on a Roe Deer Carcass
(Golden eagle, *Aquila chrysaetos*)
Isle of Skye, Highland

Taken at a baited site on the Isle of Skye in collaboration with the John Muir Trust. A permanent wooden hide was erected, which I visited many times over the winter, entering and leaving in the dark so I wasn't seen. My 14-hour sessions in the hide were eventually rewarded when this female came in to feed in beautiful evening light. As she plucked the deer, the hair was quickly blown away in the strong wind.

Camera: Canon EOS 1DX | Lens: 600mm | Shutter speed: 1/800 sec. | Aperture: f/5.6 | ISO: 1250
markhamblin.com

MATTHEW GOULD
HIGHLY COMMENDED

Finding a Host
(Ichneumonid wasp, *Ephialtes manifestator*)
RSPB Pulborough Brooks, West Sussex

When I first saw this fly past I thought it was a dragonfly. However, after it landed I realised it was more peculiar. I got level with it and waited for it to move into the light. I later found out it was a female ichneumonid wasp looking for the pupae of a bee or wasp in which to lay its eggs using its 6cm ovipositor, as seen in the photo.

Camera: Canon EOS 5D MkIV | Lens: 105mm macro | Shutter speed: 1/400 sec.
Aperture: f/9.0 | ISO: 2000

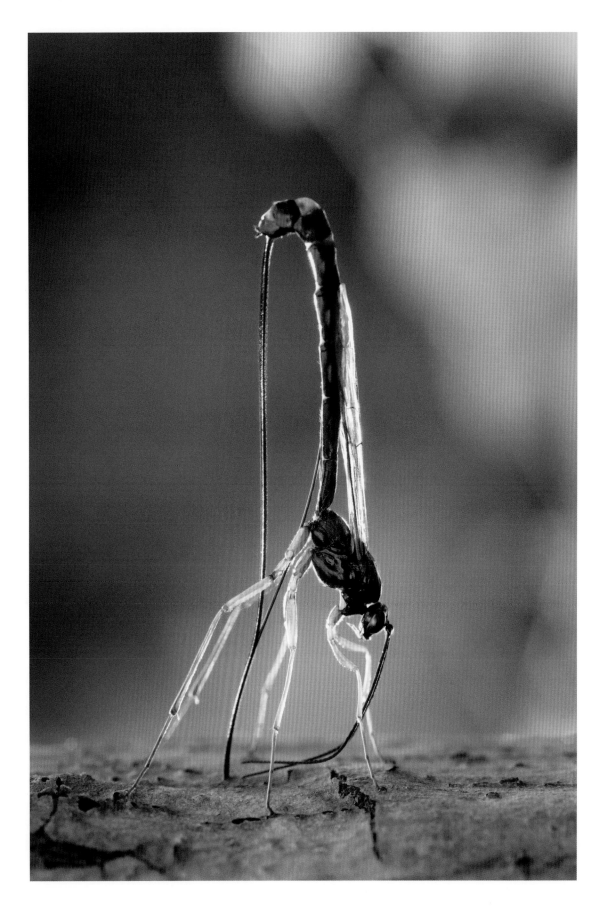

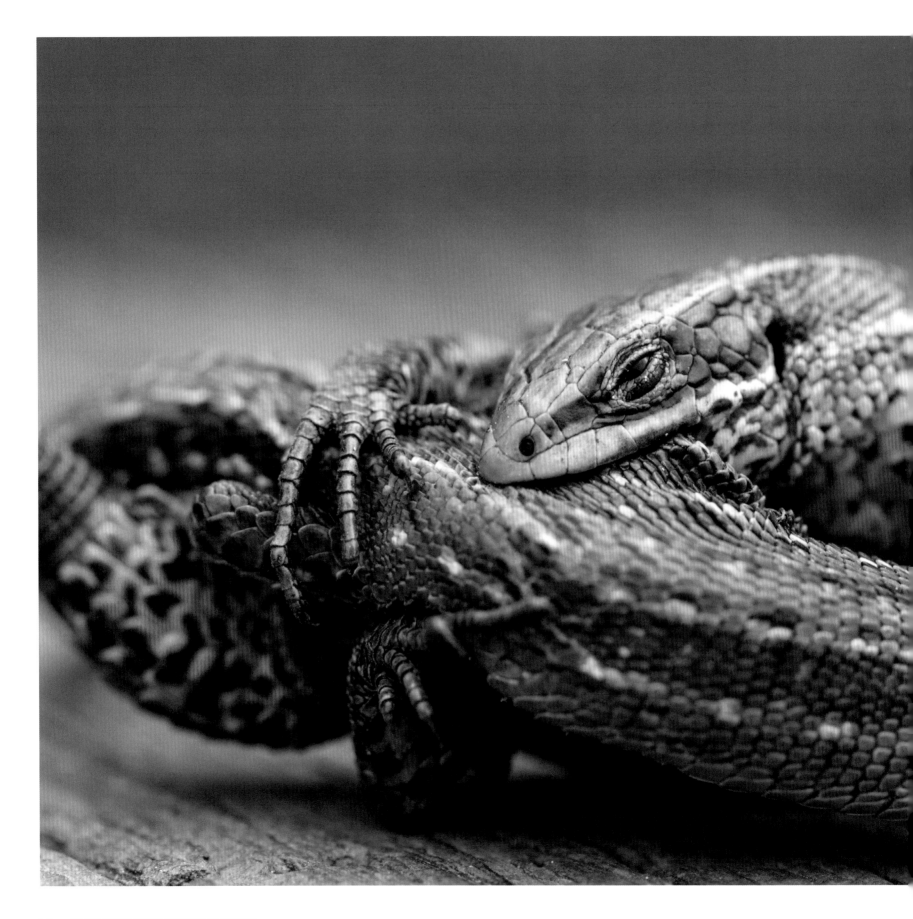

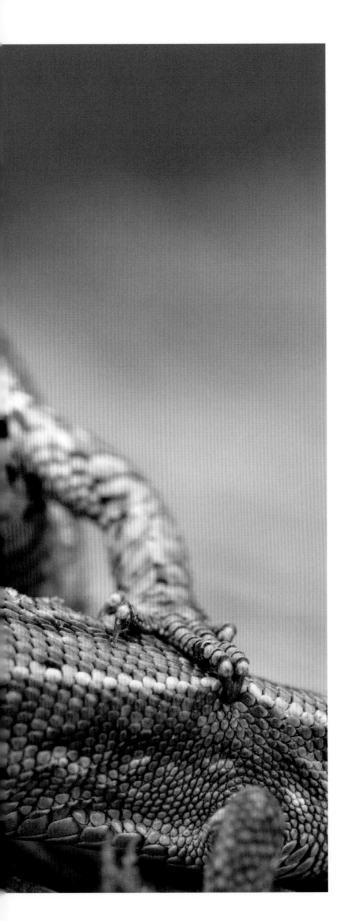

JENNIE SMITH
HIGHLY COMMENDED

Cold Embrace
(Common lizard, *Zootoca vivipara*)
Machynlleth, Powys

The gnarly intricate skin and mini monster-like appearance of lizards has ignited my imagination ever since I was a child. When I came across this entwined mating couple, my macro lens felt like the best option for revealing otherwise unseen detail and the pure intent of this fascinating creature.

Camera: Canon EOS 70D | Lens: 100mm macro | Shutter speed: 1/320 sec. | Aperture: f/5.6 | ISO: 400
jenniesmith.co.uk

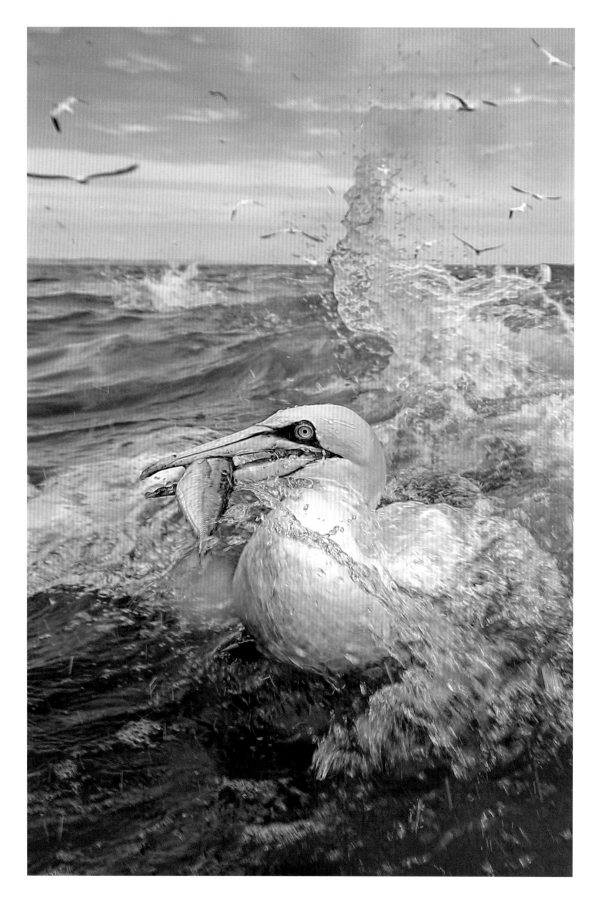

ANDY ROUSE

Gannet with Fish
(Northern gannet, *Morus bassanus*)
Bempton Cliffs, Northumberland

This was a baited gannet with a dead fish, just off Bempton Head. I leaned over the side and used the Live View feature of the camera to get a very low and close angle as the gannet caught the fish. My camera received several complete dunkings during the experience and after every sequence I had to wipe the soaked lens, but it survived and nailed me some nice, different images.

Camera: Canon EOS 1DX MkII | Lens: 12mm | Shutter speed: 1/250 sec.
Aperture: f/6.3 | ISO: 100
andyrouse.co.uk

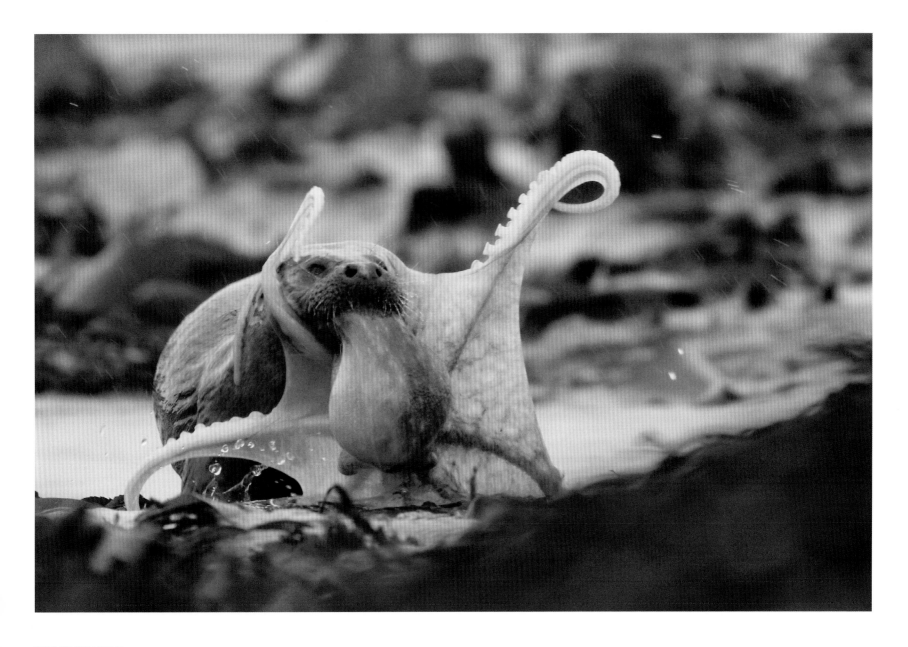

PHILIP DOUBLE
HIGHLY COMMENDED

Octopus for Dinner?
(European otter, *Lutra lutra*; Common octopus, *Octopus vulgaris*)
Near Tayvallich, Argyll and Bute

We had followed this otter and her cub for a couple of hours before we lost them as they hunted further up the shoreline. We waited in the rain for them to return and were lucky to see her catch a lobster and then this octopus, which she ate a few metres away from us. The pair then carried on hunting along the shore, oblivious to us lying in the wet seaweed.

Camera: Canon EOS 7D MkII | Lens: 100–400mm with 1.4x teleconverter | Shutter speed: 1/250 sec. | Aperture: f/8 | ISO: 800 | Beanbag

LUKE WILKINSON
HIGHLY COMMENDED

On a Mission
(Grey seal, *Halichoerus grypus*)
Norfolk Coast

This grey seal bull didn't take too kindly to another nearby bull, making his way along the beach. As he went to confront him, it appears as if he is almost flying across the beach.

Camera: Nikon D4 | Lens: 500mm | Shutter speed: 1/2500 sec. | Aperture: f/5.6 | ISO: 800

lukewilkinsonphotography.co.uk

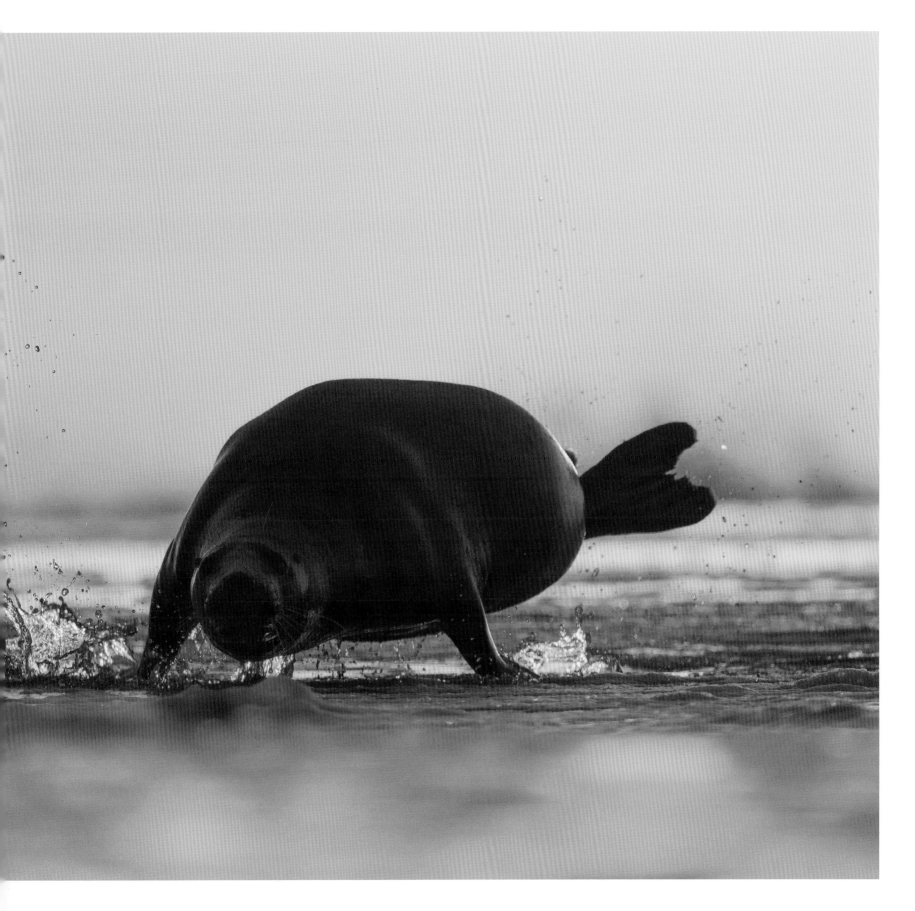

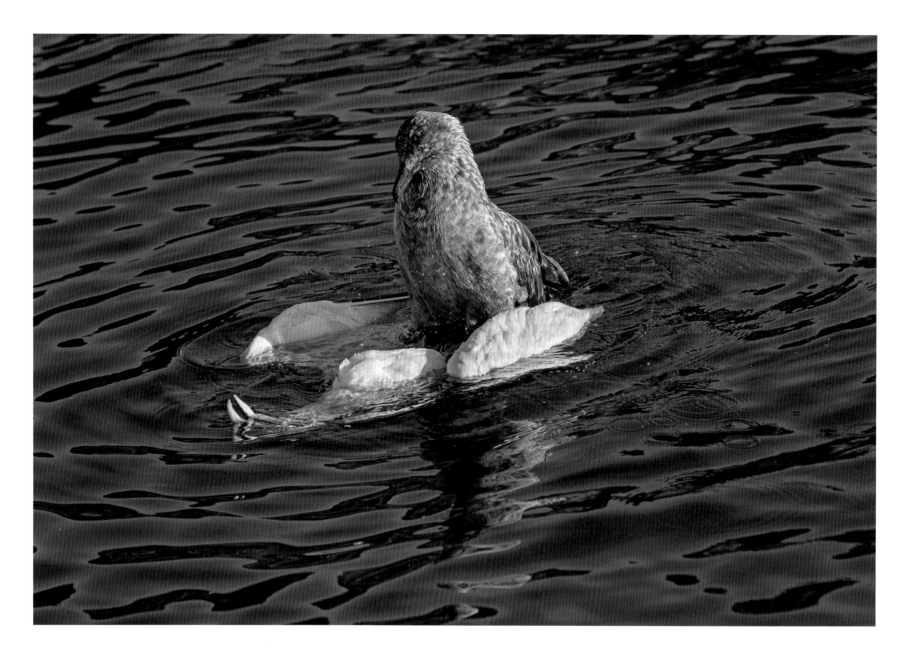

JOHN MACFARLANE
HIGHLY COMMENDED

Bonxie Riding a Gannet
(Great skua, *Stercorarius skua;* Northern gannet, *Morus bassanus*)
Near Lerwick, Shetland

A short boat trip from Lerwick in Shetland takes you to the dramatic cliffs of Noss, which is a favourite spot for observing seabirds, especially gannets. Cruising away from the cliff bottom we noticed a great skua apparently floating on a raft. We slowly approached and saw the skua was actually riding on the body of a dead gannet, pecking at its breast and removing feathers to get at the flesh. We managed to obtain several images of this disturbing scene from different angles.

Camera: Canon EOS 1DX MkII | Lens: 100–400mm at 220mm | Shutter speed: 1/1000 sec. | Aperture: f/9.0 | ISO: 500

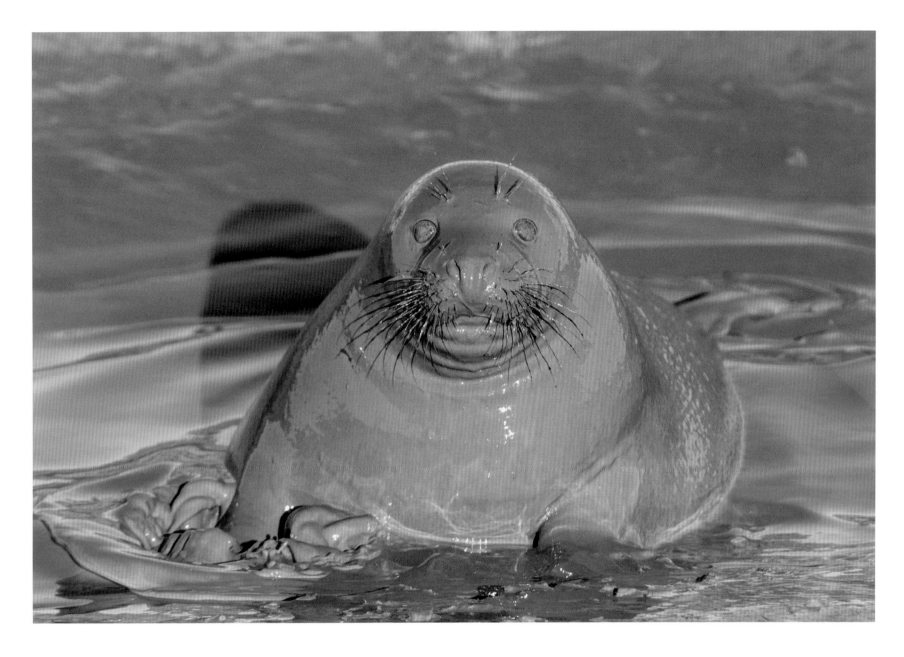

PHILIP MALE
HIGHLY COMMENDED

A Chocolate Fountain Moment
(Grey seal, *Halichoerus grypus*)
Donna Nook, Lincolnshire

While watching the grey seals pupping at Donna Nook, this youngster caught my eye, merrily enjoying a mud bath
in the midday winter sunshine.

Camera: Canon EOS 5D MkIII | Lens: 300mm with 1.4x teleconverter | Shutter speed: 1/800 sec. | Aperture: f/8 | ISO: 500

BEN HALL

Mountain Hare in Full Sprint
(Mountain hare, *Lepus timidus*)
Peak District National Park, Derbyshire

I was working on my local population of mountain hares throughout winter, and would visit them every time we had a good covering of snow. On this particular day the sky turned a beautiful shade of pastel pink as the sun started to sink, and I managed to find a hare out in the open. After taking several portraits it was spooked by a low-flying helicopter and suddenly bolted. I fired off a burst of shots, capturing the animal in full sprint against the sky.

Camera: Canon EOS 1DX | Lens: 500mm | Shutter speed: 1/1250 sec. | Aperture: f/5 | ISO: 800

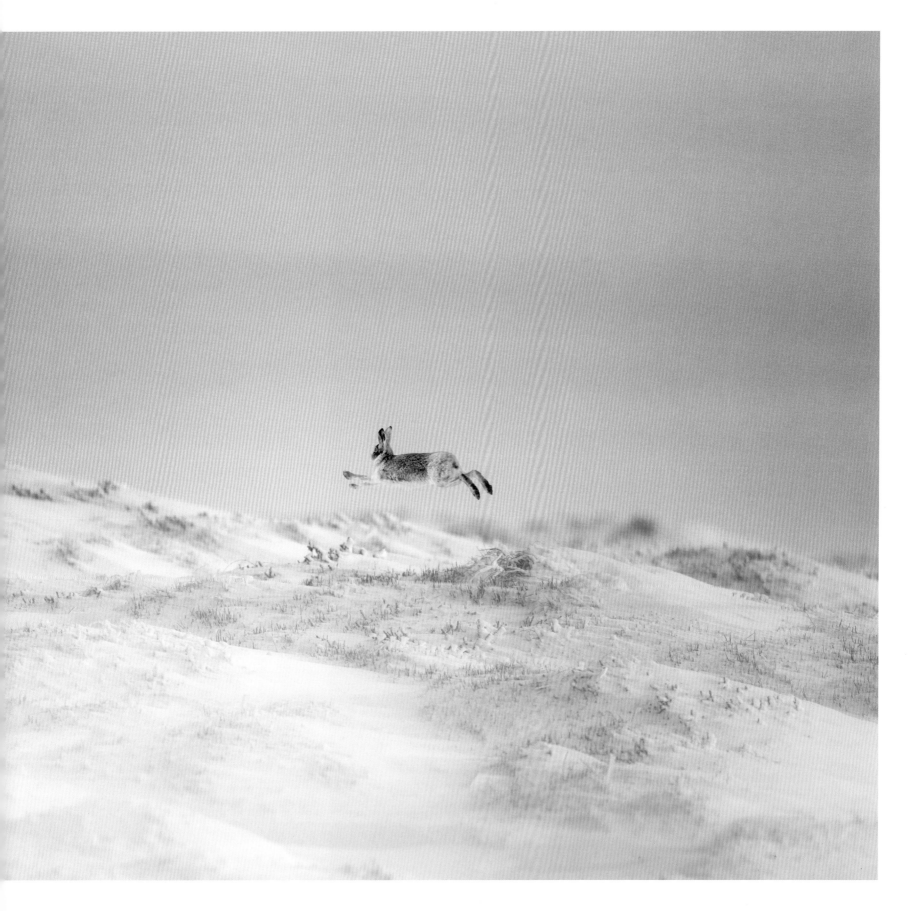

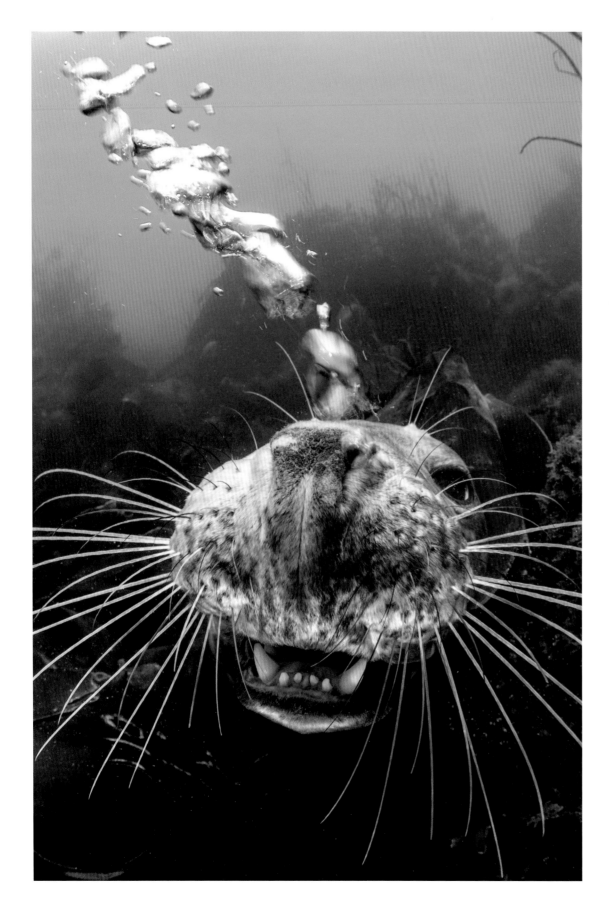

ALEX MUSTARD

Bubble Blower
(Grey seal, *Halichoerus grypus*)
Lundy, Devon

This young female seal was playfully blowing bubbles from its nose as I photographed it off the island of Lundy. It was a lot of fun swimming with the seals and taking these photographs.

Camera: Nikon D5 | Lens: 15mm | Shutter speed: 1/125 sec. | Aperture: f/14 ISO: 640 | Subal underwater housing, Inon underwater flashes
amustard.com

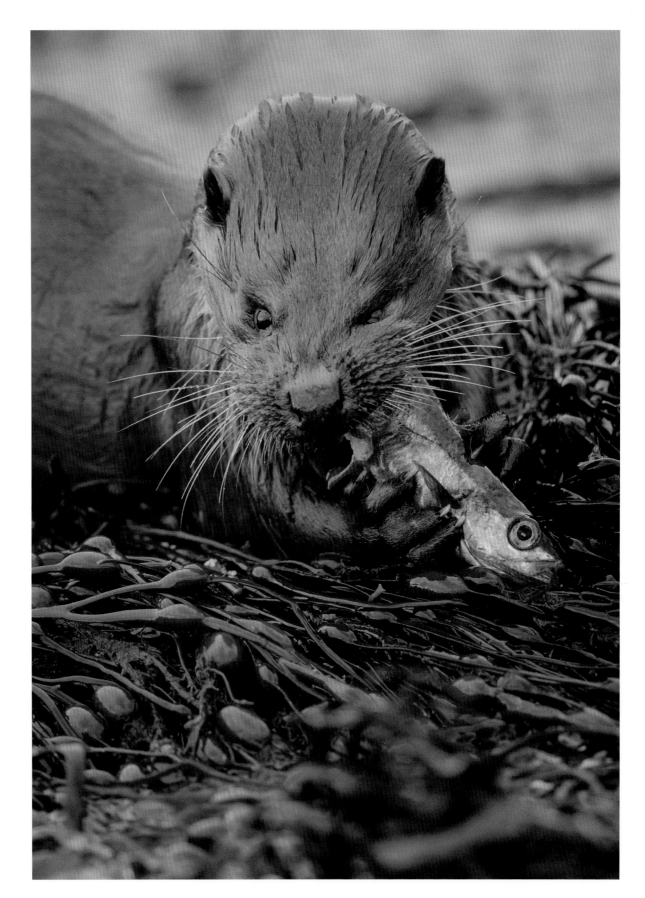

JAMES ROGERSON

Fish-eye Otter
(European Otter, *Lutra lutra*)
Isle of Mull, Argyll and Bute

I could see an otter fishing out in the loch, periodically disappearing as it dived for prey. I got into a position where I anticipated it would return to shore, and as it moved along the coastline I followed, slithering through seaweed to stay out of sight. For the next few hours I had some excellent views and left feeling very wet, very cold and very happy.

Camera: Canon EOS 1DX | Lens: 500mm | Shutter speed: 1/1000 sec.
Aperture: f/4 | ISO: 320 | Beanbag

jr-wildlife.com

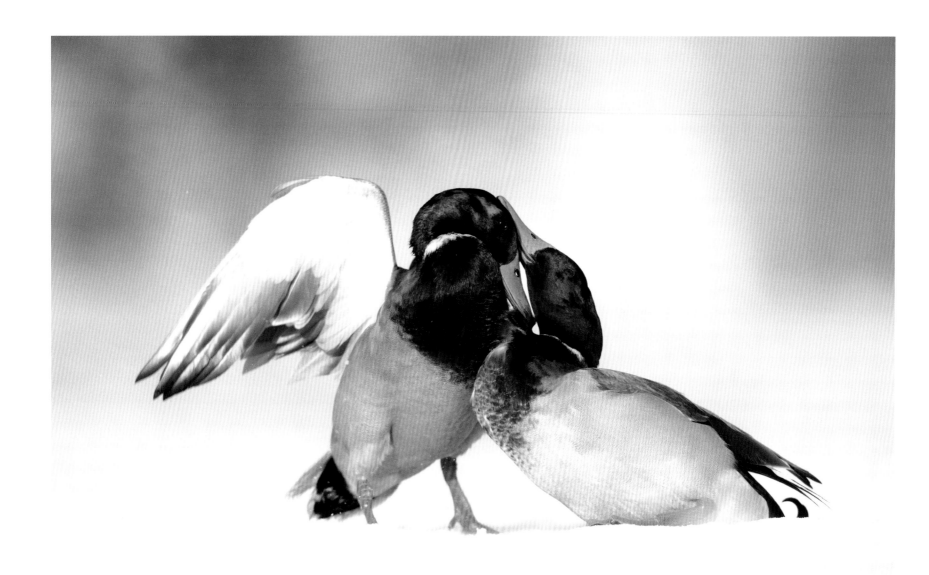

▲ CRAIG CHURCHILL

Duck Fight
(Mallard, *Anas platyrhynchos*)
Woodstock, Oxfordshire

The first snows of winter always send me into a panic: do I go out looking for random subjects or go somewhere I know I can get images? On this occasion the local lake came up trumps, as many mallards were present, desperately looking for grass to feed on. I lay in the snow for about half an hour photographing the ducks when suddenly two drakes engaged in a battle that went on for about 10 minutes as they pecked each other, jumped in the air and flapped their wings. It was incredible to witness and photograph.

Camera: Nikon D800 | Lens: 500mm | Shutter speed: 1/1250 sec. | Aperture: f/5.6 | ISO: 400
craigchurchill.co.uk

▶ LESLEY GOODING

Awww, Come on Mum, I Need a Cuddle
(Wild boar, *Sus scrofa*)
Forest of Dean, Gloucestershire

We found this female wild boar snuffling in the undergrowth with her hoglets playing round her feet, and settled down to watch their activity. Quite soon she lay down and the hoglets began to suckle. After having their fill they came to nuzzle round her face as if asking for attention and love.

Camera: Sony a9 | Lens: 100–400mm | Shutter speed: 1/160 sec. | Aperture: f/9 | ISO: 400
lesleygooding.co.uk

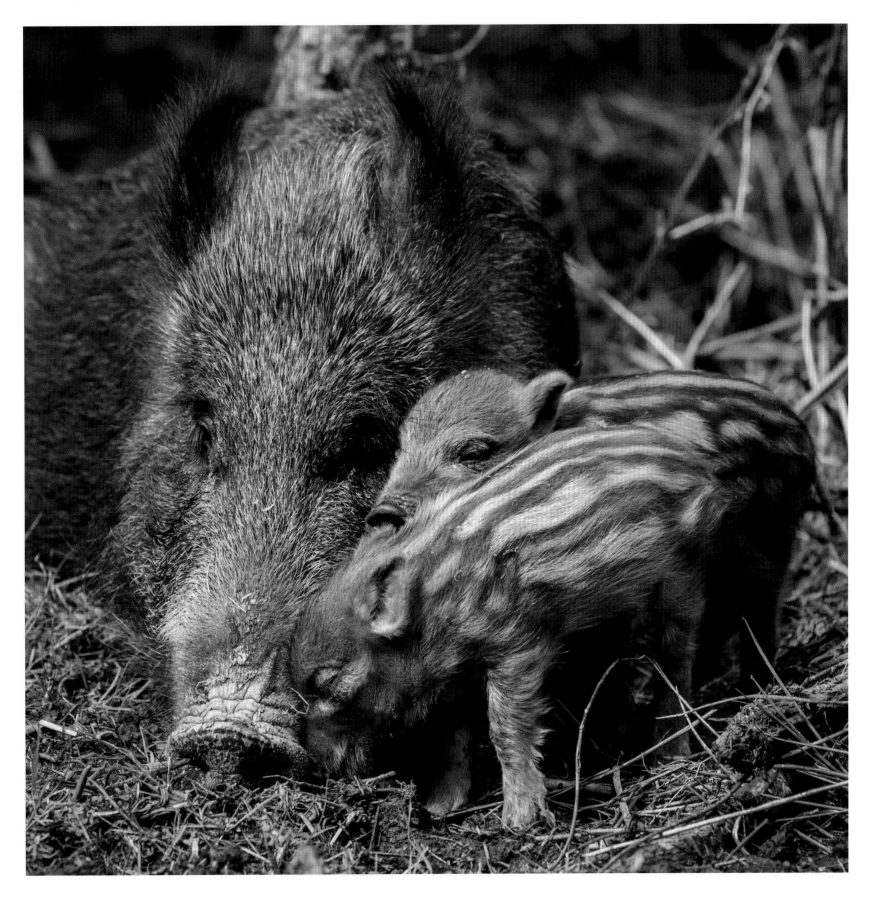

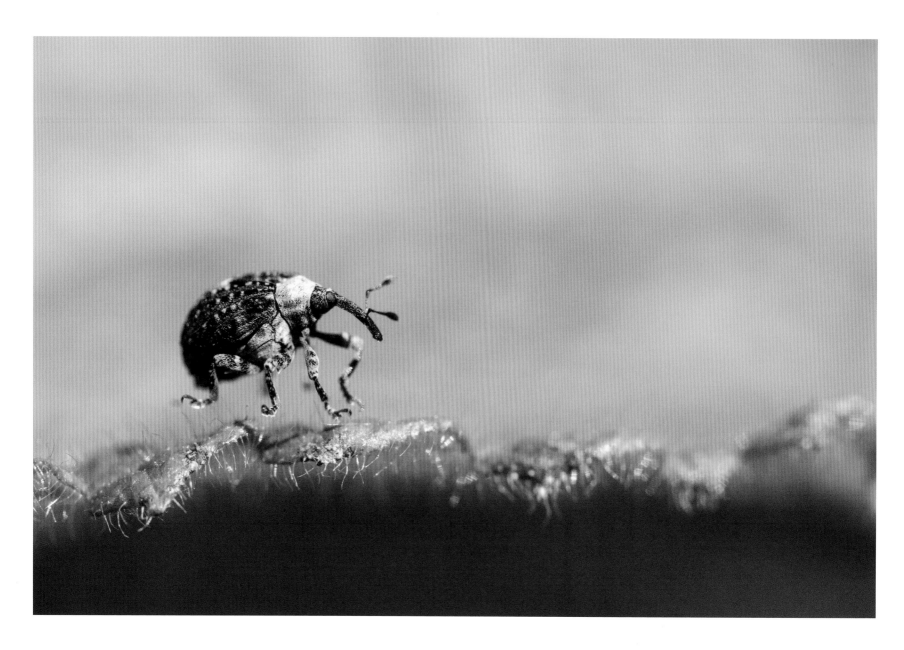

▲ JENNIE SMITH

Walking on Hair
(Figwort weevil, *Cionus scrophulariae*)
Todmorden, West Yorkshire

I spotted this figwort weevil walking on the microscopic hairs of a nettle leaf in nettles behind my house. Until then I had only seen them in pictures, so I reacted quickly and tried to stay calm, even though my adrenalin was spiking. I managed three shots before a gust of wind hit the leaf like a hurricane. The weevil took flight and disappeared, leaving me thrilled and a little bit stung by the nettle.

Camera: Canon EOS 70D | Lens: 100mm macro | Shutter speed: 1/800 sec. | Aperture: f/5.6 | ISO: 400
jenniesmith.co.uk

▶ DR JOHN H BRACKENBURY

Painted Lady Butterfly in Flight
(Painted lady butterfly, *Cynthia cardui*)
Wimpole, Cambridgeshire

I took this shot of a painted lady butterfly in flight using ambient light. The shot was handheld, with no automatic triggering device or remote release.

Camera: Nikon 1 J5 | Lens: 2.7mm fisheye | Shutter speed: 1/6500 sec. | Aperture: f/1.8 | ISO: 800

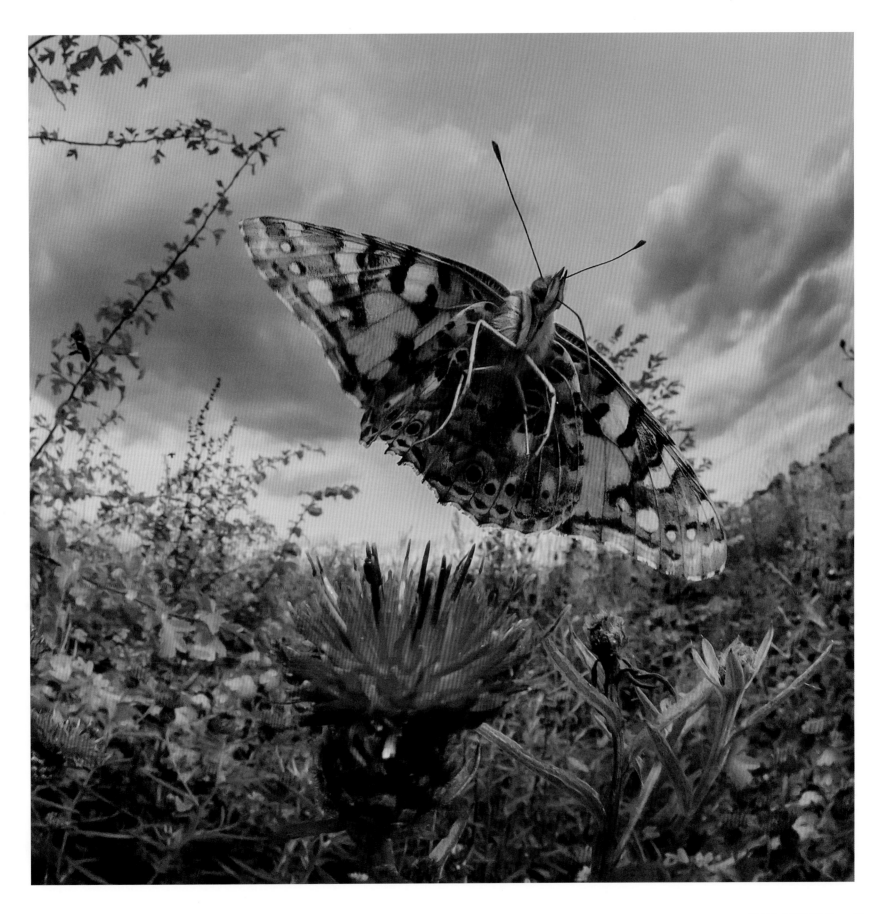

ANDY HARRIS

Pheasant Call
(Pheasant, *Phasianus colchicus*)
Stratford-upon-Avon, Warwickshire

Our garden, wildflower meadow and small woodland area sit next to open countryside. Wild pheasants treat
our land as theirs and are welcomed as part of the landscape of home. This was a spring evening with soft
golden-hour light and a beautiful male bird calling to the wild. Getting low to the ground and waiting patiently
for the setting sun to illuminate his call, a shutter click captured the moment.

Camera: Nikon D810 | Lens: 500mm | Shutter speed: 1/1000 sec. | Aperture: f/4 | ISO: 220

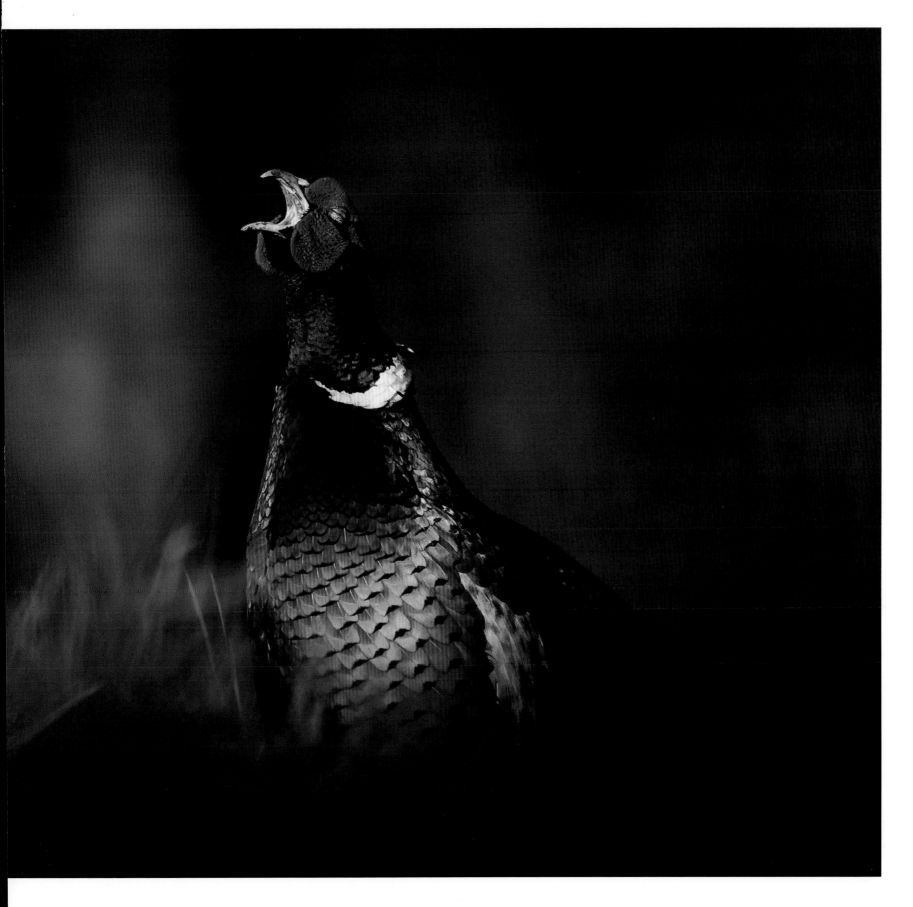

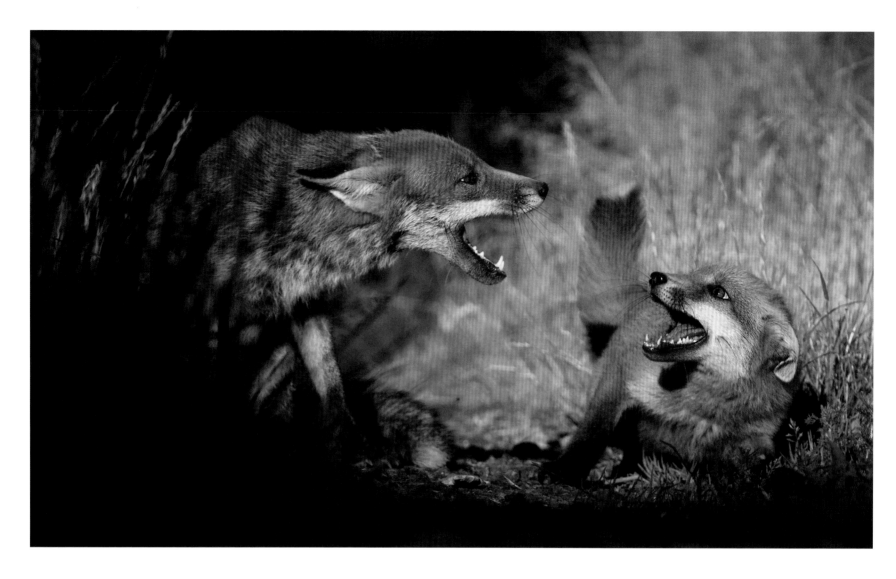

▲ ANDREW MCCARTHY

In Trouble Again!
(Red fox, *Vulpes vulpes*)
Near Ide, Devon

I was lucky enough to work for an extended period with this local fox family, which let me get a feel for the character of each animal. This particular cub (right) was far more confident than the others, and this is a typical shot of it being ticked off by its mother for some misdemeanour!

Camera: Canon EOS 1D MkIV | Lens: 70–200mm | Shutter speed: 1/500 sec.
Aperture: f/7.1 | ISO: 800
andrewmccarthyphotography.com

▶ PHILL GWILLIAM

I Saw it First
(Barn owl, *Tyto alba*)
RSPB Titchwell Marsh, Norfolk

It was mid-afternoon on an early March day and Norfolk was in the grip of a winter storm, called the 'Beast from the East'. The wildlife was struggling to survive in the bitterly cold conditions, these barn owls included. Both owls were out hunting and seemed to have spotted the same prey: a mid-air tussle took place in front of our eyes, but sadly neither bird got to eat on this occasion.

Camera: Nikon D500 | Lens: 500mm with 1.4x teleconverter | Shutter speed: 1/1000 sec. | Aperture: f/6.3 | ISO: 1000

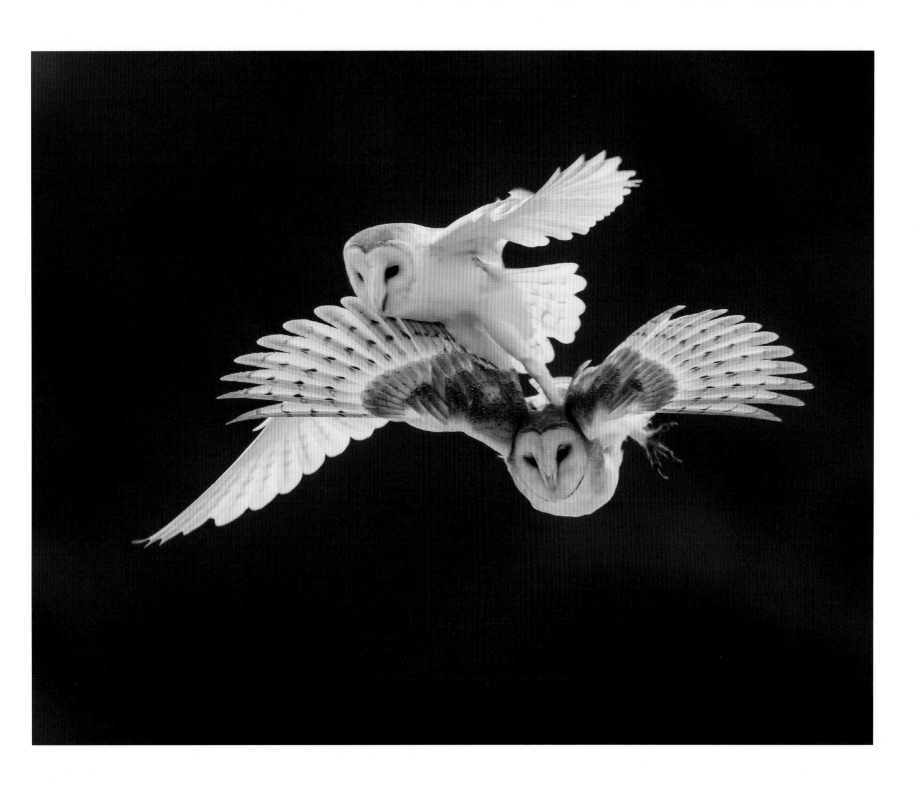

URBAN WILDLIFE

BRITISH WILDLIFE
PHOTOGRAPHY AWARDS

SPONSORED BY
THE WILDLIFE TRUSTS

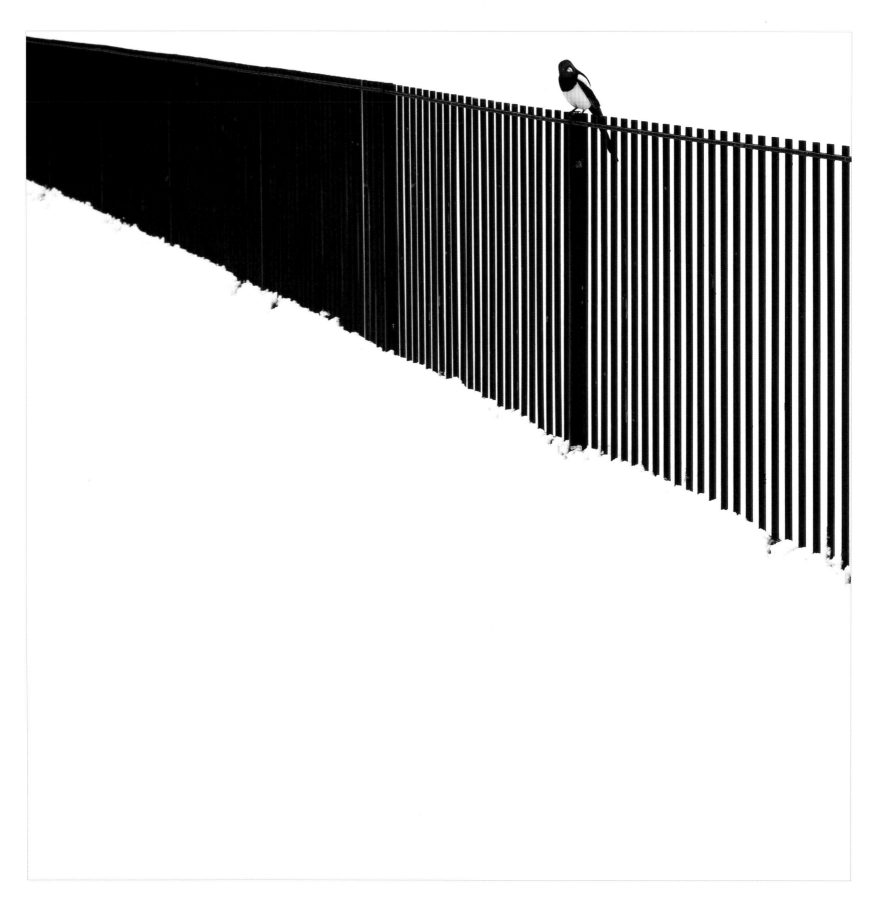

◀ CHRISTOPHER SWAN
CATEGORY WINNER

Magpie in the Snow
(Magpie, *Pica pica*)
Kelvingrove Park, Glasgow

A black-and-white bird in a black-and-white landscape.
I was lucky enough to spot this magpie in Glasgow's
Kelvingrove Park after a snowfall; it was perched on
the black railings against the white of the snow and
made for a very graphic image. The magpie kindly
waited until I'd taken my shot before cocking its
head and flying off!

Camera: Fuji X-T2 | Lens: 18-55mm | Shutter speed: 1/80 sec.
Aperture: f/8 | ISO: 200

christopherswan.co.uk

▶ WILLIAM HARVEY
HIGHLY COMMENDED

Roe Deer Through Headstone Carving
(Roe deer, *Capreolus capreolus*)
Graveyard, Surrey

I first spotted the back end of this buck sticking
out from behind the headstone where he was lying.
I am very familiar with these particular deer and know
how tolerant (or not) the various individuals are. I was
confident that with a careful approach I could get
into position to photograph him through the carving,
without disturbing his rest.

Camera: Canon EOS 1DX MkII | Lens: 500mm with 1.4x teleconverter
Shutter speed: 1/200 sec. | Aperture: f/5.6 | ISO: 3200

williamharveyphotography.co.uk

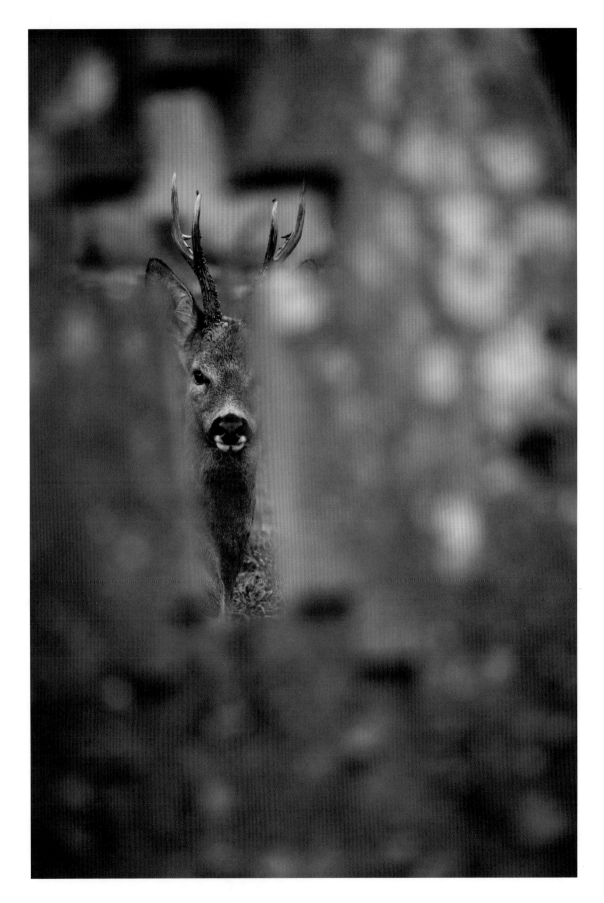

SAM ROWLEY
HIGHLY COMMENDED

Underground Emergence
(House mouse, *Mus musculus*)
London Underground, London

Twenty metres beneath the streets of one of the world's busiest cities isn't a typical location for a wildlife photographer. 'Tube mice' are a common sight on London's Underground, but few people stop to give them a second glance. I think they're amazing creatures, living their entire lives in this most bizarre place.

Camera: Nikon D500 | Lens: 105mm | Shutter speed: 1/200 sec. | Aperture: f/2.8 | ISO: 1600
sam-rowley.com

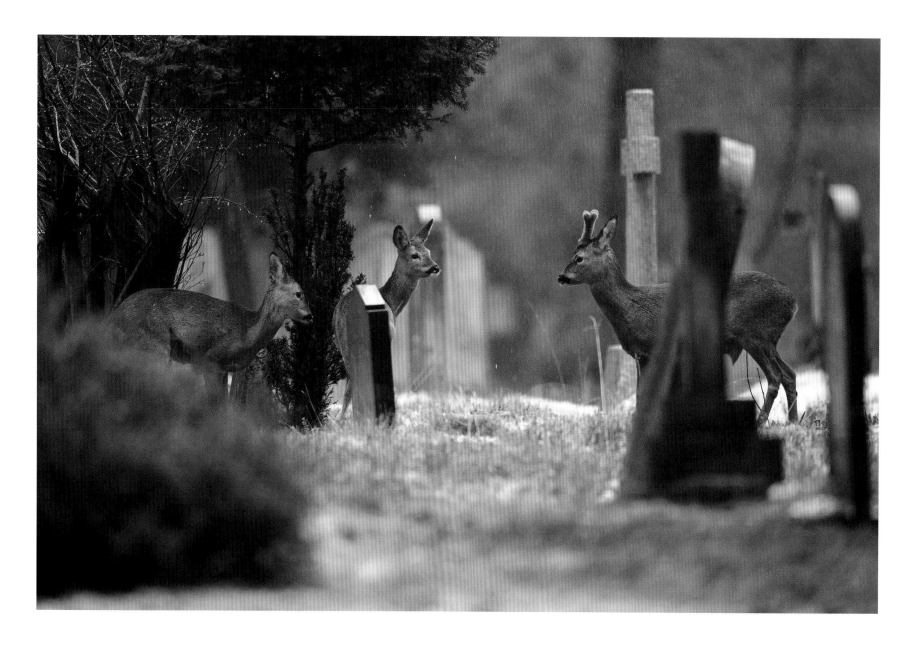

ALEX WITT
HIGHLY COMMENDED

Graveyard Family
(Roe deer, *Capreolus capreolus*)
Woking, Surrey

With sporadic snow having just started to fall, I made my way to my local cemetery in the quest for some long-awaited wintry images. As luck would have it, the moment I arrived the snow turned to rain. Despite my initial disappointment I decided to stay and persevere, as the cold rain and hints of snow on the ground added a sense of atmosphere to the location. This rather poignant moment between these three deer made for a worthy trip.

Camera: Canon EOS 1DX | Lens: 500mm | Shutter speed: 1/400 sec. | Aperture: f/4 | ISO: 1250

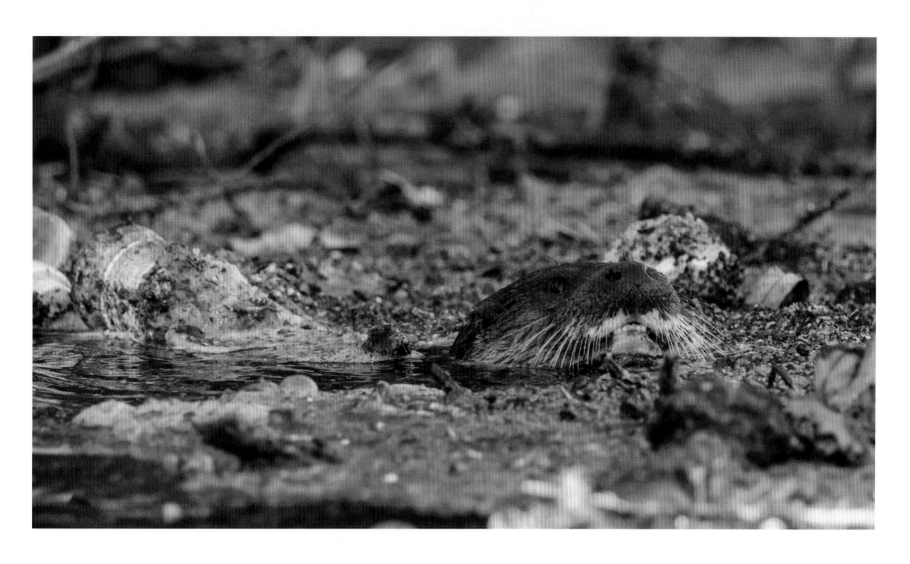

NEIL PHILLIPS
HIGHLY COMMENDED

Otter Swimming Through a Polluted River Full of Plastic
(European otter, *Lutra lutra*)
Little Ouse River, Norfolk

I was photographing this otter as it swam along catching fish. It surfaced in an area of overhanging tree branches, where a large amount of debris had gathered, much of which was plastic waste. It shows the threat of plastic waste occurs in freshwater as well as in the sea.

Camera: Olympus OM-D E-M1 MkII | Lens: 300mm | Shutter speed: 1/500 sec. | Aperture: f/4 | ISO: 800
uk-wildlife.co.uk

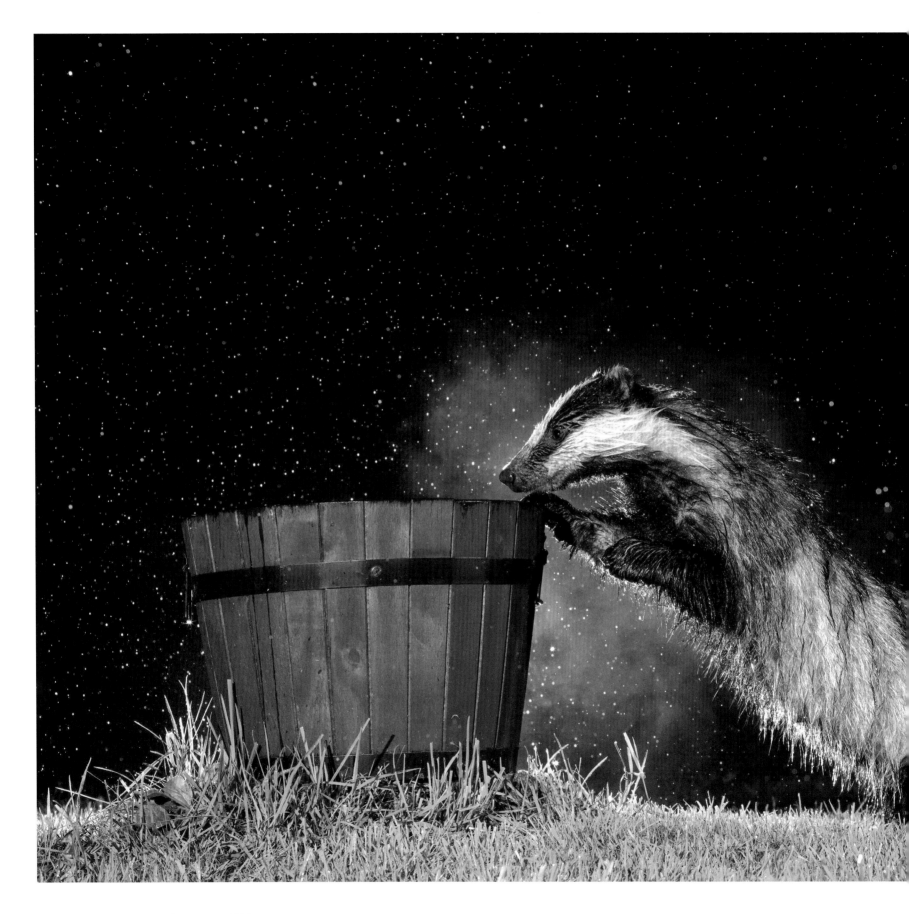

ALAN SEYMOUR
HIGHLY COMMENDED

Inquisitive Brock
(Badger, *Meles meles*)
Elstead, Surrey

With badgers regularly visiting my garden, I have always thrown a few peanuts about, so we can watch from our garden hide. I noticed they often checked out the flower pots, so I put a few peanuts in a wooden tub and placed it in the middle of the lawn. I set up my camera using a passive infrared motion sensor and three flashes – two in front and one as a backlight, which has picked out the badger's breath and the raindrops. This was the first night of trying this setup and I have not been able to capture a similar image since.

Camera: Canon EOS 5D MkIII | Lens: 85mm | Shutter speed: 1/200 sec. | Aperture: f/11 | ISO: 800 | Three Nikon SB-28 Speedlights, PIR motion sensor
seymourwild.com

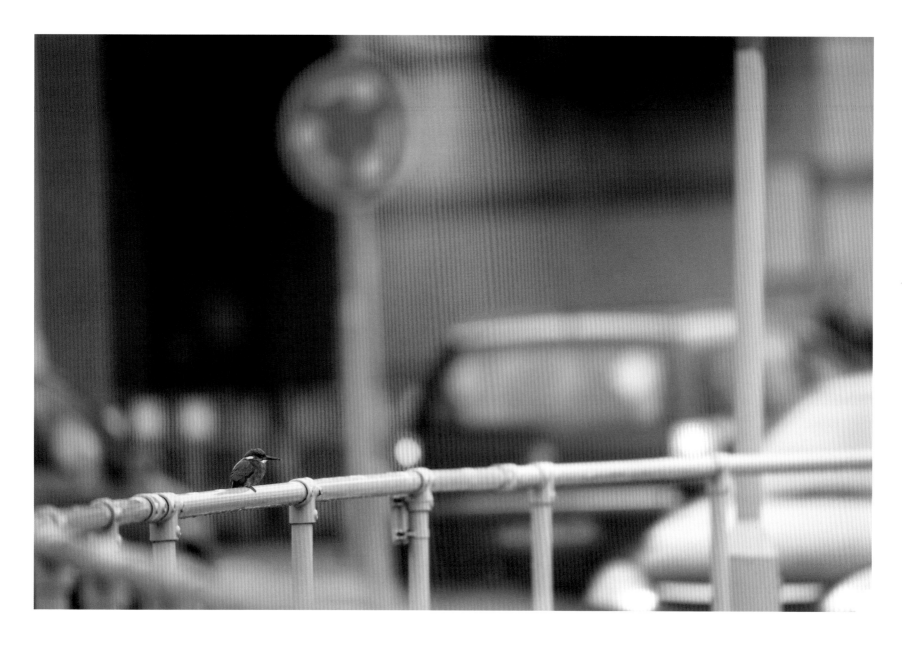

DANIEL TRIM
HIGHLY COMMENDED

Kingfisher About Town
(Common kingfisher, *Alcedo atthis*)
Hemel Hempstead, Hertfordshire

During cold spells, wildlife often ventures into towns where it can be a few degrees warmer; this can be the difference between having access to food or not. This kingfisher hit the jackpot by finding a thriving population of sticklebacks in a town-centre water garden. Having found food, this bird stayed around for most of the winter, often using the urban street furniture as it sat and waited for a tasty morsel to swim into view.

Camera: Canon EOS 5DS | Lens: 500mm | Shutter speed: 1/60 sec. | Aperture: f/4 | ISO: 800
danieltrimphotography.co.uk

MARTIN C ESCHHOLZ

Cormorant Contrast
(Cormorant, *Phalacrocorax carbo*)
Bridport, Dorset

For cormorants, posts in the harbour make good vantage points to rest on, and for me the contrast between their soft natural outline and the hard artificial shape of the post is quite fascinating. It is not easy to distinguish between a cormorant and a shag, especially in silhouette, but it seems most likely the two birds in this picture are cormorants.

Camera: Canon EOS 7D | Lens: 70-200mm with 2x teleconverter
Shutter speed: 1/6400 sec. | Aperture: f/9 | ISO: 640
natureinpictures.co.uk

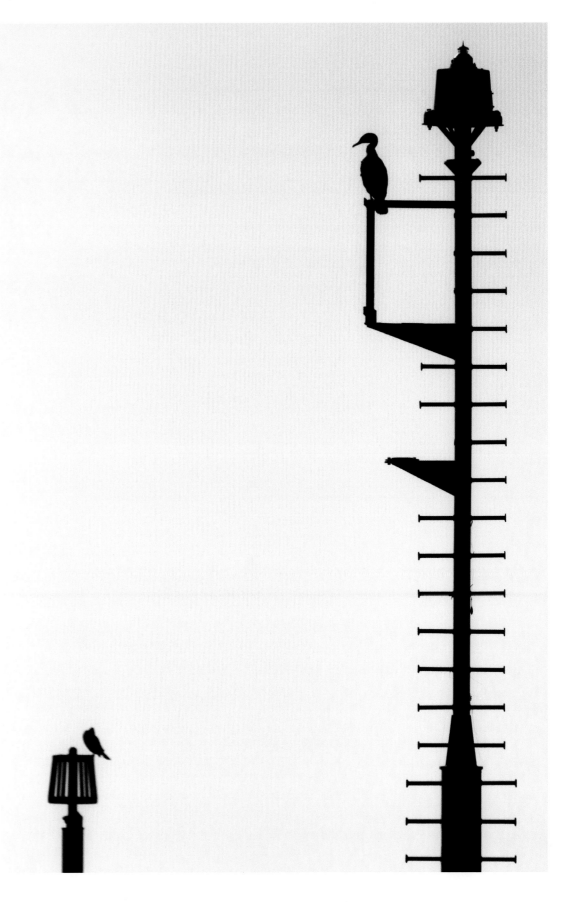

HIDDEN BRITAIN

BRITISH WILDLIFE PHOTOGRAPHY AWARDS

SPONSORED BY
BUGLIFE

ANDREW MCCARTHY
CATEGORY WINNER

Waiting for Her Prey
(Nursery web spider, *Pisaura mirabilis*)
Dunchideock, Devon

I came across this female nursery web spider sitting patiently in a stunning dahlia bloom in a corner of our garden late last summer. The species is an ambush predator and will wait motionless for a considerable time before springing out and subduing its prey. Despite the prevailing warm temperatures that day this spider seemed oblivious to my presence; this allowed me ample time to set up my equipment and run a 32-image focus stack before she disappeared back into the flower head.

Camera: Canon EOS 5D MkIV | Lens: 180mm macro | Shutter speed: 1/20 sec. | Aperture: f/7.1 | ISO: 800 | Tripod
andrewmccarthyphotography.com

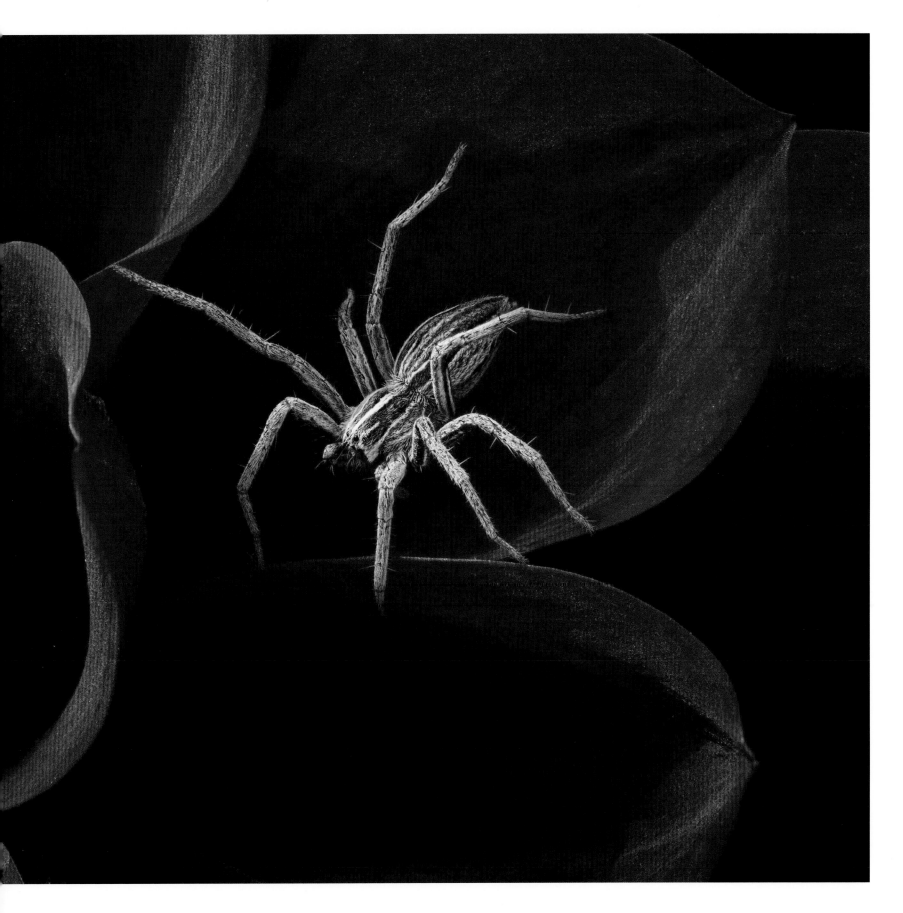

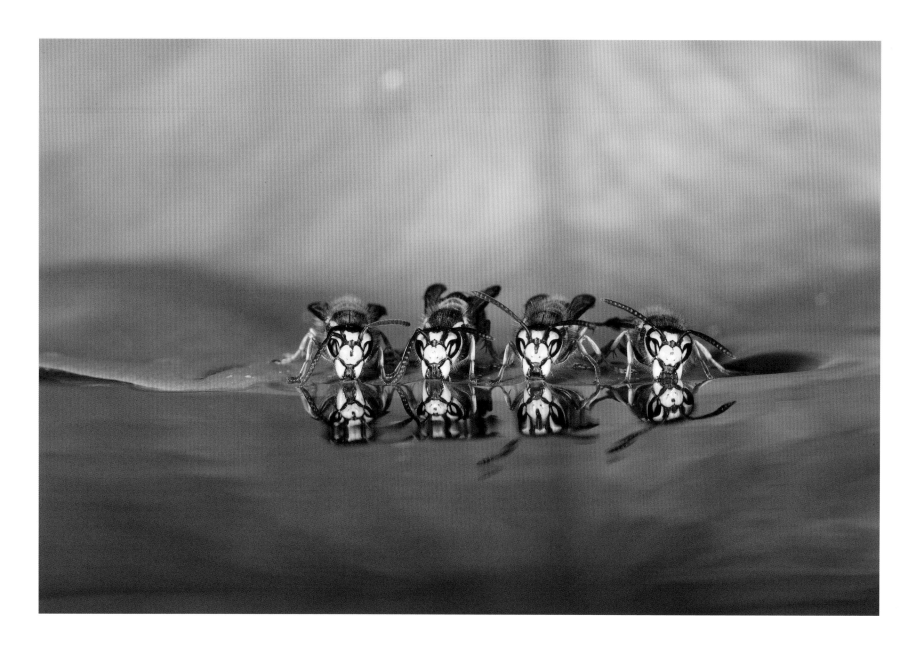

ROY RIMMER
HIGHLY COMMENDED

Four Common Wasps Drinking
(Common wasp, *Vespula vulgaris*)
Wigan, Greater Manchester

I had a wasp nest in my garden and noticed that some of the wasps would land on the lilies in my pond to drink water. I set up with two flash units, a beanbag and a parasol to keep the ambient light off the scene and prevent ghosting. I had to wait for a calm day so that I wouldn't get any ripples.

Camera: Canon EOS 1DX MkII | Lens: 180mm macro | Shutter speed: 1/200 sec. | Aperture: f/22 | ISO: 200 | Two flash units, beanbag, parasol

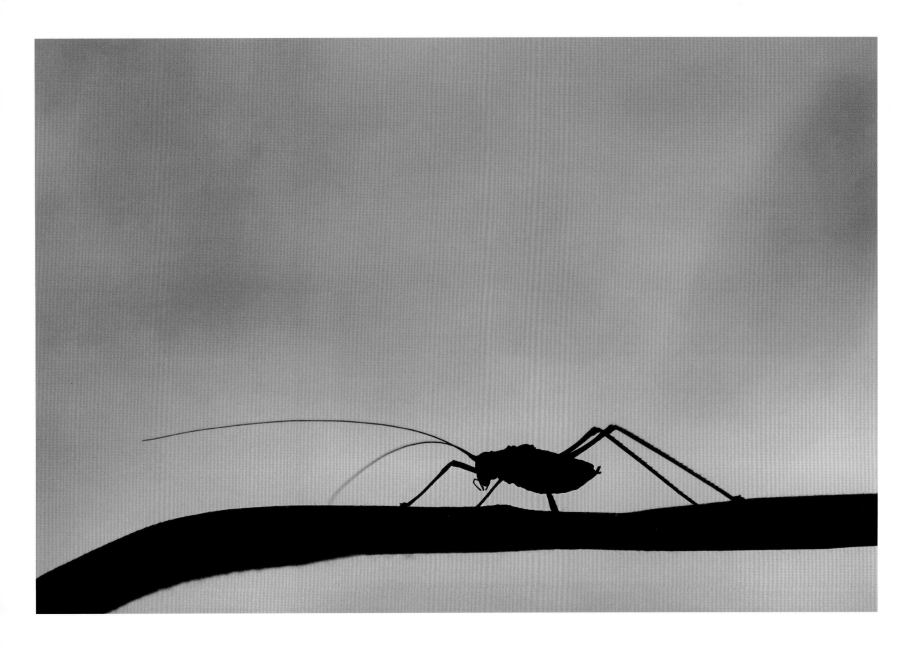

GUY PILKINGTON
HIGHLY COMMENDED

Basking in the Sun
(Speckled bush-cricket, *Leptophyes punctatissima*)
Woodwalton Fen National Nature Reserve, Cambridgeshire

Sitting in one of the hides at my local nature reserve, I spotted this speckled bush-cricket basking in the sun on a leaf a few metres in front of me. I took a couple of photographs, reviewed them on my camera and decided that it would look good as a silhouette, so took another shot deliberately underexposing to create the silhouette effect. The golden colour of the background is the out-of-focus reflection of the sun off the water.

Camera: Sony RX10 MkIII | Lens: 600mm | Shutter speed: 1/1250 sec. | Aperture: f/4 | ISO: 100 | Hide clamp, tripod head
fenphotos.wordpress.com/author/fenguy/

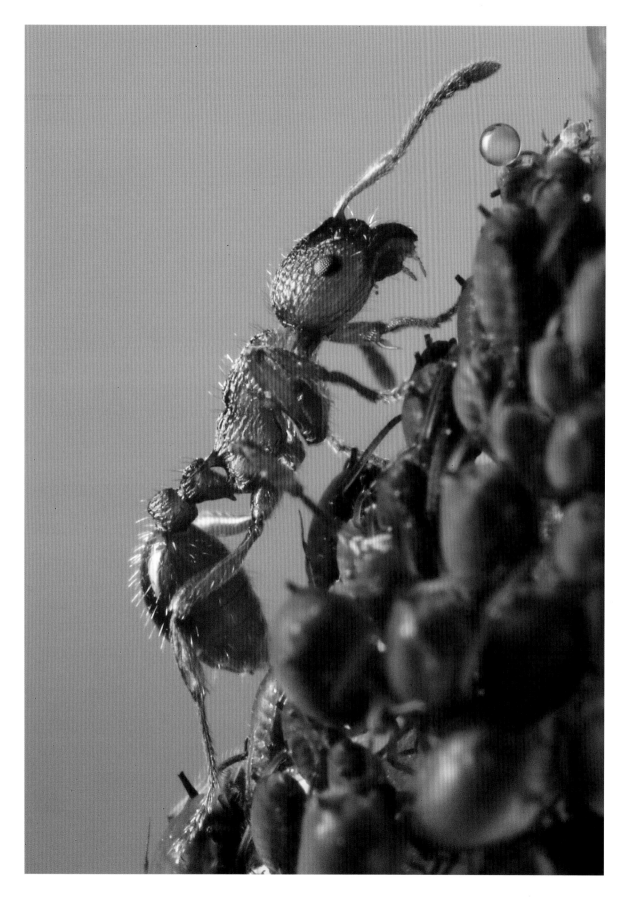

◄ ROY RIMMER

Red Ant Farming Aphids and Being Rewarded with a Honeydew Globule
(Red ant, *Myrmica sp*)
Wigan, Greater Manchester

I noticed some red ants farming aphids on a dock plant in my wild garden and I wanted to show the relationship between them. The aphids reward the ants with a honeydew globule for protecting them from various other insects.

Camera: Canon EOS 1DX MkII | Lens: 65mm macro
Shutter speed: 1/160 sec. | Aperture: f/16 | ISO: 400
Canon MT-24EX Macro Twin Lite Flash

► OLIVER WRIGHT

Damselfly Covered in Dew
(Large red damselfly, *Pyrrhosoma nymphula*)
Timble Ings, Yorkshire

I took this shot at first light, while the damselfly was torpid and covered in dew. I had to work quickly as the midges were ferocious. I used focus-stacking to achieve a greater effective depth of field in the final image.

Camera: Canon EOS 5D MkIV | Lens: 65mm macro
Shutter speed: 1/30 sec. | Aperture: f/11 | ISO: 800
Tripod, remote release
oliverwrightphotography.com

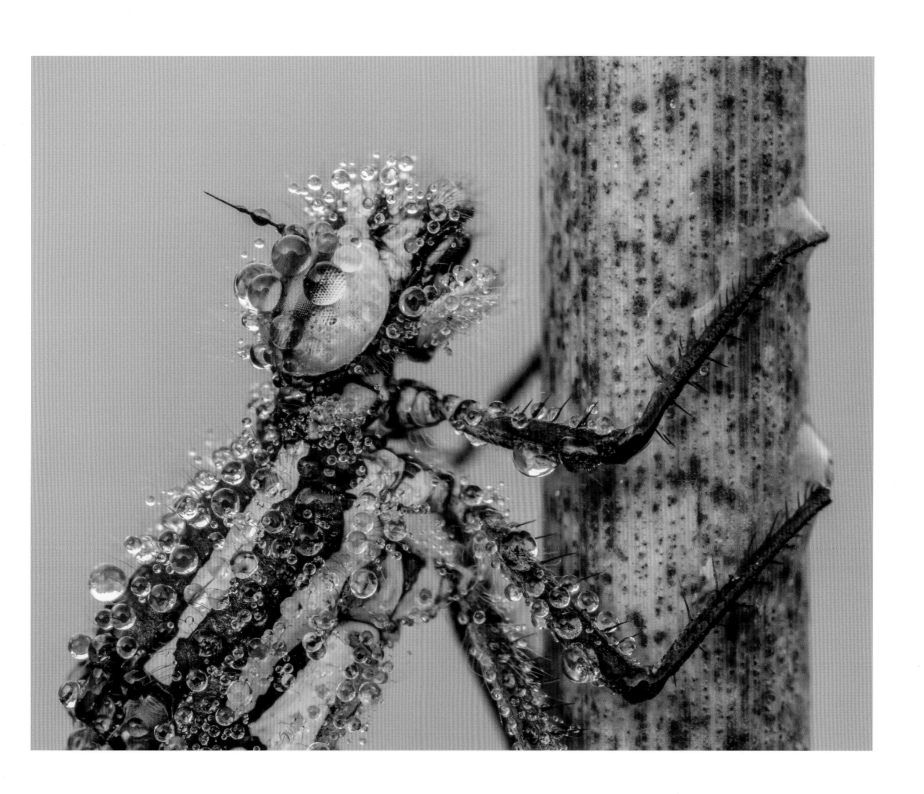

JASON PARRY
HIGHLY COMMENDED

A Good Spot
(Small copper, *Lycaena phlaeas*)
Prawle Point, Devon

I find the variety of patterns that occur on butterfly wings truly mesmerising, but I find the intricacy of their delicate bodies just as fascinating. This small copper butterfly was resting on a leaf while the sun had gone behind a cloud and allowed me to get close enough to take this image.

Camera: Canon EOS 6D | Lens: 105mm macro | Shutter speed: 1/1000 sec. | Aperture: f/4.5 | ISO: 1600

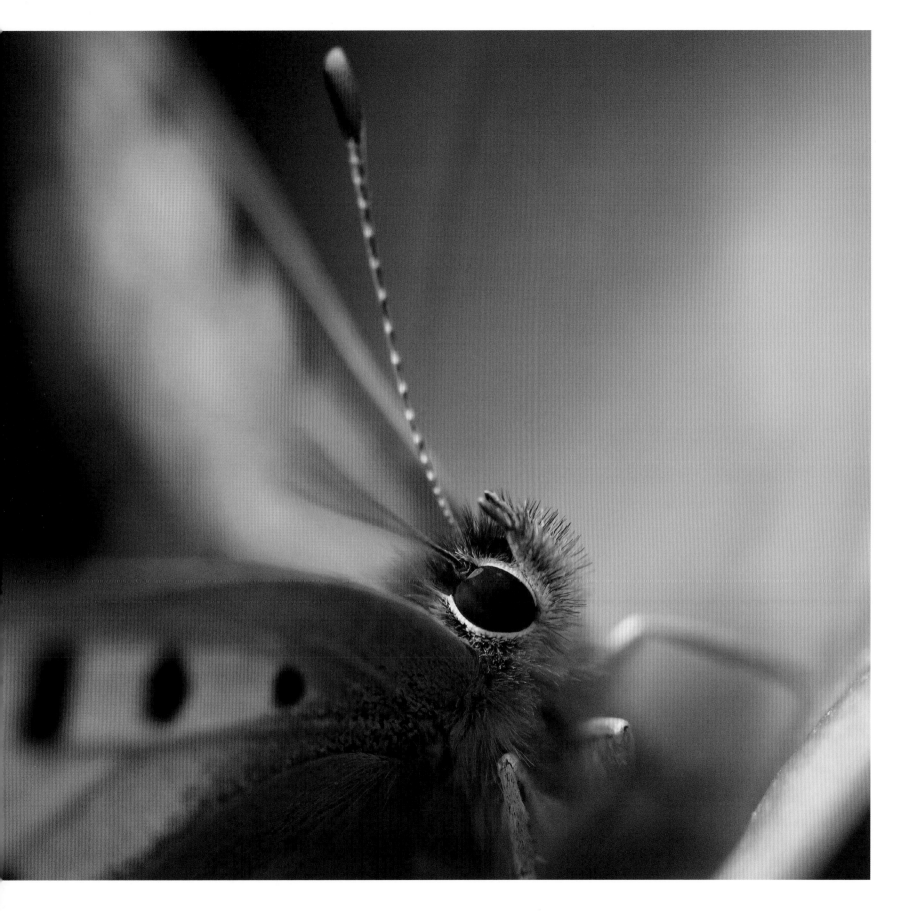

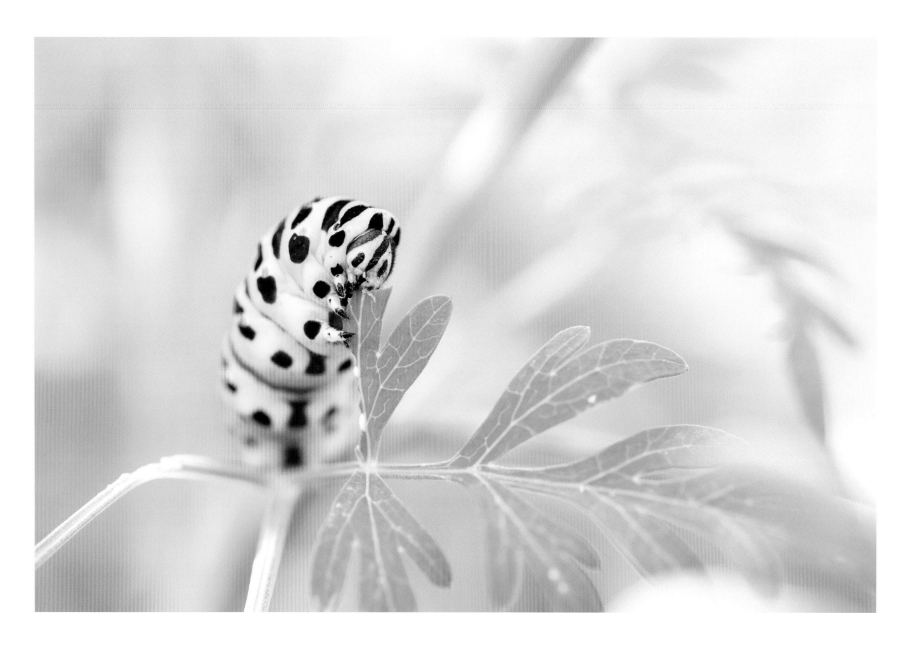

LUKE WILKINSON

Swallowtail Caterpillar Feeding
(Swallowtail caterpillar, *Papilio machaon*)
Broads National Park, Norfolk

Living in Norfolk I am fortunate enough to know a few spots where swallowtail caterpillars can be found.
For a couple of weeks in the middle of summer they can be found along the broads feeding on the nearby
milk parsley.

Camera: Nikon D800 | Lens: 60mm macro | Shutter speed: 1/320 sec. | Aperture: f/8 | ISO: 640
lukewilkinsonphotography.co.uk

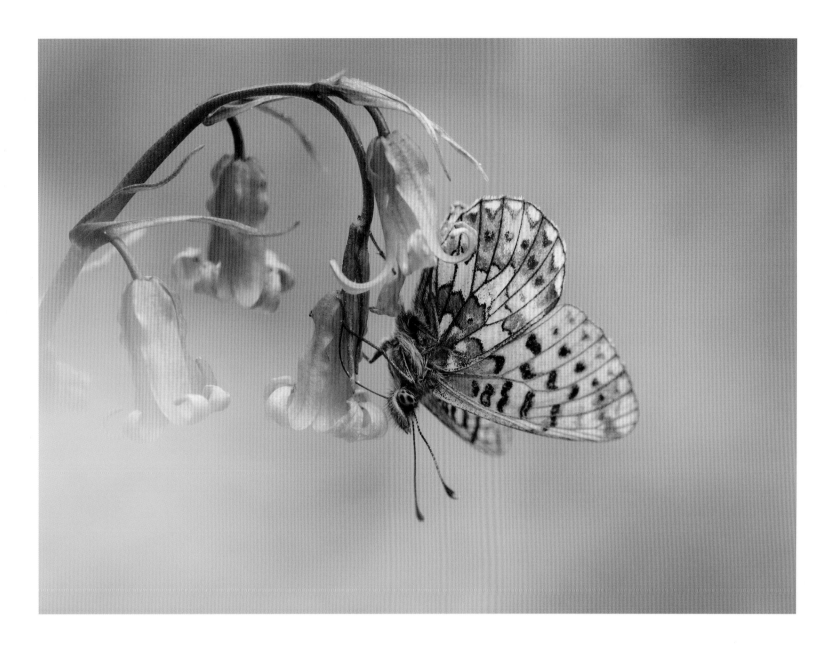

ANDREW MCCARTHY

Pearl-Bordered Fritillary Feeding on Bluebell
(Pearl-bordered fritillary, *Boloria euphrosyne*)
Haldon Hill, Devon

I am lucky enough to live close to an important site for one of the UK's most threatened species of butterfly, the pearl-bordered fritillary. This shot was taken late in the season, by which time most of the bluebells had gone over. I was lucky to find this still-lovely specimen nectaring on one of the last pristine flower heads on the site.

Camera: Olympus OM-D EM-1 MkII | Lens: 40–150mm with 1.4x teleconverter | Shutter speed: 1/500 sec. | Aperture: f/5.6 | ISO: 800
andrewmccarthyphotography.com

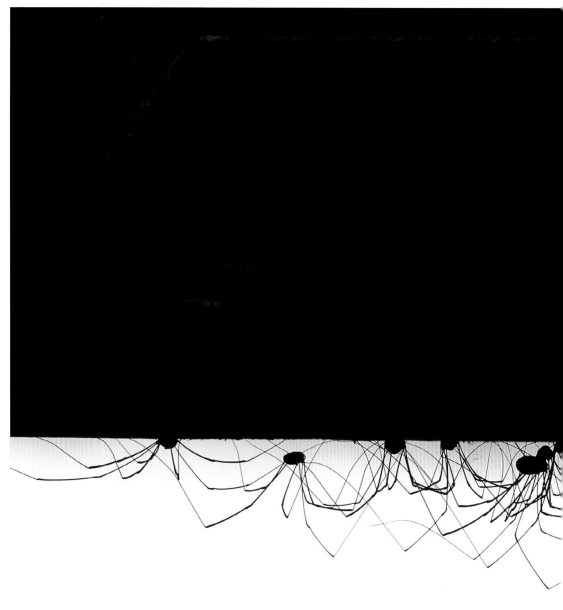

ALLEN HOLMES

Dancing on the Ceiling
(Harvestmen, *Opilones*)
Potteric Carr, Yorkshire

I spotted these harvestmen under a gate rail, as I was about
to pass through – it was unusual to see so many in such
a situation. They gather in groups and can bob and weave
together as a form of defence. It was also apparent that
they were pairing up and the whole situation reminded me
of a '90s nightclub scene, but upside down, hence the title.

Camera: Canon EOS 7D | Lens: 150–600mm | Shutter speed: 1/60 sec.
Aperture: f/10 | ISO: 400 | Tripod, remote release
twitter.com/AllenHolmes_1

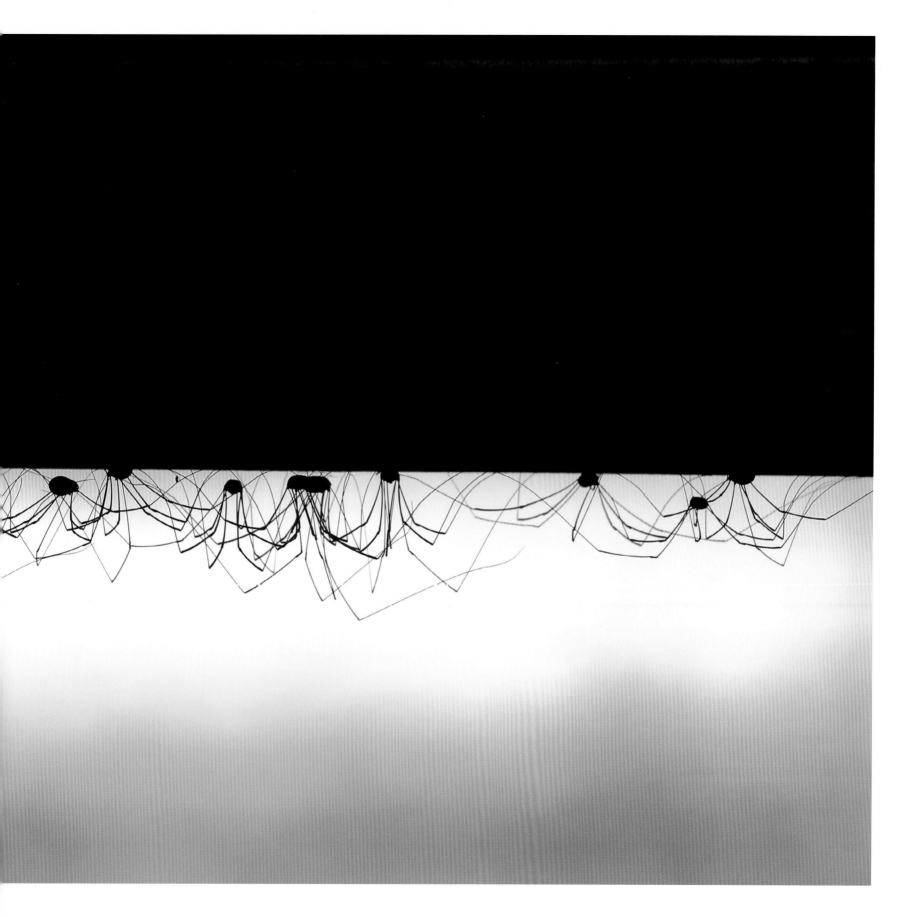

COAST
AND
MARINE

BRITISH WILDLIFE
PHOTOGRAPHY AWARDS

SPONSORED BY
WWF

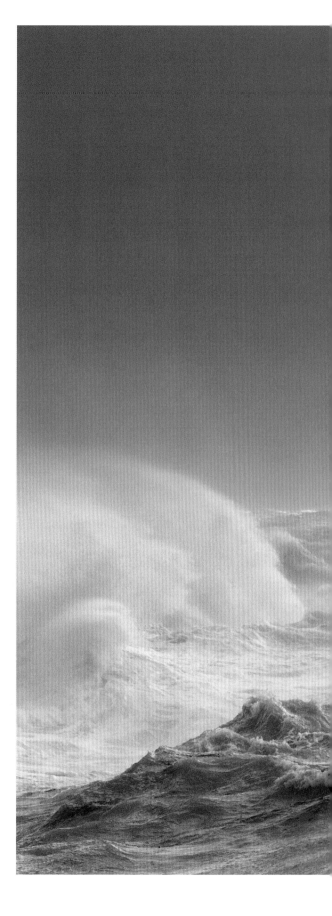

CRAIG DENFORD
CATEGORY WINNER

Storm Gull
(Lesser black-backed gull, *Larus fuscus*)
Newhaven, East Sussex

Taken at Newhaven as Storm Brian hit our shores in October 2017. A gale force wind meant having to constantly hold on to my tripod to prevent it being blown away, and I was forever having to wipe the sea spray from the lens. The gulls were clearly enjoying it, though, catching the wind and flying low over the waves before circling around and going again.

Camera: Canon EOS 7D MkII | Lens: 75–300mm at 190mm | Shutter speed: 1/800 sec. | Aperture: f/10 | ISO: 200 | Tripod
craigdenfordphotography.co.uk

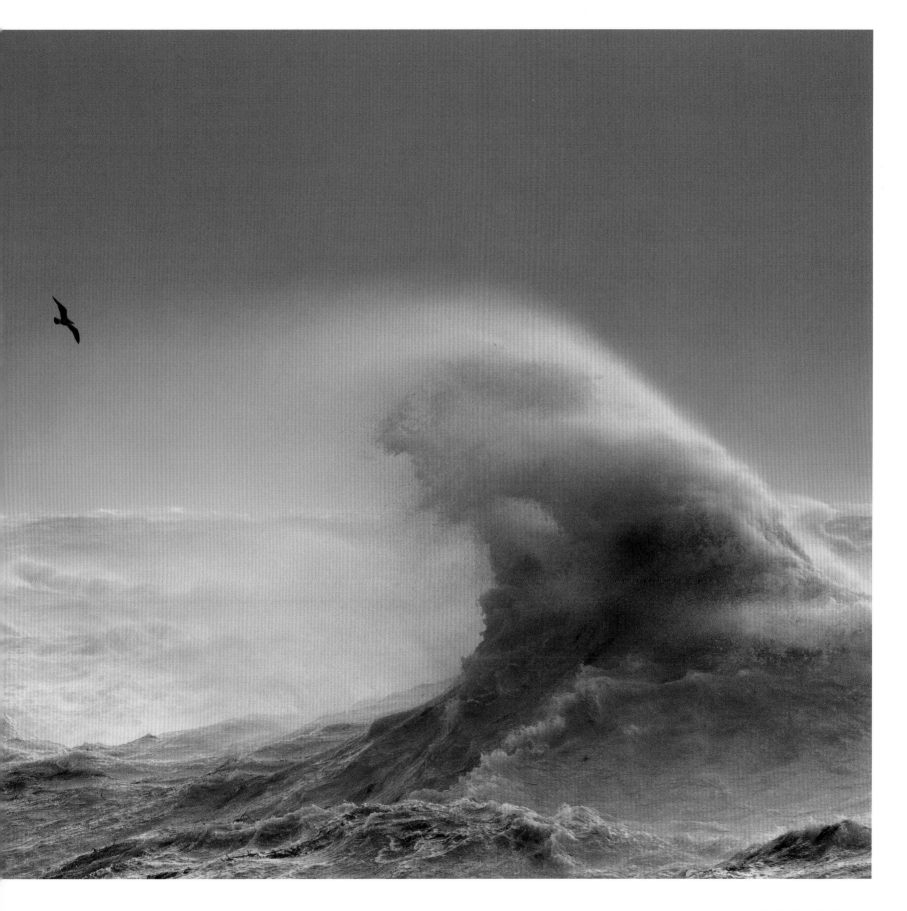

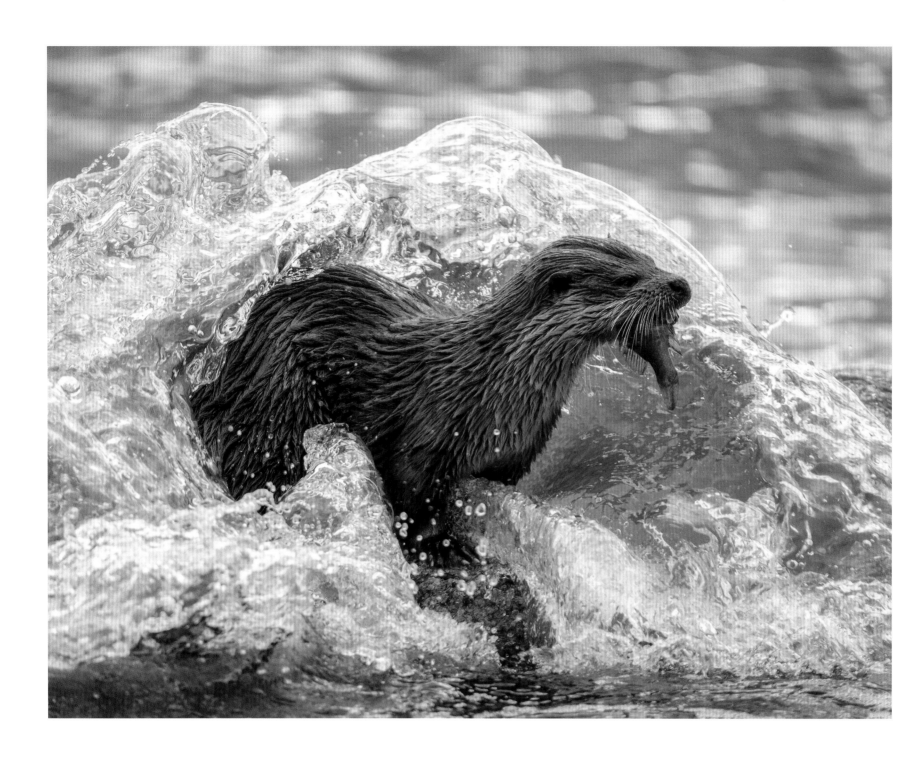

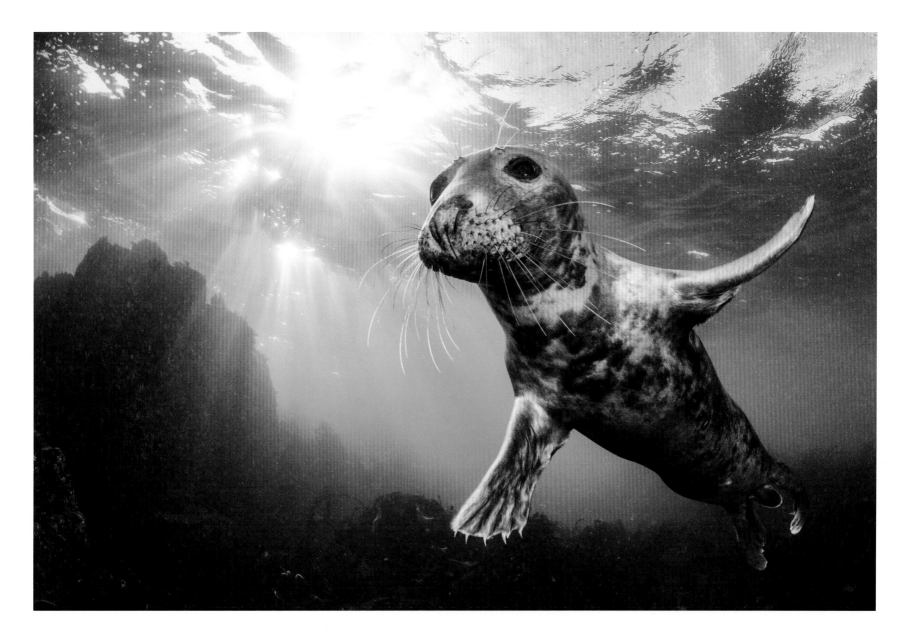

◄ KEITH THORBURN
HIGHLY COMMENDED

Otter and Water
(European otter, *Lutra lutra*)
Loch Linnhe, Highland

I was out for a walk with my dog in an area that I know otters frequent, when I spotted this fellow coming in to feed on its catch. I lay in the rocks among the seaweed with my dog until it landed on the rock, then it just sat there eating while I was photographing. Every now and again, when the waves hit its back, it would look straight at us, but then carry on eating.

Camera: Nikon D750 | Lens: 150-600mm | Shutter speed: 1/1000 sec. | Aperture: f/6.3 | ISO: 2500
kwtimages.smugmug.com

▲ KIRSTY ANDREWS
HIGHLY COMMENDED

Ta Da!
(Grey seal, *Halichoerus grypus*)
Farne Islands, Northumberland

This juvenile grey seal in the Farne Islands kept circling the rocks to get a closer look at me. I moved into a position that enabled me to capture the afternoon sun rays, and waited for the seal to approach. Grey seals are incredibly photogenic, with big, Labrador-like eyes and expressions, and with its flippers outstretched, this one really seemed to be posing for the camera.

Camera: Nikon D7200 | Lens: 10-17mm at 10mm | Shutter speed: 1/200 sec. | Aperture: f/11 | ISO: 200
Sea & Sea underwater housing, two Sea & Sea D1 strobes
kirstyandrewsunderwater.com

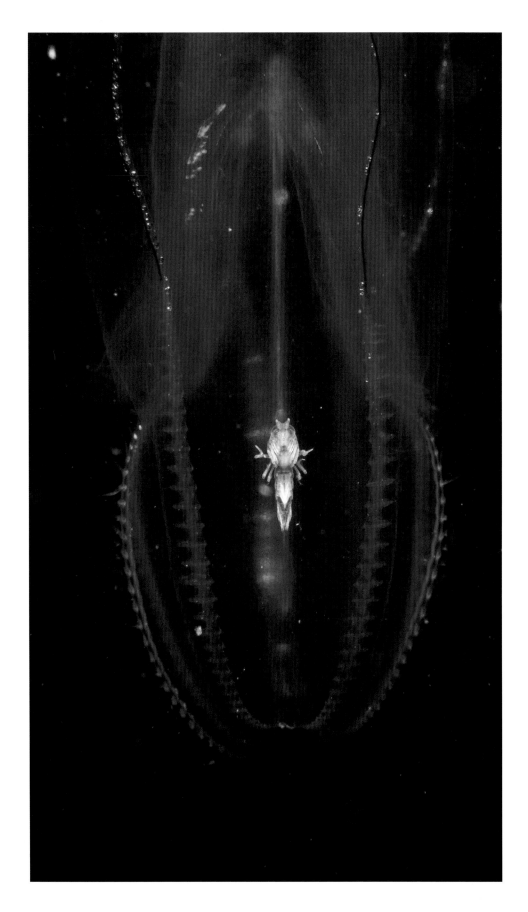

KIRSTY ANDREWS
HIGHLY COMMENDED

Undersea Alien
(Amphipod, *Amphipoda*; Comb jelly, *Ctenophore*)
Farne Islands, Northumberland

In spring, as the water around the UK warms up, a sign of burgeoning life is the multitude of jellies floating past in the water column. Occasionally these will include stowaways, such as this parasitic amphipod which burrows into its host. This shot reminded me of a scene from a science fiction film, both in appearance and the creature's behaviour: an alien resident in another world.

Camera: Nikon D500 | Lens: 60mm | Shutter speed: 1/320 sec. | Aperture: f/22 | ISO: 250
Nauticam underwater housing, two Sea & Sea D1 strobes
kirstyandrewsunderwater.com

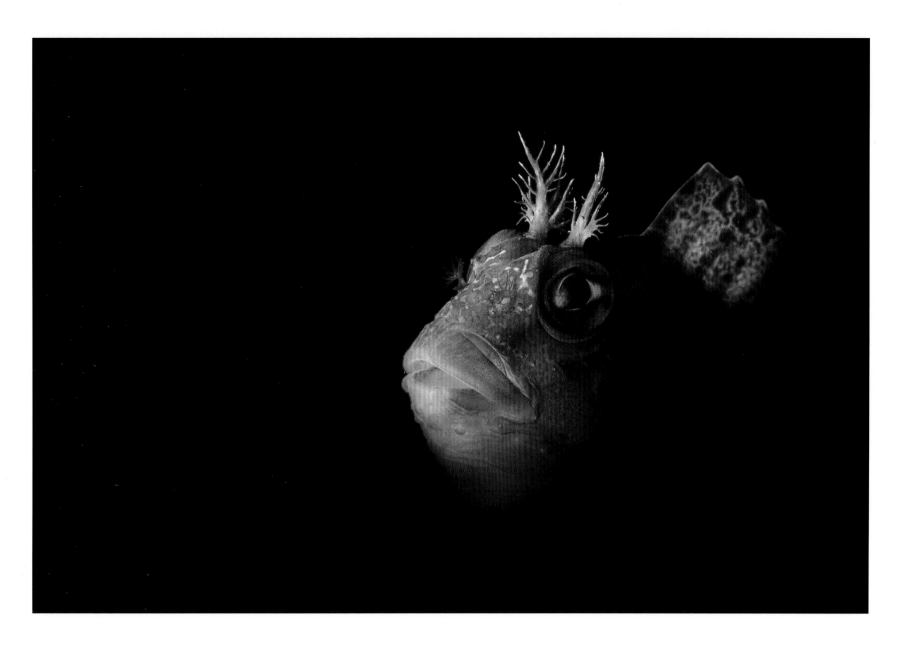

HENLEY SPIERS
HIGHLY COMMENDED

Tompot in the Light
(Tompot blenny, *Parablennius gattorugine*)
Swanage, Dorset

The curious profile of a tompot blenny, captured using snooted flash lighting under Swanage pier.

Camera: Nikon D7200 | Lens: 60mm | Shutter speed: 1/250 sec. | Aperture: f/16 | ISO: 200 | Nauticam housing, Inon Z240 strobe, Retra LSD
henleyspiers.com

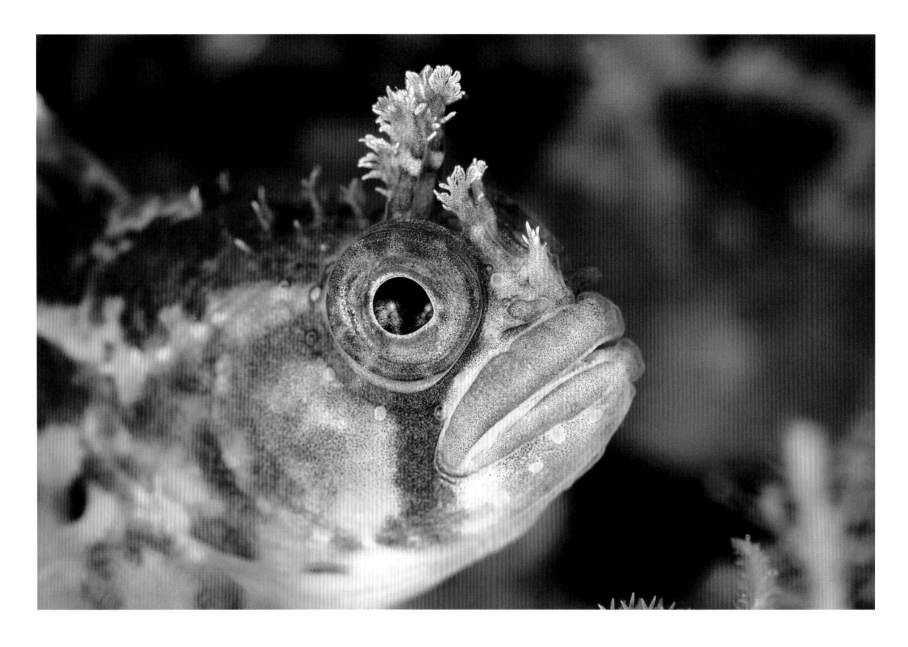

CATHY LEWIS
HIGHLY COMMENDED

Saucer Eyes
(Yarrell's blenny, *Chirolophis ascanii*)
Loch Carron, Highland

Some fish have a naturally comical appearance: with its large round eyes, bulbous mouth and tufted
head tentacles, the characterful Yarrell's blenny is most definitely one of them!

Camera: Nikon D7000 | Lens: 105mm | Shutter speed: 1/125 sec. | Aperture: f/16 | ISO: 200 | Nauticam underwater housing, two Sea & Sea D1 strobes
cathylewisphotography.com

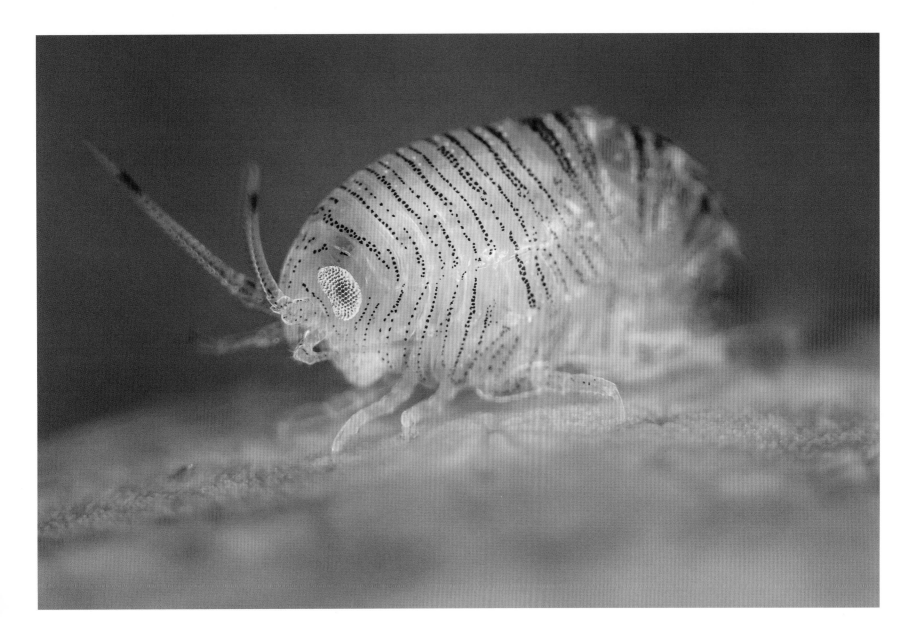

ALEX MUSTARD
HIGHLY COMMENDED

Tiny Wonder
(*Iphimedia obesa*)
Loch Carron, Highland

This high magnification photo reveals in detail a tiny, 8mm-long amphipod living on the surface of a soft coral in a Scottish loch. It was a difficult photo to take at such high magnification when working in dark, cold water and wearing thick neoprene gloves.

Camera: Nikon D7000 | Lens: 105mm | Shutter speed: 1/320 sec. | Aperture: f/20 | ISO: 200
Nauticam underwater housing, two Inon underwater strobes, Subsee +10 close-up lens
www.amustard.com

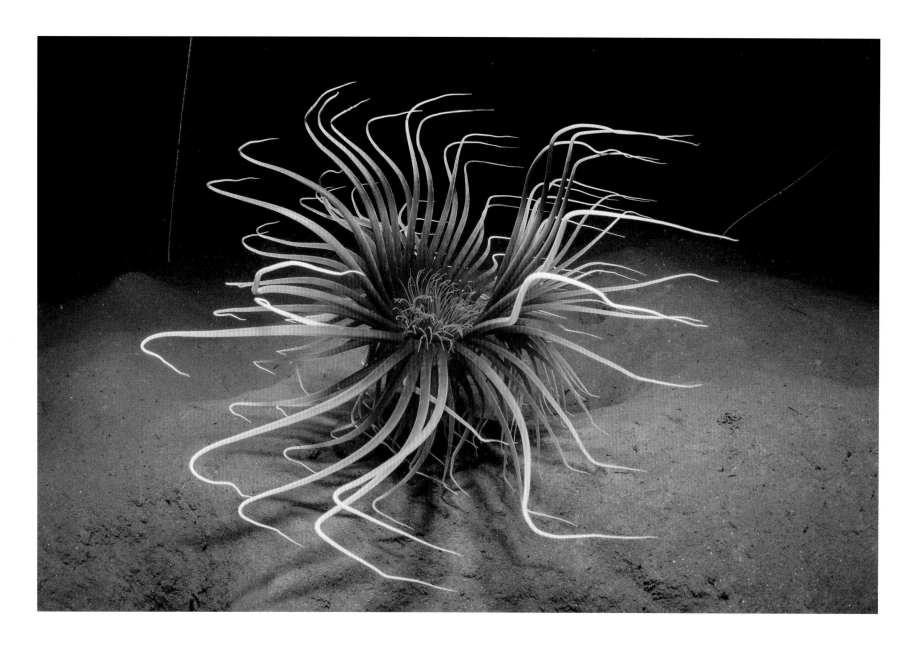

KIRSTY ANDREWS
HIGHLY COMMENDED

Fireworks Display
(Fireworks anemone, *Pachycerianthus multiplicatus*)
Loch Duich, Highland

It is easy to see how these burrowing creatures got their common name of the 'fireworks anemone'. Fireworks anemones can be found in Loch Duich at a depth of around 22–25m, where the light levels are low and the bright tentacles of the anemone are picked up by a diver's torchlight in the gloom. Most are predominantly white, but every so often you will find one that is more colourful, as in this example, with its tentacles wafting spectacularly in the light current.

Camera: Nikon D500 | Lens: 10-17mm with 1.4x teleconverter | Shutter speed: 1/250 sec. | Aperture: f/14 | ISO: 640
kirstyandrewsunderwater.com

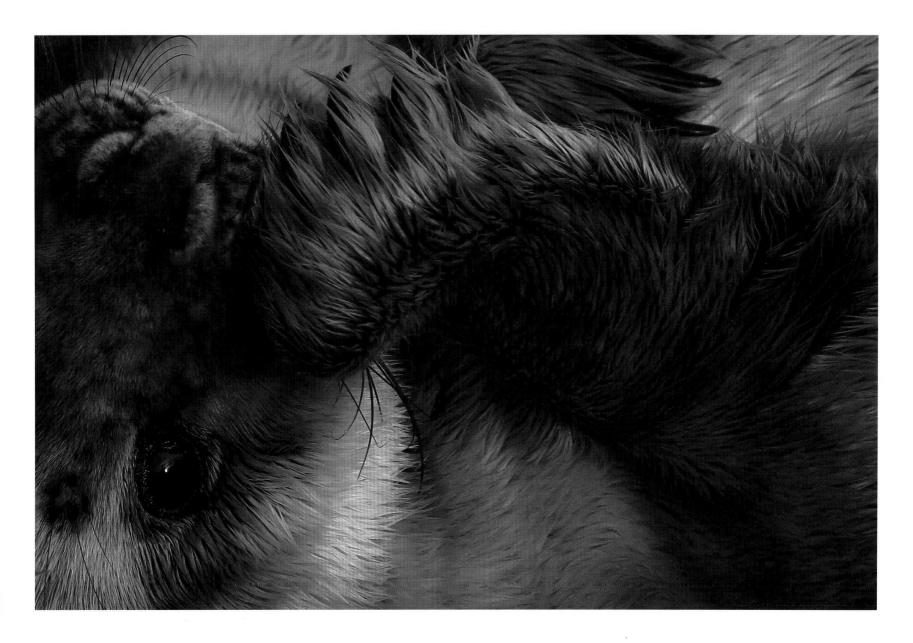

RUTH HUGHES
HIGHLY COMMENDED

Seal Pup
(Grey seal pup, *Halichoerus grypus*)
Donna Nook, Lincolnshire

I had an amazing encounter at Donna Nook with this beautiful seal pup, which stole the heart of its mother and myself. The day was chilly and mist was lingering around the rocks as newly born pups huddled close to their parents for warmth. Seal families were everywhere, but this pup got all my attention.

Camera: Canon EOS 5D MkIII | Lens: 100-400mm | Shutter speed: 1/125 sec. | Aperture: f/11 | ISO: 250
britishwildlifephotos.smugmug.com

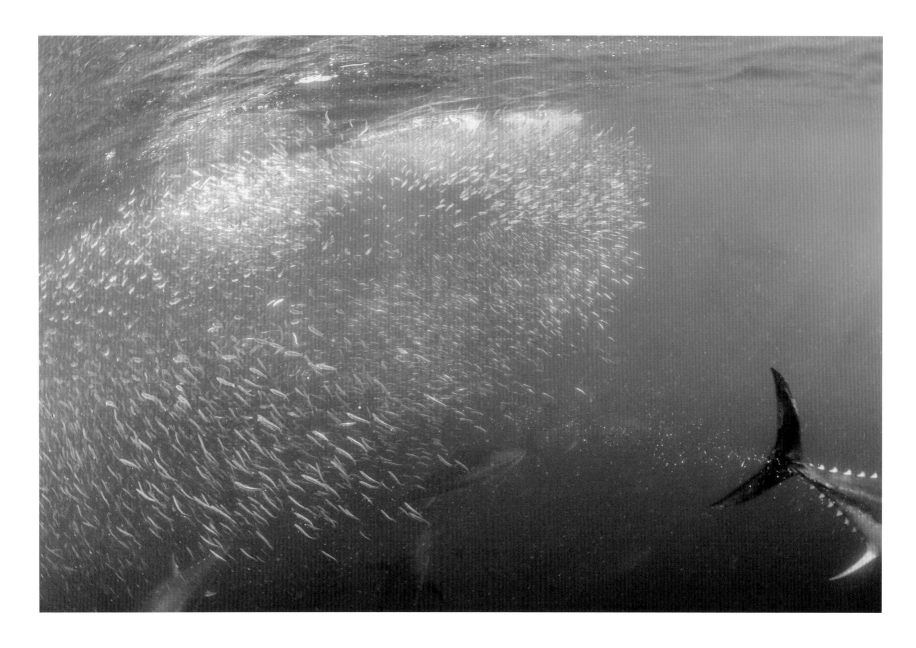

HENLEY SPIERS
HIGHLY COMMENDED

The Hunt
(Atlantic bluefin tuna, *Thunnus thynnus;* European sardine, *Sardina pilchardus*)
Off Penzance, Cornwall

A school of sardines is ruthlessly hunted down by a pack of bluefin tuna in an incredible encounter off the south coast of Cornwall.

Camera: Nikon D7200 | Lens: 10-17mm | Shutter speed: 1/320 sec. | Aperture: f/8 | ISO: 320 | Nauticam underwater housing, Inon Z240 strobes
henleyspiers.com

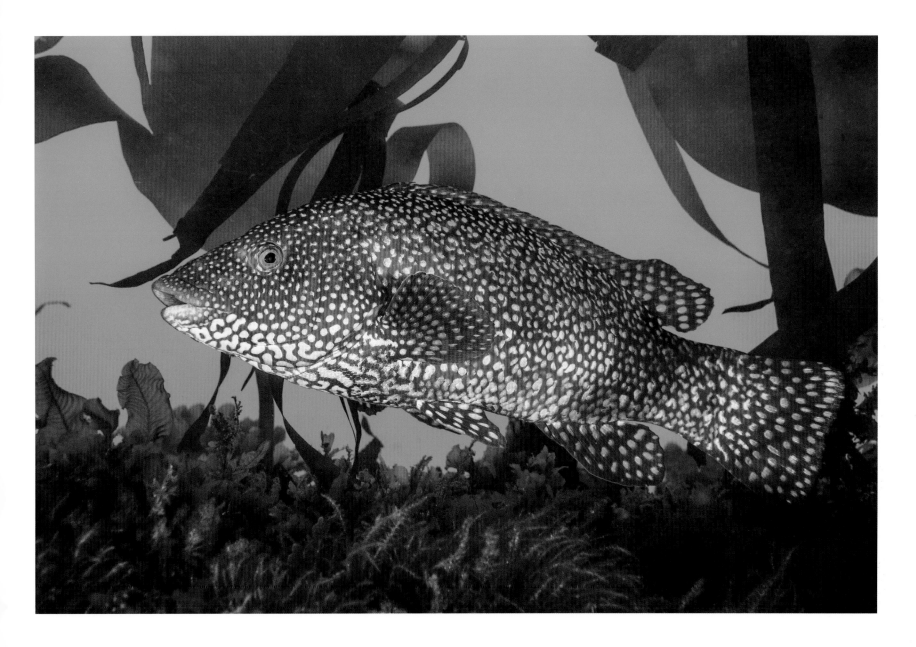

ALEX MUSTARD
HIGHLY COMMENDED

'Tropical' Fish
(Ballan wrasse, *Labrus bergylta*)
Plymouth, Devon

This male ballan wrasse is probably the most colourful fish I have ever seen underwater in the UK.
He would look completely at home on a tropical coral reef.

Camera: Nikon D4 | Lens: 60mm | Shutter speed: 1/160 sec. | Aperture: f/13 | ISO: 400 | Subal underwater housing, Inon underwater strobes
amustard.com

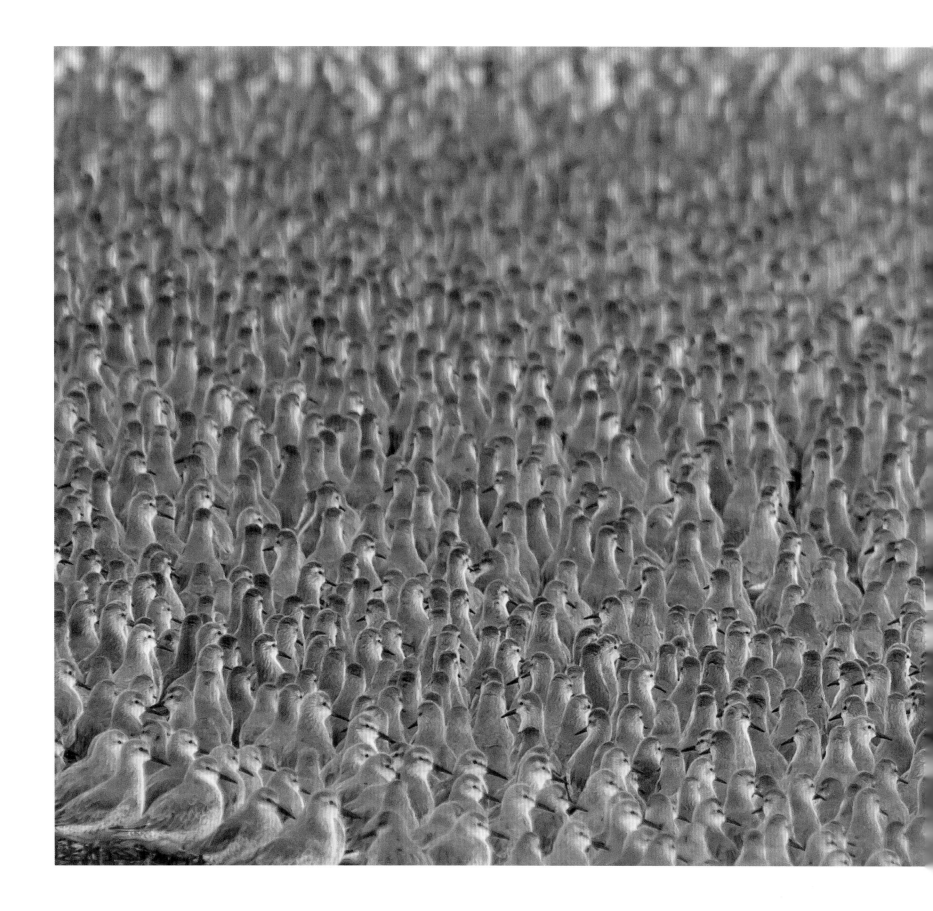

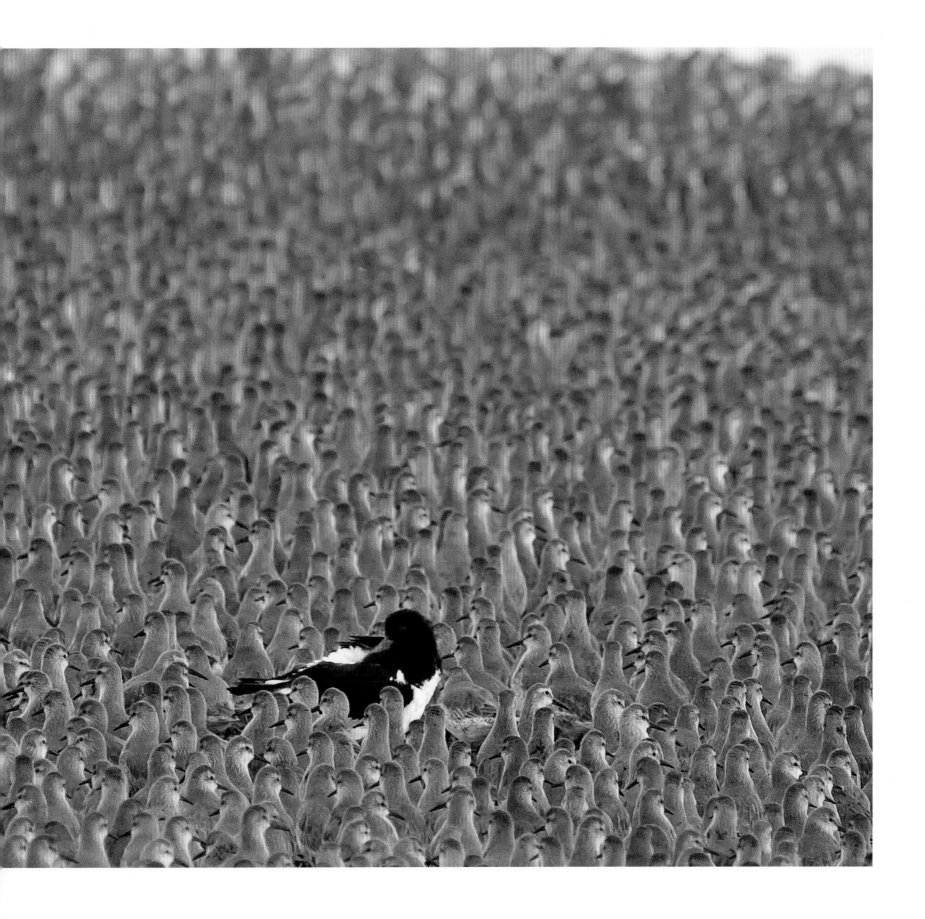

Where's Wally?
(Red knot, *Calidris canutus*; Oystercatcher,
Haematopus ostralegus)
Snettisham, Norfolk

This was my first visit to Snettisham and I was observing the behaviour of the red knot around the ever-grumpy oystercatchers. Occasionally, the oystercatchers would attack the red knot, and they would give them a wide berth, but this chap seemed quiet relaxed with the other birds swirling around him. I could see the image I wanted to capture and waited to get the photograph.

Camera: Canon EOS 1D MkIV | Lens: 300mm with 1.4x teleconverter
Shutter speed: 1/100 sec. | Aperture: f/4 | ISO: 640 | Beanbag

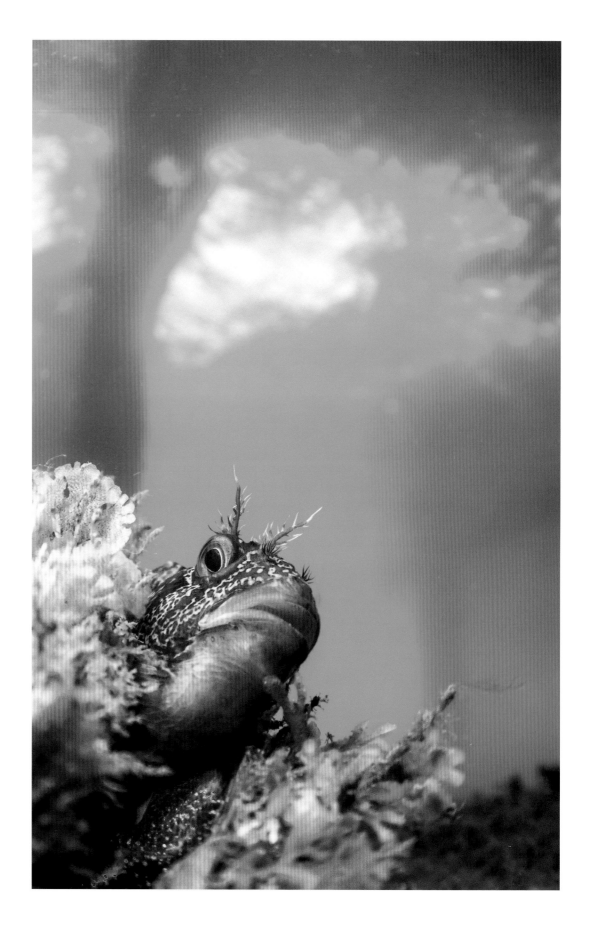

◀ PAUL PETTITT
HIGHLY COMMENDED

Tompot with Eggs
(Tompot blenny, *Parablennius gattorugine*)
Swanage, Dorset

This tompot blenny had made its nest in an old rock oyster under Swanage pier and was guarding its eggs. The water was nice and clear, so I managed to get some nice light behind the subject. Sadly, two weeks after this picture was taken I returned and noticed its nesting point had been destroyed.

Camera: Nikon D500 | Lens: 10–17mm with 1.4x teleconverter
Shutter speed: 1/60 sec. | Aperture: f/8 | ISO: 320 | Strobe from left

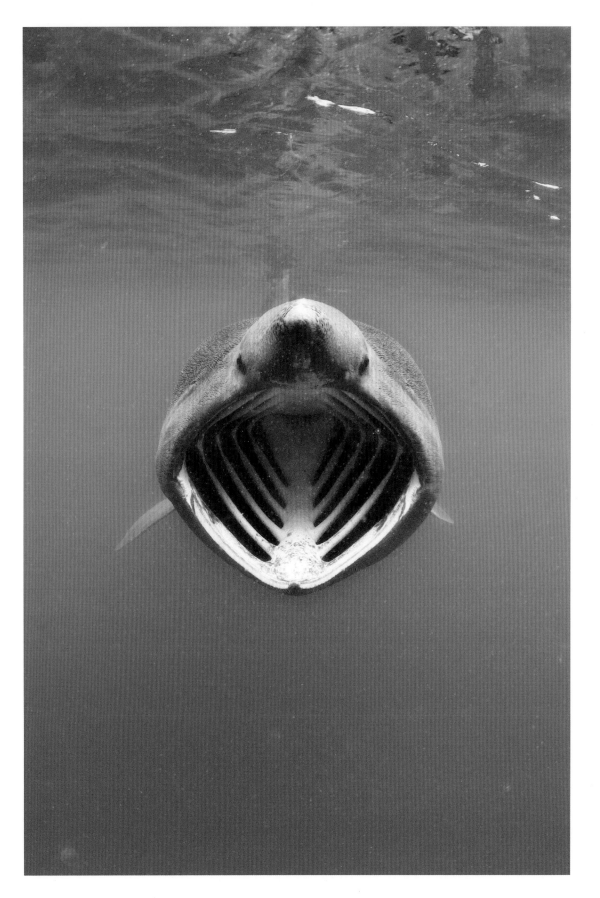

▶ ALEX MUSTARD

Basking Shark Portrait
(Basking shark, *Ceterhinus maximus*)
Isle of Coll, Argyll and Bute

Despite being the second biggest fish in the sea (and the largest found in British waters) basking sharks are hard to find and even harder to get close to. It took many weeks at sea to make this head-on image.

Camera: Nikon D700 | Lens: 16mm | Shutter speed: 1/125 sec. | Aperture: f/9
ISO: 640 | Subal underwater housing

amustard.com

WILD WOODS

BRITISH WILDLIFE
PHOTOGRAPHY AWARDS

JAMES RODDIE
CATEGORY WINNER

Seasonal Overlap
(European beech, *Fagus sylvatica*)
Aviemore, Highland

A carpet of autumn beech leaves showing through an early dusting of snow in the Cairngorms.

Camera: Nikon D750 | Lens: 50mm | Shutter speed: 1/13 sec. | Aperture: f/11 | ISO: 250
jamesroddie.com

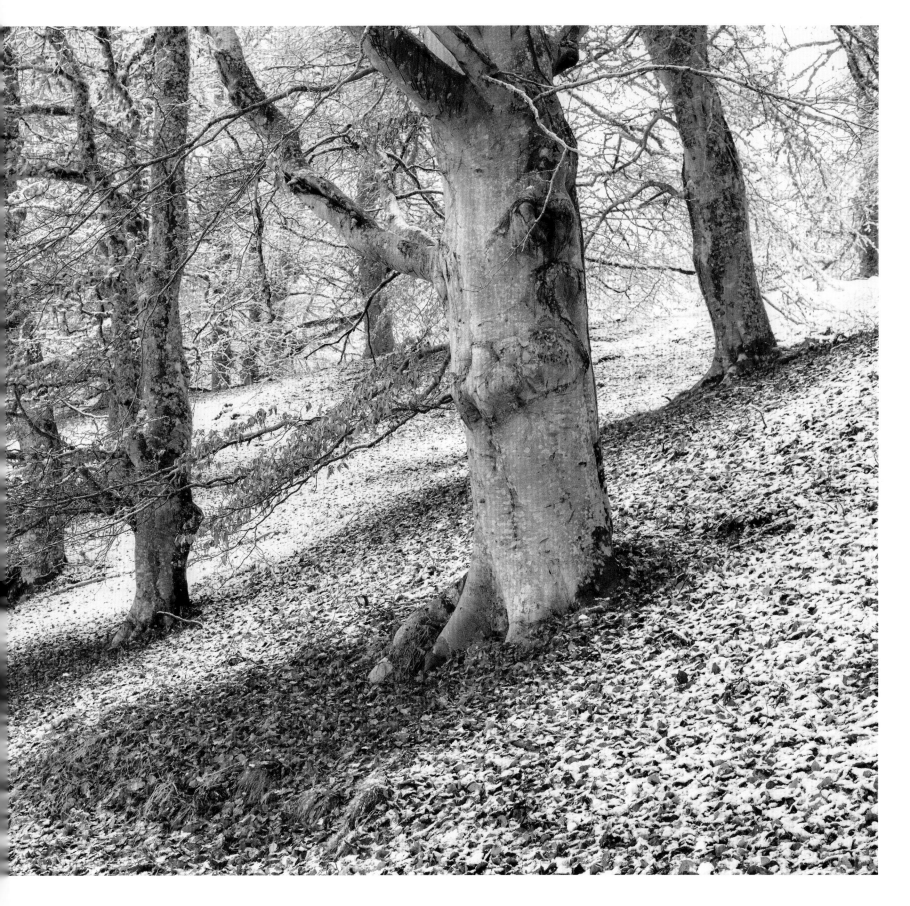

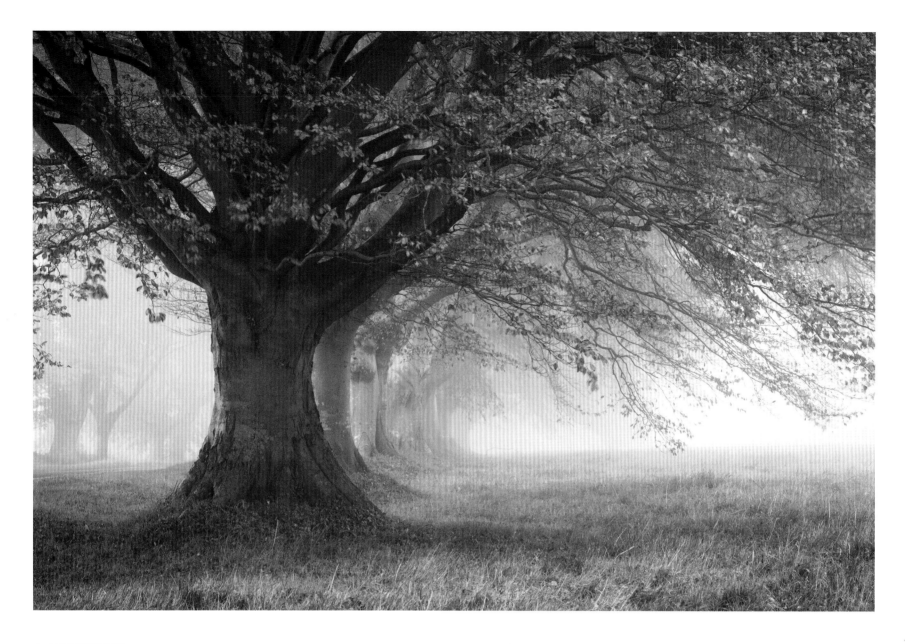

▲ ANDY FARRER
HIGHLY COMMENDED

The Beech Avenue
(European beech, *Fagus sylvatica*)
Kingston Lacy, Dorset

The Beech Avenue at Kingston Lacy in Dorset is a majestic row of ancient beech trees. On one side of the road are 365 trees, while the other has 366 to signify a leap year. The rows of trees never look better than on a misty autumn morning when they are in their full russet splendour.

Camera: Canon EOS 5DS | Lens: 100–400mm at 100mm | Shutter speed: 0.8 sec. | Aperture: f/11 | ISO: 100
andyfarrer.co.uk

▶ CHRIS DALE
HIGHLY COMMENDED

Spotlight
(Silver birch, *Betula pendula*)
Sherwood Forest, Nottinghamshire

I spent a frosty December morning walking around Sherwood Forest. As the day went on, the sun started streaming through the trees giving transient moments of light. I was shooting handheld with a long lens so I could react quickly to the fleeting conditions and isolate little detailed scenes. I was lucky to catch the sun hitting this single birch trunk like a spotlight.

Camera: Canon EOS 6D | Lens: 70–300mm | Shutter speed: 1/80 sec. | Aperture: f/6.3 | ISO: 200

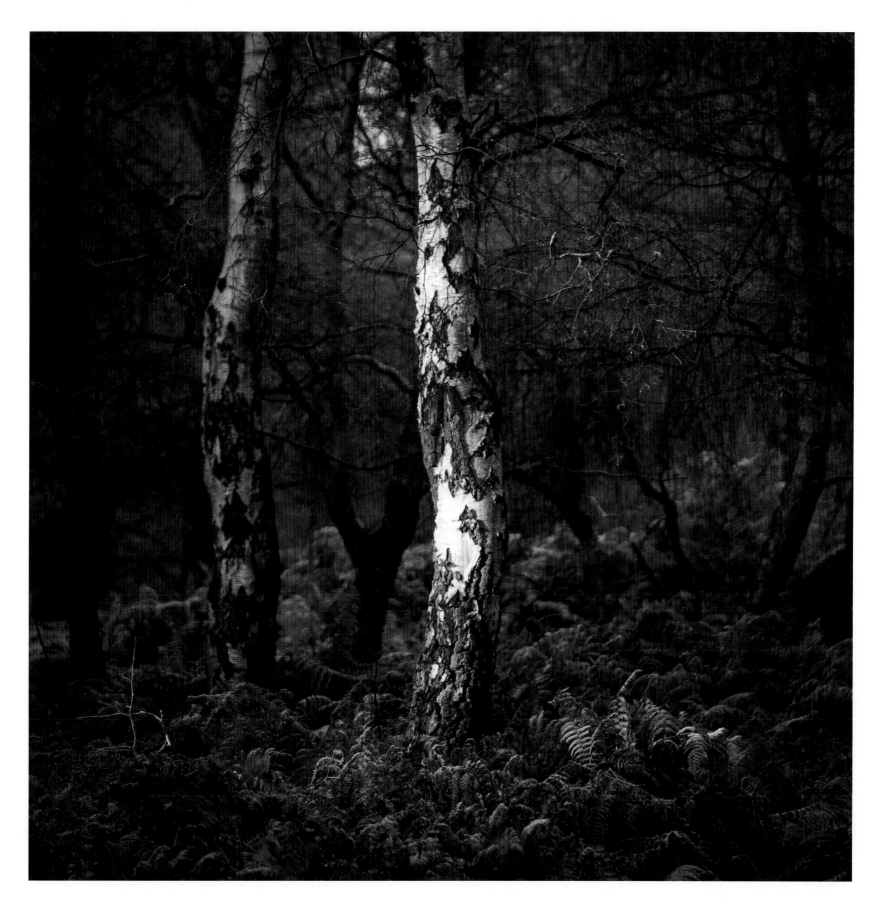

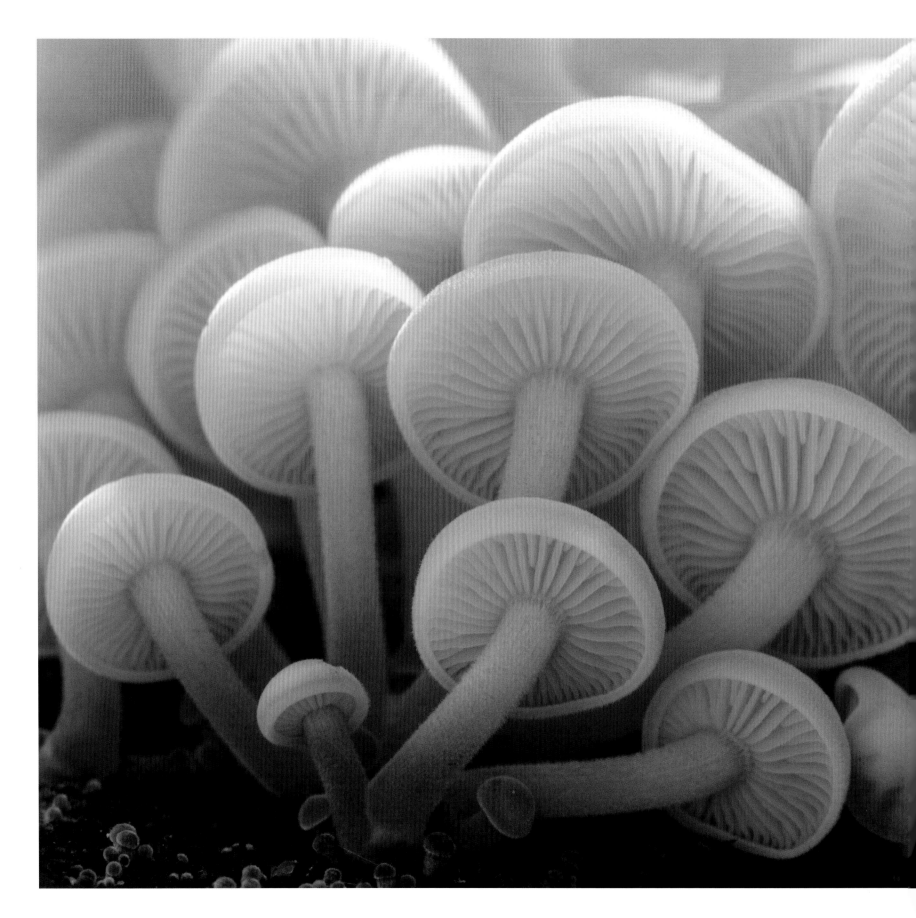

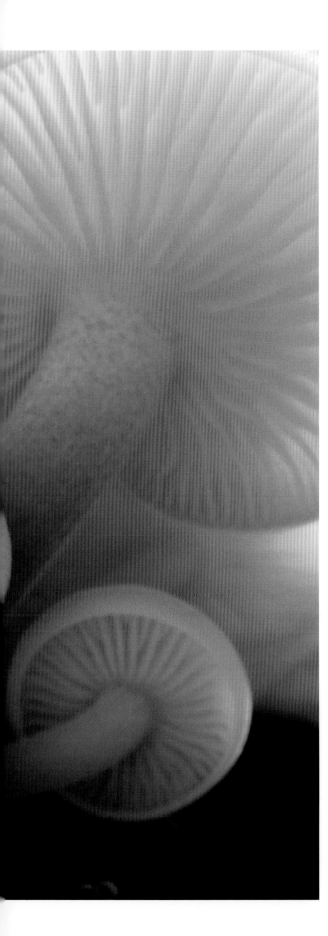

ROSS HODDINOTT
HIGHLY COMMENDED

Mushrooms
(believed to be Sulphur tuft, *Hypholoma fasciculare*)
Broxwater, Cornwall

Just before Christmas, my father-in-law kindly popped over with his chainsaw to help cut up logs ready for the winter. While he was sawing, we uncovered a log decorated with an amazing clump of tiny, pristine mushrooms, so I carefully placed it to one side. I must have been taking photos of it for over an hour, opting for a low viewpoint in order to highlight the incredible structure and detail of the fungi and their gills.

Camera: Nikon D850 | Lens: 200mm macro | Shutter speed: 0.3 sec. | Aperture: f/32 | ISO: 800 | Tripod, LED light
rosshoddinott.co.uk

▲ JAMES RODDIE
HIGHLY COMMENDED

Some Gold Among the Silver
(Silver birch, *Betula pendula*)
Aviemore, Highland

Lingering autumn colours and an early
dump of snow combined to create this
seasonal overlap in the Cairngorms.

Camera: Nikon D750 | Lens: 85mm | Shutter speed: 1/100 sec.
Aperture: f/10 | ISO: 400
jamesroddie.com

▶ ROBIN GOODLAD
HIGHLY COMMENDED

Morning Mist
Little Langdale, Cumbria

As is often the case, I didn't wake up with this shot in mind. The image I had planned was not going to work, as
it was down in the fog, so I knew I needed to quickly get up high before the fog evaporated in the morning sun.
I love knowing that my wife and daughter were sleeping soundly in the cottage in the middle of the picture, down
in the valley below, while the dog and I enjoyed this magnificent early-morning view.

Camera: Nikon D800 | Lens: 70–200mm | Shutter speed: 1/640 sec. | Aperture: f/8 | ISO: 400
naturallightphotography.co.uk

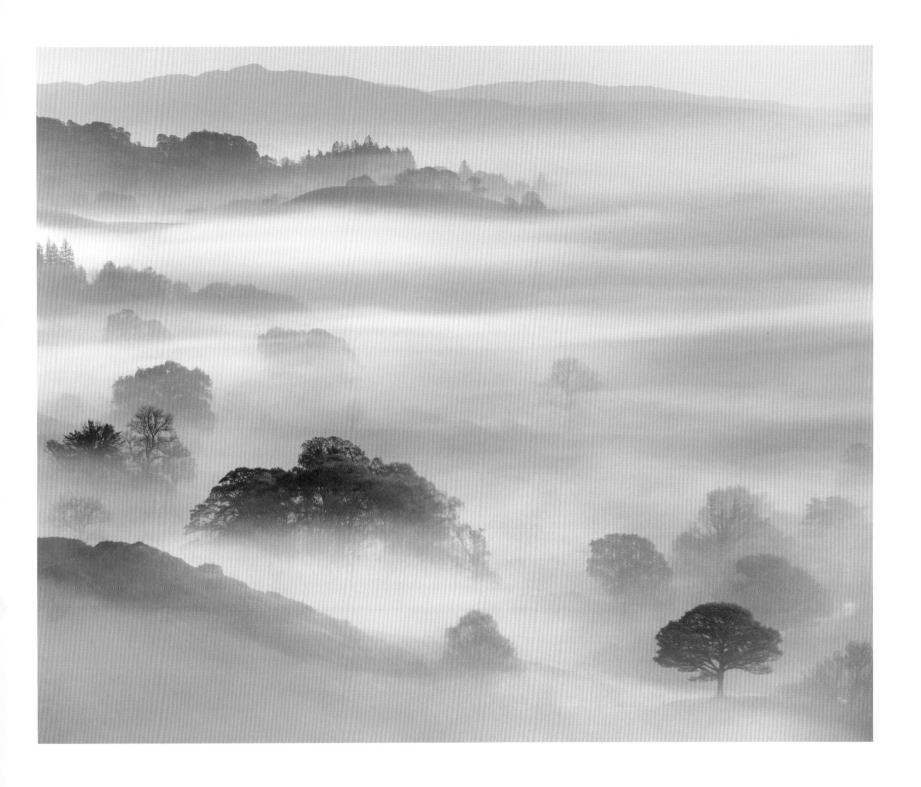

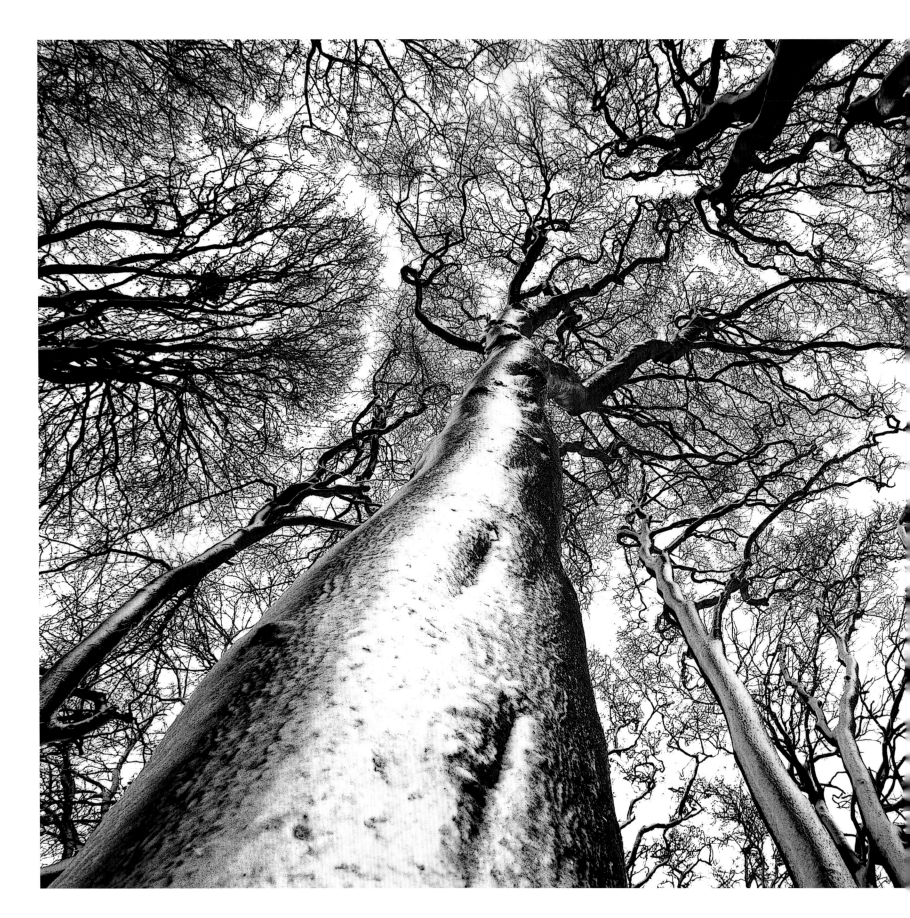

MAX MORE
HIGHLY COMMENDED

Beech in Winter
(European beech, *Fagus sylvatica*)
Hackpen Hill, Wiltshire

It was a winter's afternoon in December and snow had fallen. The bare beech trees seemed to glow a bright metallic white in the soft side lighting of the setting sun and I was particularly taken by the potent mix of colour provided by the broken sky and the almost monochromatic trees touched and punctuated by the golden light of the sun.

Camera: Nikon D850 | Lens: 24–70mm at 24mm | Shutter speed: 1/320 sec. | Aperture: f/11 | ISO: 800
instagram.com/maxmore56

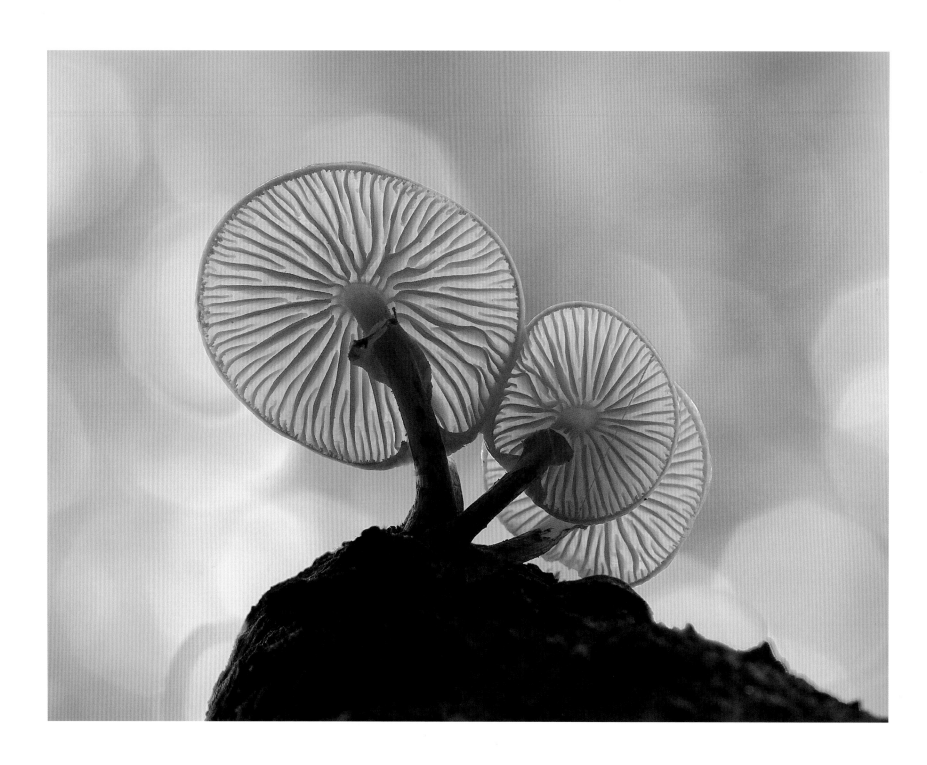

◀ PETER GREENSTREET
HIGHLY COMMENDED

Porcelain Fungi in the Canopy
(Porcelain fungi, *Oudemansiella mucida*)
Padley Gorge, Derbyshire

I went out early one unpromising morning looking for
some landscape potential when I found these porcelain
fungi in the canopy of a host beech tree. I didn't have
a long lens so returned later. Luckily, I was able to
photograph the fungi with an interesting bokeh from
the gaps in the autumn canopy. This is my favourite
fungus as its translucence allows some great effects.

Camera: Canon EOS 5D MkIII | Lens: 180mm macro with 1.4x teleconverter
Shutter speed: 0.3 sec. | Aperture: f/11 | ISO: 200 | Tripod

▶ LUKE WILKINSON

Going Up...
(Pine marten, *Martes martes*)
Ardnamurchan, Highland

These pine marten would often emerge from the
woodland in the final moments of daylight, but on
this particular evening they came out much earlier,
and I spotted this individual making its way up a
nearby tree.

Camera: Nikon D4 | Lens: 500mm | Shutter speed: 1/640 sec.
Aperture: f/4 | ISO: 1600

lukewilkinsonphotography.co.uk

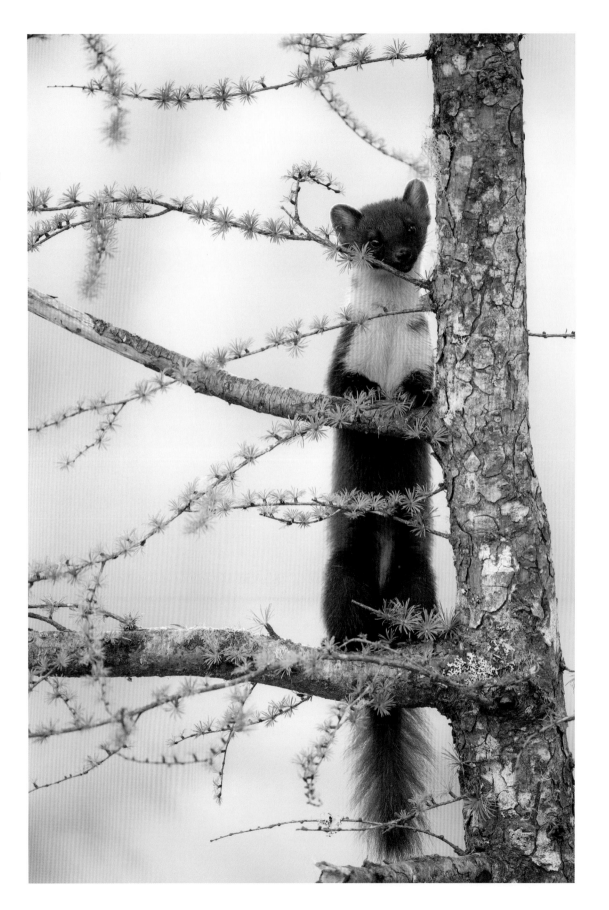

HABITAT

SPONSORED BY
WILDLIFE WORLDWIDE

ANDREW PARKINSON
CATEGORY WINNER

Spectacular Isolation
(Mountain hare, *Lepus timidus*)
Cairngorms National Park, Highland

These conditions are probably the most dramatic and most exciting that I have ever worked in. High winds were blowing huge amounts of snow across the plateau and it was pure luck that I was able to find a familiar hare. We endured the conditions together and over time I moved towards him on my knees, keeping my camera out of the surging spindrift and photographing him with a wide-angle lens.

Camera: Canon EOS 5D MkIV | Lens: 16-35mm | Shutter speed: 1/1250 sec. | Aperture: f/13 | ISO: 400
andrewparkinson.com

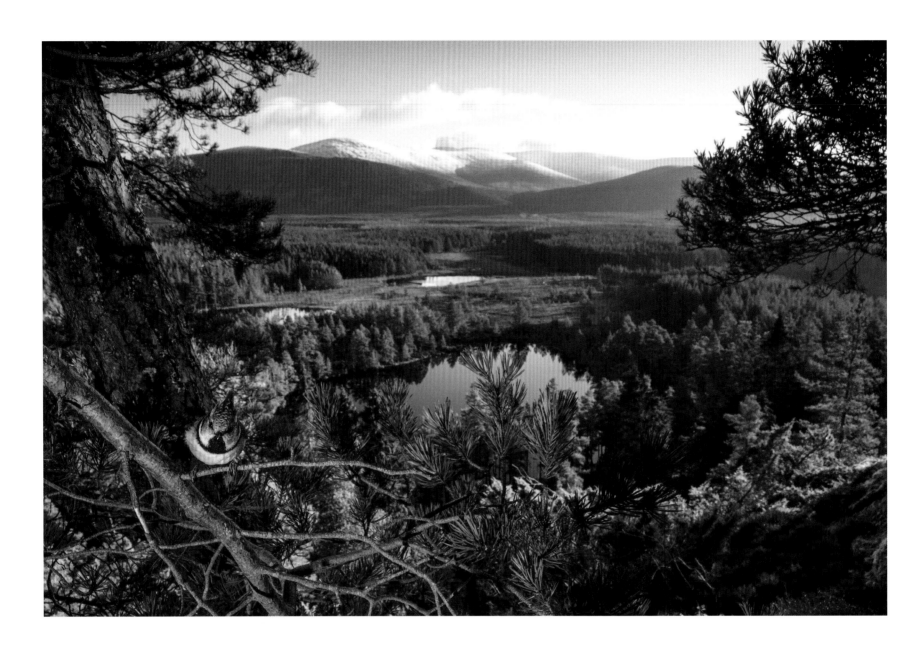

JAMES SHOOTER
HIGHLY COMMENDED

A Room with a View
(Crested tit, *Lophophanes cristatus*)
Glenfeshie, Highland

This is one of my favourite views in the Cairngorms National Park and it is a short walk from my house. For this image I wanted to place one of the region's iconic species – the crested tit – in front of the pinewood habitat on which it relies. This species is confined to areas of ancient Caledonian forest and Scots pine plantations and struggles to disperse to other areas due to a lack of forest corridors.

Camera: Canon EOS 7D | Lens: 15–85mm | Shutter speed: 1/60 sec. | Aperture: f/11 | ISO: 320
jamesshooter.com

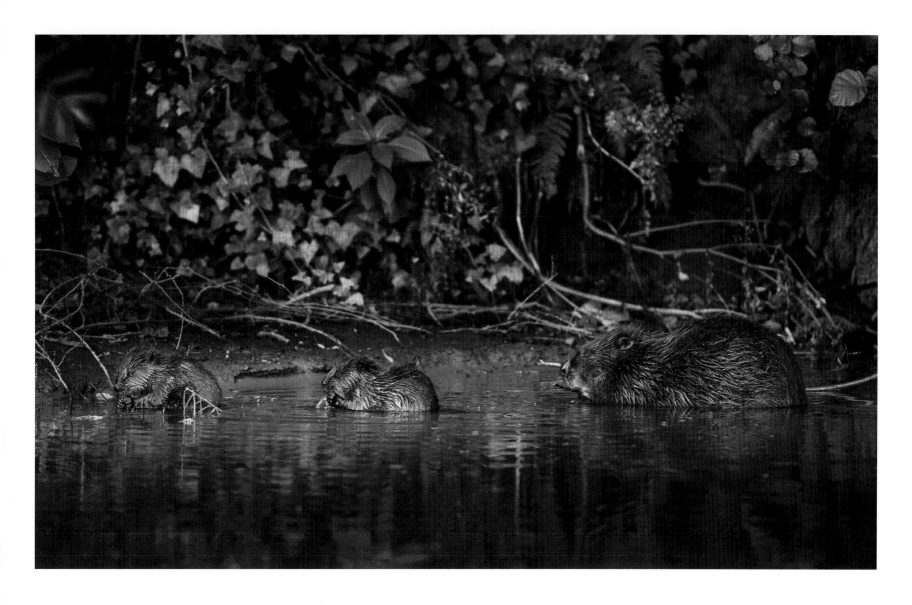

MATTHEW MARAN
HIGHLY COMMENDED

A Mother Beaver with Her Kits
(Eurasian beaver, *Castor fiber*)
River Otter, Devon

I was shooting in east Devon, gathering images for a book about the importance of natural assets for land managers. The highlight for me was watching and photographing the beavers that have taken up residence on the River Otter. The female had five kits that year and this photograph shows two of them learning the skills they will need to survive.

Camera: Canon EOS 5D MkIII | Lens: 300mm | Shutter speed: 1/80 sec. | Aperture: f/2.8 | ISO: 800
matthewmaran.com

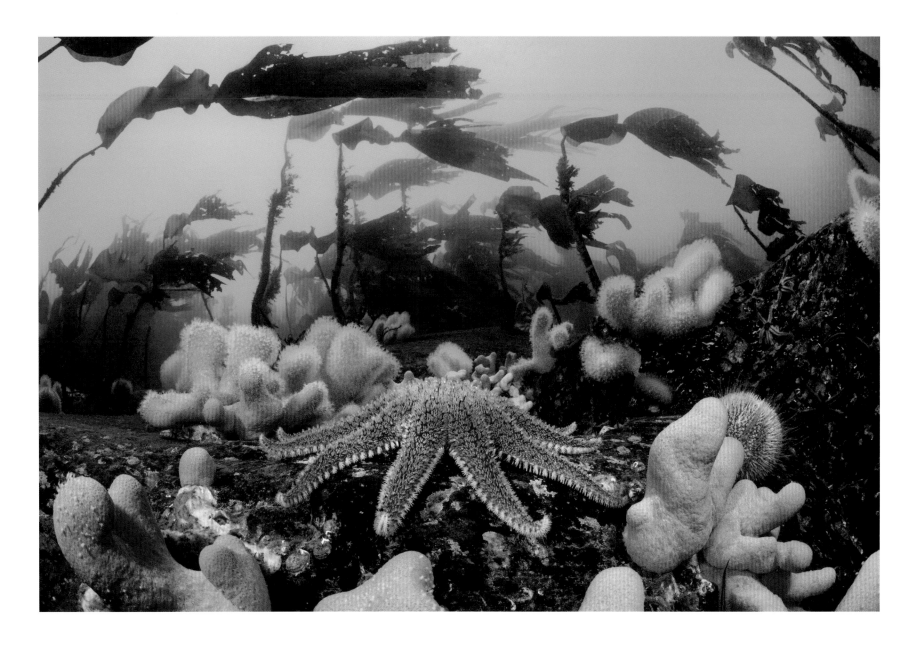

TREVOR REES
HIGHLY COMMENDED

Purple Sunstar and Kelp
(Purple sunstar, *Crossaster papposus*; Dead man's fingers, *Alcyonium digitatum*)
Loch Carron, Highland

The purple sunstar and orange dead man's fingers add colour to the green water and kelp background scene.
This picture was taken at Easter when the water was cool, little plankton was about and the visibility was good.
I put the starfish centre stage and used a fisheye lens to capture as much of the background scene as possible.

Camera: Nikon D850 | Lens: 15mm | Shutter speed: 1/40 sec. | Aperture: f/22 | ISO: 1600 | Nauticam underwater housing, two Inon S2000 strobes with diffusers
trevorreesphotography.co.uk

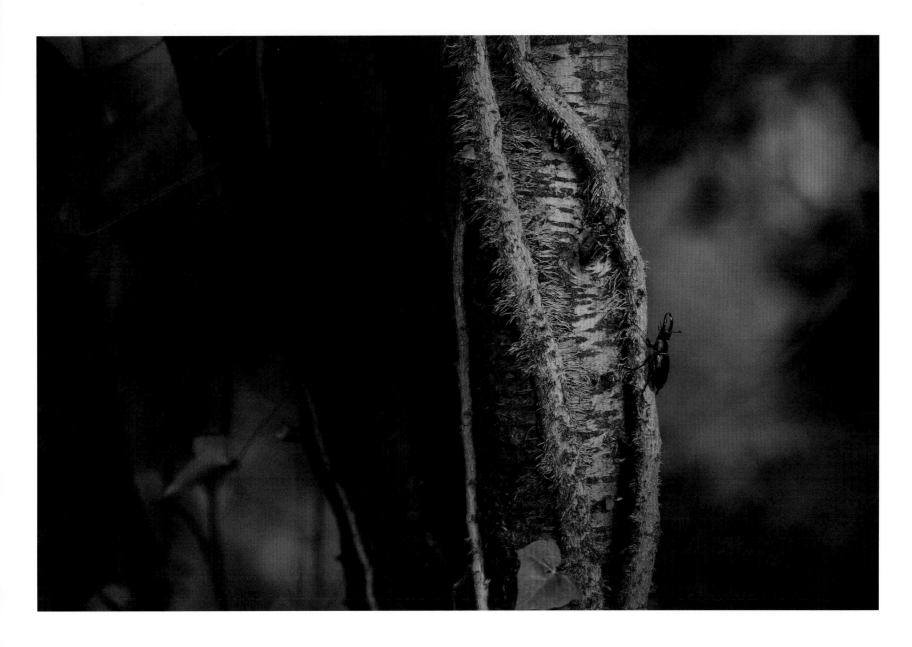

BEN ANDREW
HIGHLY COMMENDED

Stag Night
(Stag beetle, *Lucanus cervus*)
Near Dunstable, Bedfordshire

I am lucky to have a local population of stag beetles and for a few weeks each year they are active every evening with the males taking flight and looking for a mate – some even crash land in the pub garden! Every now and then they can also be found on a woodland path or climbing a tree ready to launch themselves into the sky again. This individual was moving slowly up a trunk and with just enough light before it got too dark I captured this shot.

Camera: Nikon D800 | Lens: 70–200mm | Shutter: 1/160 sec. | Aperture: f/2.8 | ISO: 800

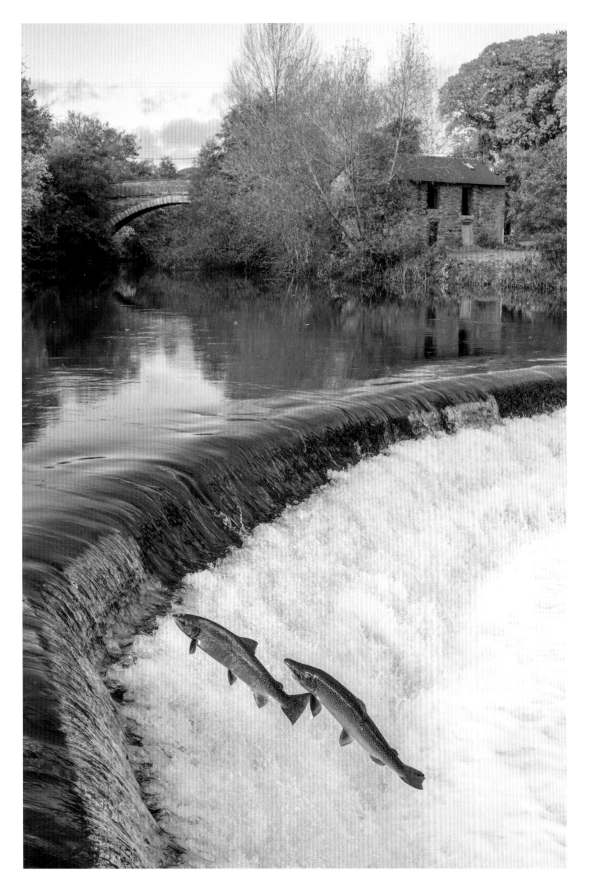

◀ ANDREW FUSEK PETERS
HIGHLY COMMENDED

Cock and Hen Salmon Leaping the Weir
(Salmon, *Salmo salar*)
Ashford Carbonel, Shropshire

I've visited this private weir with permission for the past four years. On this occasion, the river was running and the weather was fantastic, so I set up my tripod and focused on the near side of the weir where there was activity. I used a remote release to catch the airborne moments and when I got a hen and cock leaping together in the sunlight, I knew the endless visits had been worth it.

Camera: Canon EOS 5D MkIV | Lens: 24–70mm at 53mm
Shutter speed: 1/2500 sec. | Aperture: f/10 | ISO: 2500
andrewfusekpeters.com

▶ DAN BOLT
HIGHLY COMMENDED

Out-There Reef
(Cuckoo wrasse, *Labrus mixtus*; Spiny lobster, *Palinurus elephas*)
Near Plymouth, Devon

With this image I wanted to highlight just how rich, diverse and colourful the abundant marine life is off the south-west coastline of England. We have large areas that form stunning reef systems, which remain active all year round. I was pleased to see the spiny lobster (crawfish) nestling in the rock, and when the male cuckoo wrasse came over to see what was going on the scene was perfectly set. This photograph was taken in the depths of winter, so the eight-degree water contains no plankton, which gave me the almost tropical-looking blue background.

Camera: Olympus OM-D E-M1 | Lens: 8mm fisheye | Shutter speed: 1/125 sec.
Aperture: f/9 | ISO: 400 | Aquatica underwater housing, two Sea & Sea D1 strobes
underwaterpics.co.uk

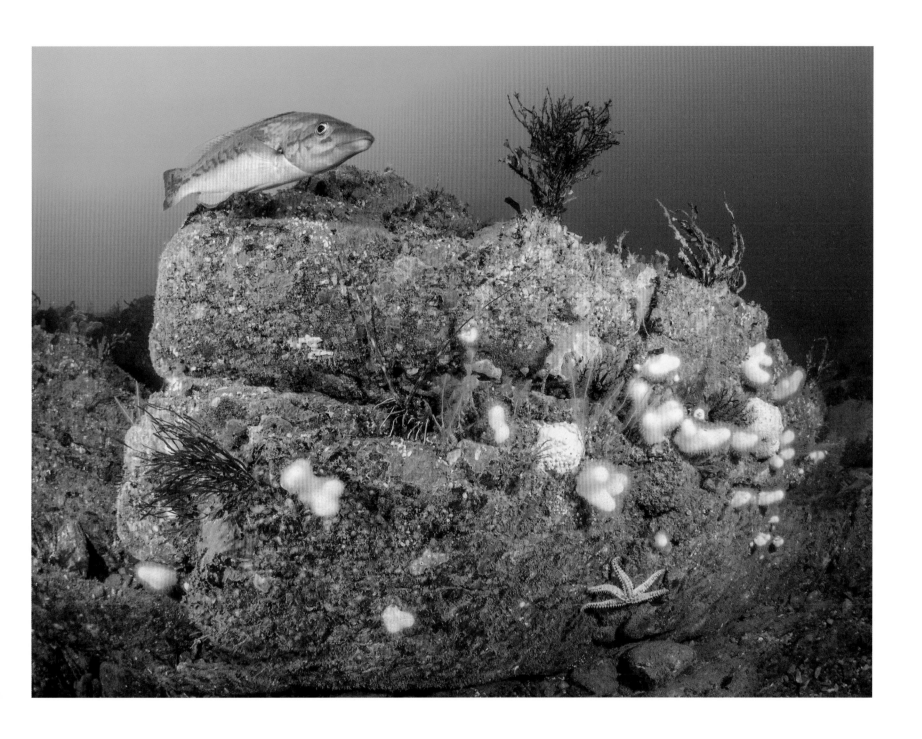

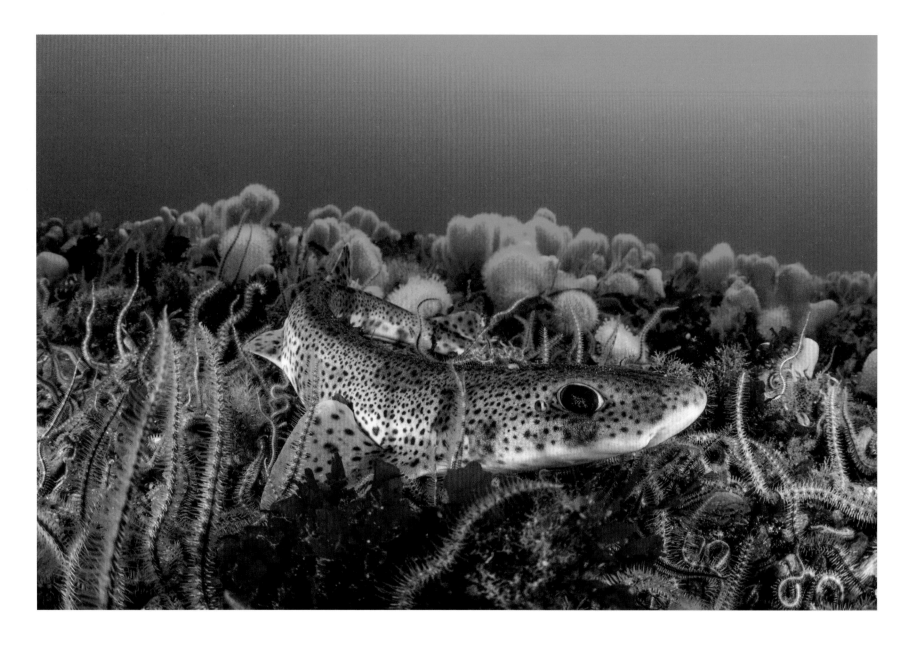

ROBERT BAILEY
HIGHLY COMMENDED

Dogfish on a Bed of Brittle Stars
(Lesser-spotted dogfish, *Scyliorhinus canicula;* Common brittle stars, *Ophiocomina nivea*)
Loch Carron, Highland

Free from the swell of the open sea, the quiet sheltered sea lochs of north-west Scotland are ideal for underwater photography. Vast numbers of common brittle stars cover the entire seabed in places, and during our dive we saw several dogfish settle down on top of them.

Camera: Nikon D300 | Lens: 10–17mm | Shutter speed: 1/125 sec. | Aperture: f/11 | ISO: 400 | Sea & Sea underwater housing, two Inon Z240 strobes
robertbaileyphotography.com

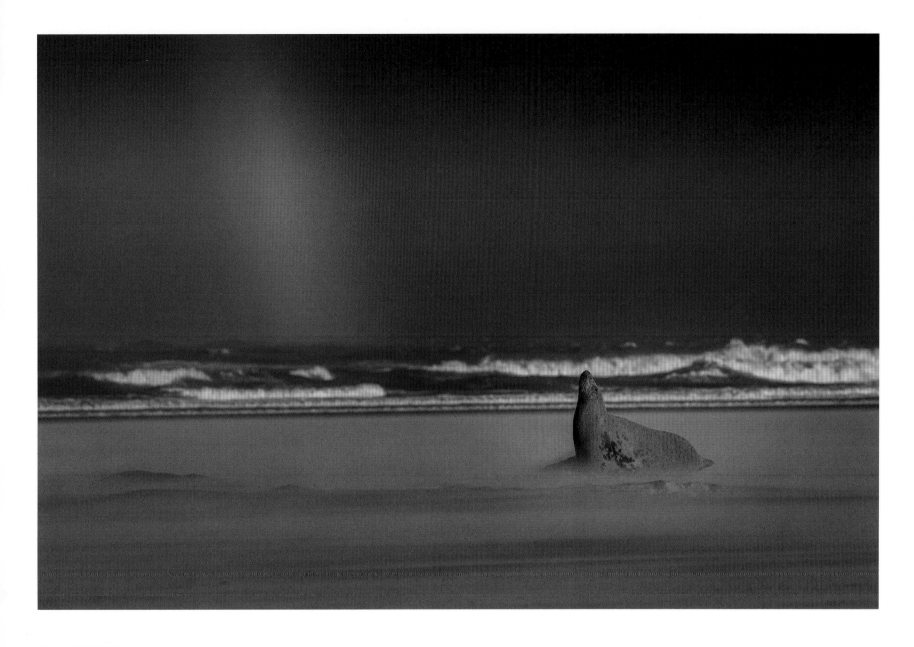

SEAN WEEKLY
HIGHLY COMMENDED

At the End of the Rainbow
(Grey seal, *Halichoerus grypus*)
North Somercotes, Lincolnshire

These were some of the toughest conditions I have photographed in, with 70mph winds blowing sand everywhere.
I knew I wanted to capture the seals in pretty harsh conditions, and while I was photographing this individual a
storm was brewing out to sea. The sun made a brief appearance, creating this beautiful rainbow backdrop.

Camera: Canon EOS 5D MkIII | Lens: 300mm | Shutter speed: 1/800 sec. | Aperture: f/8 | ISO: 400

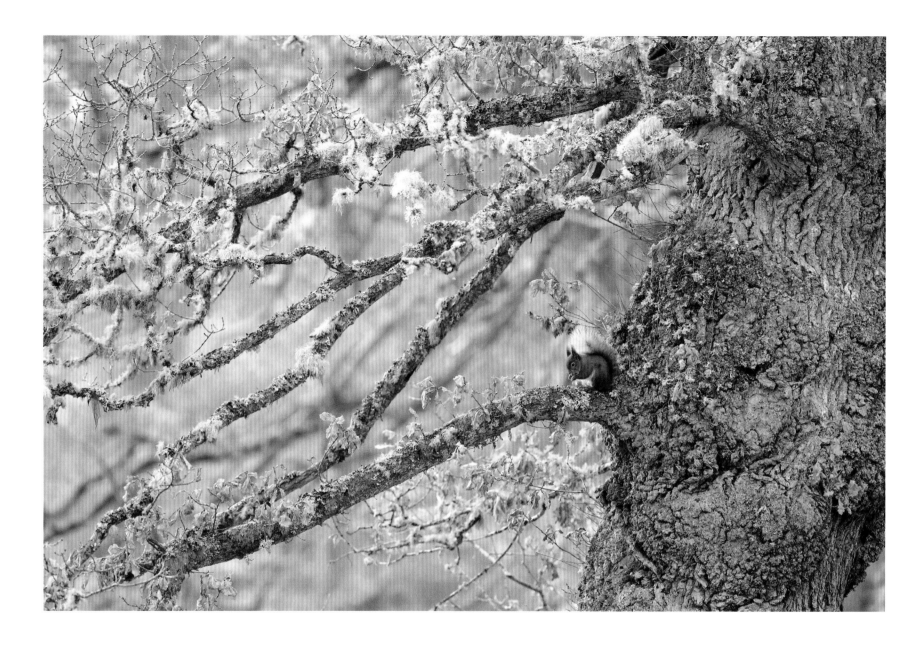

NEIL MCINTYRE
HIGHLY COMMENDED

Red Squirrel on Giant Old Oak
(Red squirrel, *Sciurus vulgaris*; Sessile oak, *Quercus petraea*)
Kinrara, Highland

This amazing old oak tree was situated not far from a house I used to stay in. I would often think how cool it would be to get a red squirrel somewhere among these lichen-covered branches. After a few weeks of placing hazelnuts around the old tree I was eventually rewarded when this squirrel sat in the ideal spot, allowing me to frame the tree around it.

Camera: Canon EOS 1DX | Lens: 500mm | Shutter speed: 1/160 sec. | Aperture: f/5.6 | ISO: 1250 | Tripod

neilmcintyre.com

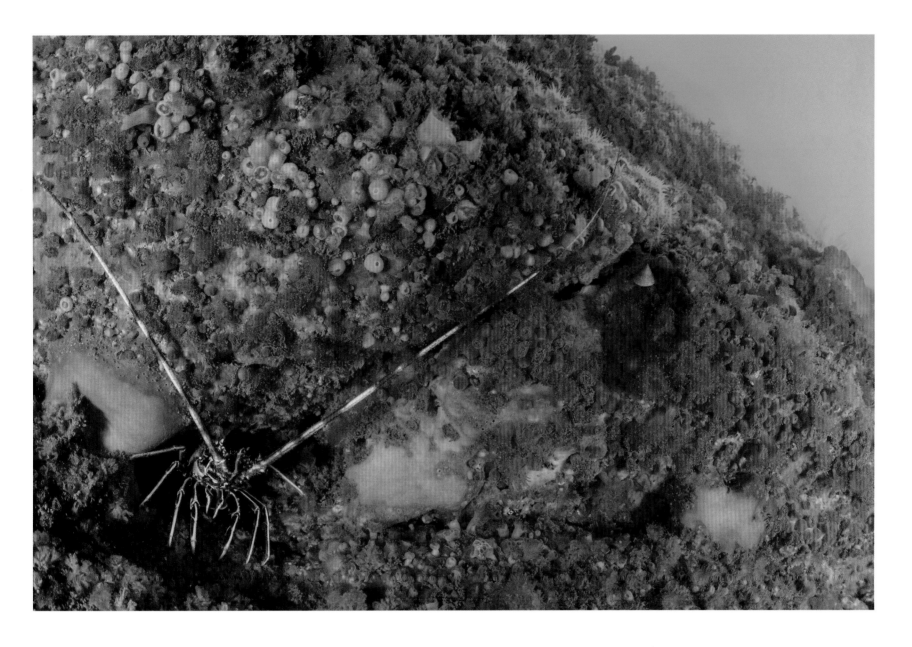

MATT DOGGETT
HIGHLY COMMENDED

Spiny Lobster Among Jewel Anemones
(Spiny lobster, *Palinurus elephas*)
Sark, Channel Islands

The spiny lobster, or crawfish, is making a big comeback in the south of the UK, after being fished to near-extinction in
the late 20th century. During a spectacular dive in the clear waters off Sark in the Channel Islands I encountered this one
inhabiting a crevice on a colourful wall of sponges and jewel anemones. Vertical walls full of nooks and crannies are habitats
favoured by this species and this was one of seven crawfish I saw during the same dive.

Camera: Canon EOS 5D MkIII | Lens: 15mm fisheye with 1.4x teleconverter | Shutter speed: 1/50 sec. | Aperture: f/11 | ISO: 800 | Nauticam underwater housing, Inon Z220 strobes
mattdoggett.com

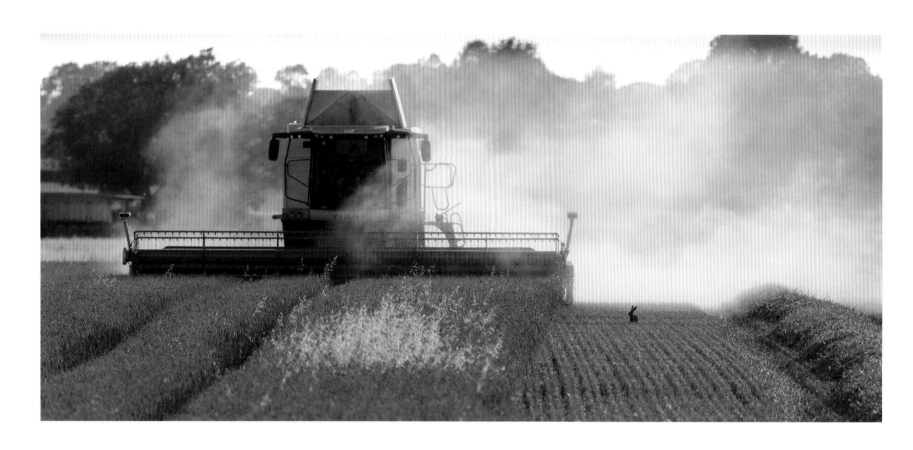

ROBIN MORRISON

Watching the Harvest
(Brown hare, *Lepus europaeus*)
Curry Rivel, Somerset

Brown hares can be difficult to spot in their natural habitat, but come harvest time their natural cover is removed and they are more visible. I've had this picture in my head for many years, but hares normally run ahead of the combine and into the nearest cover. I was deliberately shooting into the setting sun in order to capture the dust as this one hare opted to stay and watch as the combine approached.

Camera: Canon EOS 5D MkIII | Lens: 300mm with 1.4x teleconverter | Shutter speed: 1/1250 sec. | Aperture: f/5.6 | ISO: 800 | Monopod
flickr.com/photos/68911555@N03/

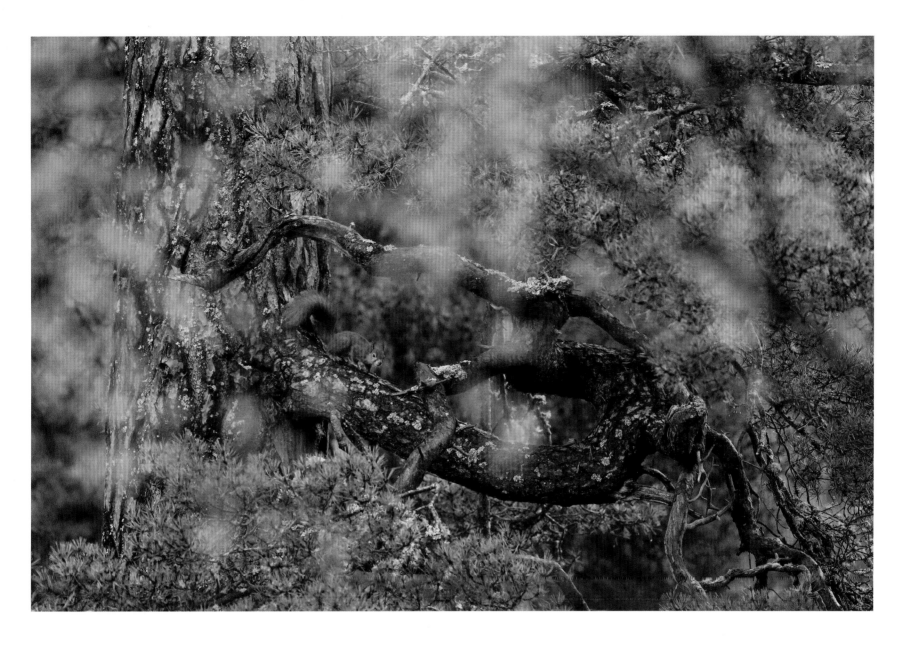

NEIL MCINTYRE
HIGHLY COMMENDED

Red Squirrel in Autumnal Pine Forest
(Red squirrel, *Sciurus vulgaris*)
Aviemore, Highland

I was working on my red squirrel book and needed a wide variety of images to show off these engaging little characters. As trees and forests are the squirrels' home, these were also playing a prominent part in the book, so my intention was to combine these elements. This fantastic old knarled pine tree with some out-of-focus autumn foliage and, of course, the squirrel, did the trick.

Camera: Canon EOS 1DX | Lens: 500mm | Shutter speed: 1/320 sec. | Aperture: f/5.6 | ISO: 2000 | Tripod
neilmcintyre.com

BOTANICAL
BRITAIN

BRITISH WILDLIFE
PHOTOGRAPHY AWARDS

SPONSORED BY
COUNTRYSIDE JOBS SERVICE

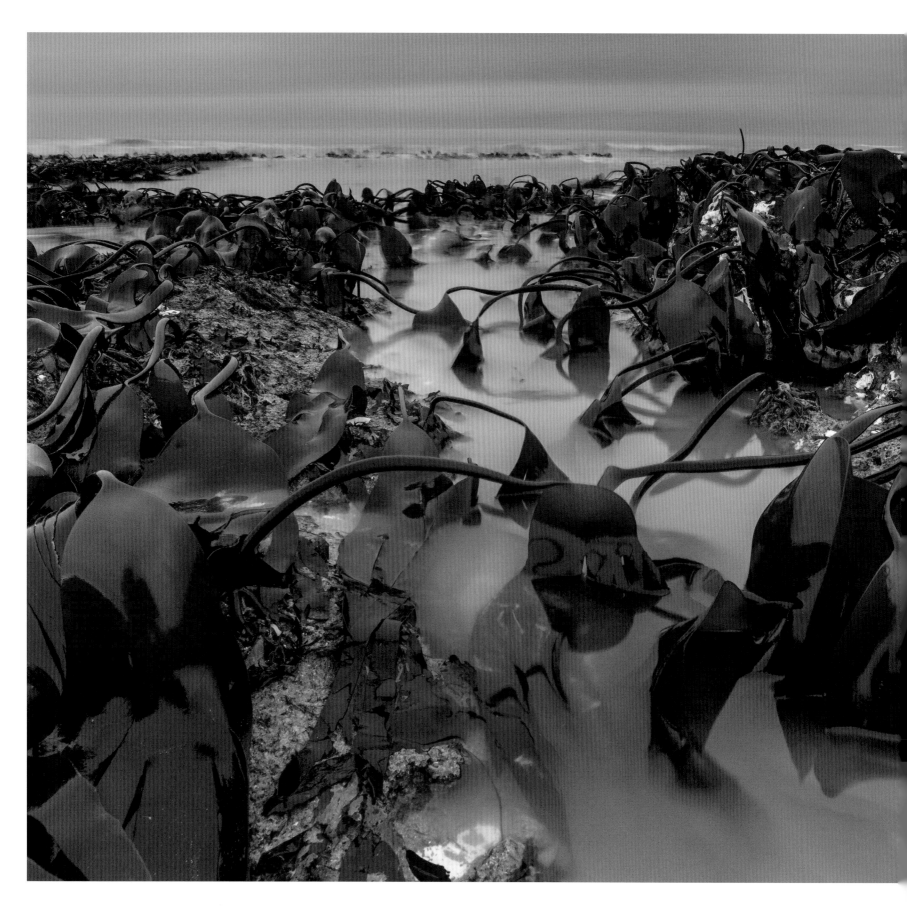

ROBERT CANIS
CATEGORY WINNER

Kelp Bed at Dawn
(Oarweed, *Laminaria digitata*)
Kingsgate Bay, Kent

My initial intention was to simply photograph the beach at sunrise, but noticing the exposed kelp beds as the tide receded I instead focused my attention on illustrating those as the tide ebbed and flowed under the blue light of dawn.

Camera: Nikon D600 | Lens: 20mm | Shutter speed: 2.5 sec. | Aperture: f/16 | ISO: 100 | Polariser, two-stop ND grad, tripod, cable release, mirror-lock

robertcanis.com

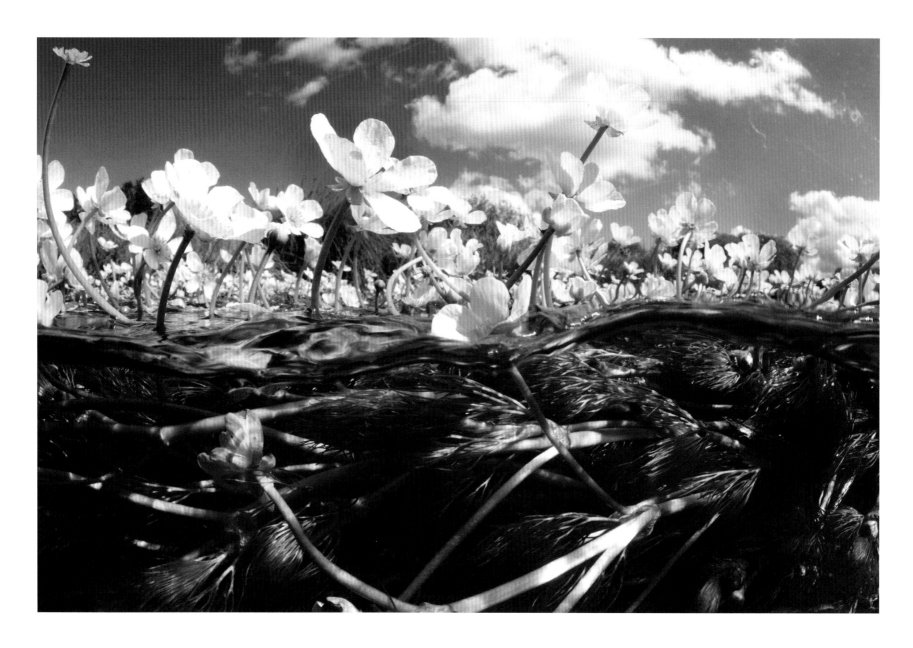

CHARLOTTE SAMS
HIGHLY COMMENDED

English Chalk Stream
(Water crowfoot, *Ranunculus aquatilis*)
Hampshire, England

Water crowfoot is a common flower in British streams and I wanted to capture it in an interesting way. Positioning my camera to create a split-shot, I tried to capture the sea of flowers facing towards the bright sun and the lush green stalks underwater.

Camera: Nikon D7000 | Lens: 10–17mm fisheye | Shutter speed: 1/250 sec. | Aperture: f/22 | ISO: 400 | Nauticam underwater housing, Sea & Sea strobe
charlottesams.com

TOBY HOULTON
HIGHLY COMMENDED

Windblown Pine Pollen
(Scots pine, *Pinus sylvestris*)
Kildary, Highland

Every time a gust of wind caught the pines in my garden, clouds of pollen were scattered into the air. I could
see the potential for an image and set up my tripod and camera, focused on what looked like heavily laden sprigs.
As the wind rose, I fired the remote hoping to capture the moment of dispersal. It was my first time witnessing
such an impressive event.

Camera: Nikon D500 | Lens: 180mm macro | Shutter speed: 1/640 sec. | Aperture: f/5.6 | ISO: 800 | Tripod, remote release
tobyhoultonphotography.co.uk

DANIEL TRIM
HIGHLY COMMENDED

The Sentinel
(Fly orchid, *Ophrys insectifera*)
Pegsdon Hills, Bedfordshire

These dainty orchids are hard to find if you've not seen one before, as they are incredibly small. Their size also makes it a challenge to get a good photo! Here I framed the orchid with some greenery in the foreground to isolate the subject and kept the aperture as wide as possible to create an ultra-shallow depth of field.

Camera: Canon EOS 5DS | Lens: 100mm macro | Shutter speed: 1/3200 sec. | Aperture: f/3.2 | ISO: 500
danieltrimphotography.co.uk

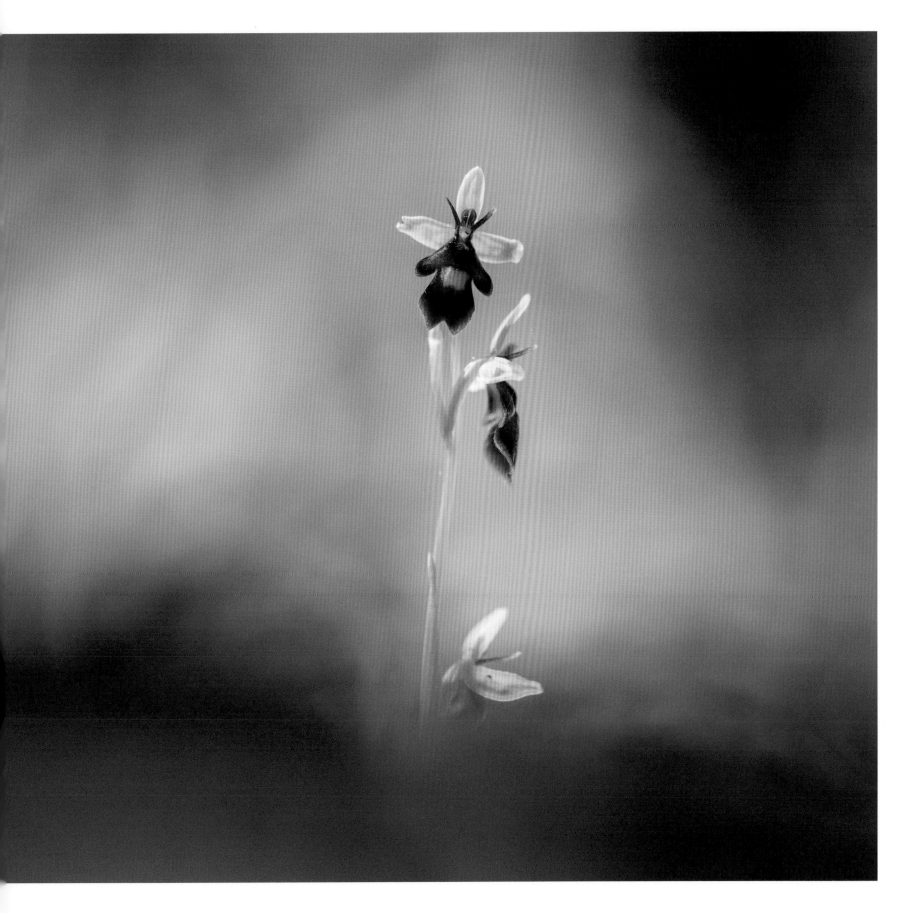

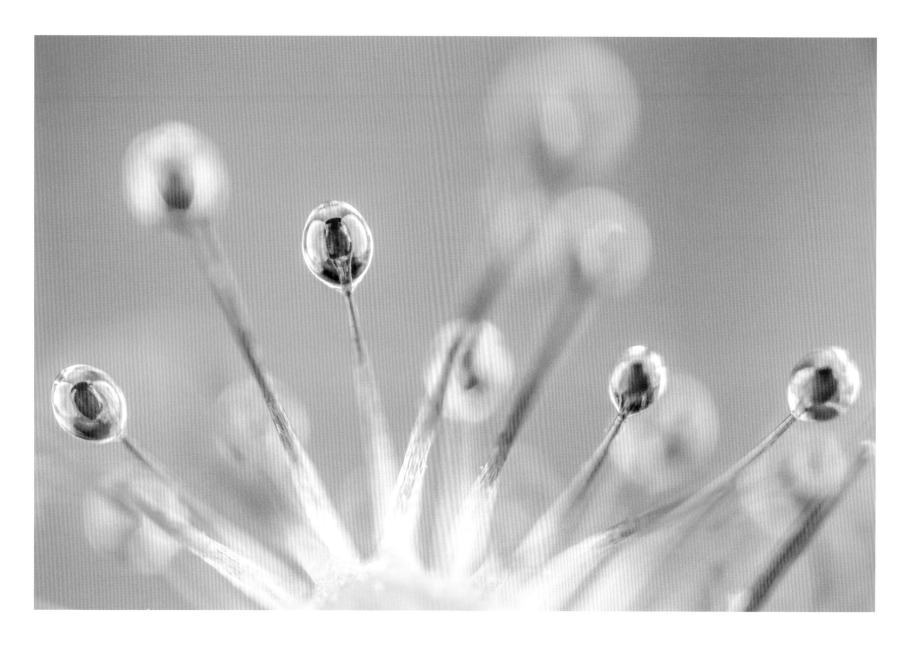

KEITH TRUEMAN
HIGHLY COMMENDED

Sundew
(Sundew, *Drosera rotundifolia*)
Exmoor National Park, Devon

I took this photograph of sundew at Exmoor National Park. It's a single image cropped to show detail in the glandular tentacles that are topped with sticky secretions, which cover their laminae. Sundew plants have the ability to move their tentacles when edible prey lands on them, making them quite amazing plants.

Camera: Canon EOS 6D | Lens: 65mm macro | Shutter speed: 1/4 sec. | Aperture: f/2.8 | ISO: 400 | Tripod

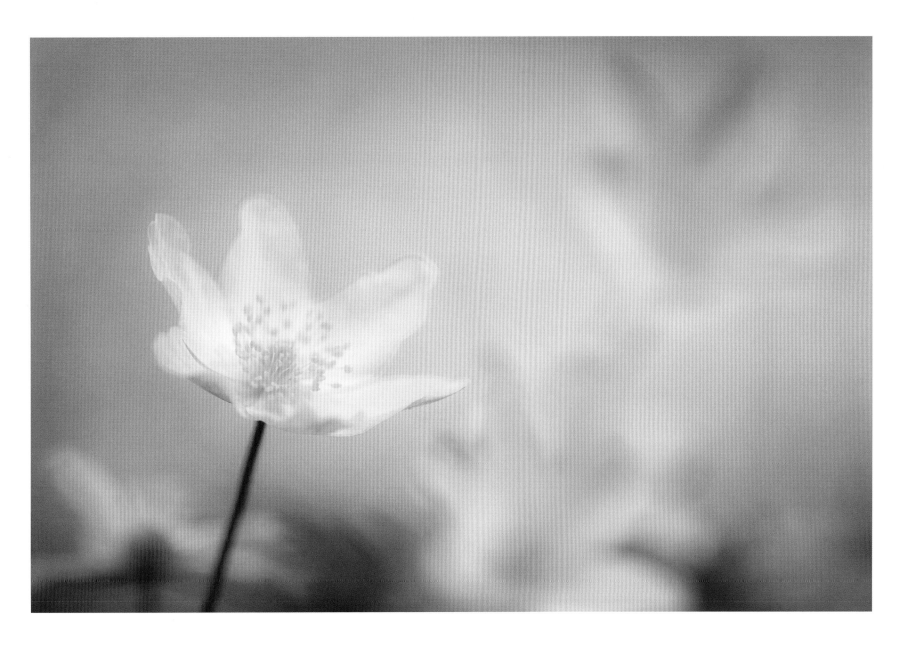

ROSS HODDINOTT

Wood Anemone
(Wood anemone, *Anemone nemorosa*)
RHS Rosemoor, Devon

Wood anemone is probably my favourite wild flower. During a family visit to RHS Rosemoor last spring, I sneaked away for half an hour to photograph the anemones that carpet parts of the woodland there. The light was warm and rich and I decided to isolate a single flower using a large aperture and shallow depth of field. I shot handheld, lying on the ground to achieve a low, natural-looking perspective.

Camera: Nikon D810 | Lens: 200mm macro | Shutter speed: 1/500 sec. | Aperture: f/4.8 | ISO: 320
rosshoddinott.co.uk

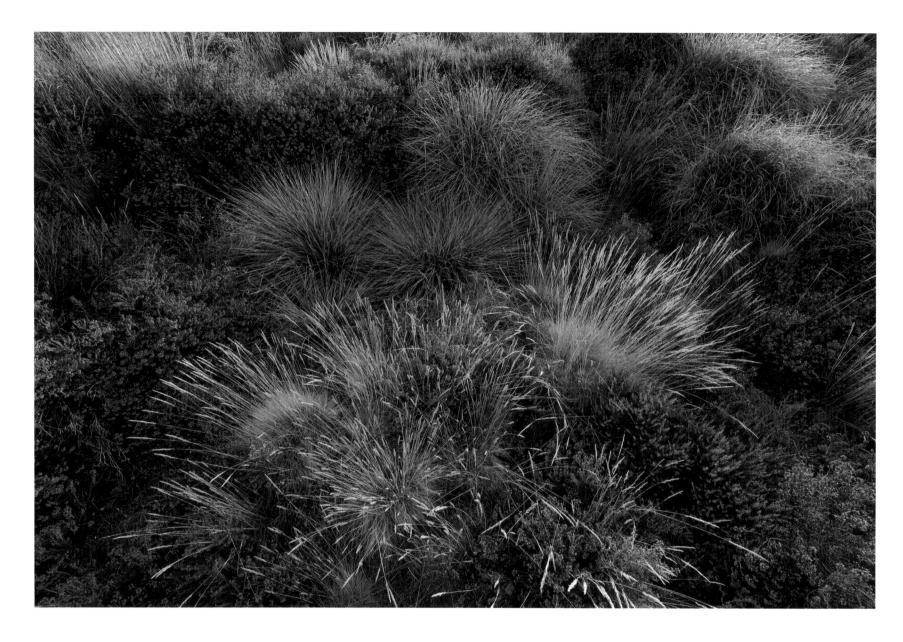

TIM HUNT

Heathland Fireworks
(Dorset heath, *Erica ciliaris*)
Studland, Dorset

Every year between July and September, Dorset heath – a species of heather – puts on an amazing colour display.
In the late evening the colours really come alive, so I spent time exploring and found a spot that really emphasised
the beauty of the heather. The wild grasses really complemented the pinks and purples.

Camera: Canon EOS 5DSR | Lens: 16–35mm | Shutter speed: 1/100 sec. | Aperture: f/9 | ISO: 400
timhuntphotography.co.uk

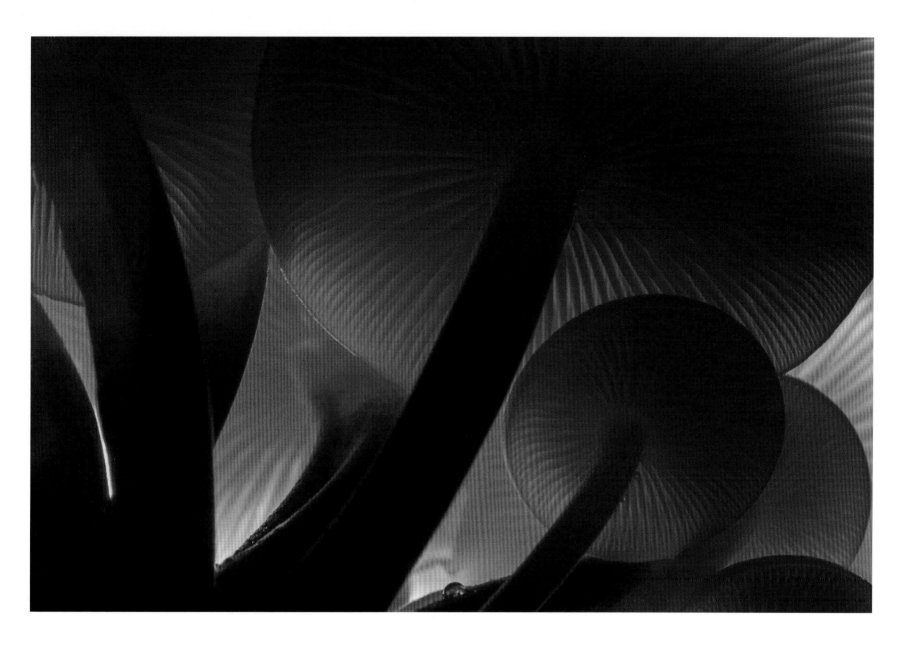

JACK MORTIMER

Embers of the Forest Floor
(Velvet shank mushroom, *Flammulina velutipes*)
Coombe Wood, Wheatley, Oxfordshire

Dusk is a difficult time to search for macro subjects to photograph on the forest floor, but scanning my torch across the distant ground, the burnt orange hues of this cluster of velvet shank mushrooms stood out from the bleak, frosty landscape. Fungi are a vastly overlooked part of British biodiversity and it is only when you take a closer look that you can appreciate their beauty.

Camera: Nikon D7100 | Lens: 105mm macro | Shutter speed: 1/250 sec. | Aperture: f/16
ISO: 100 | Nikon SU-800 Wireless Commander unit, two SB-R200 remote Speedlights, tripod
jackmortimerphotography.com/

CLOSE TO NATURE

BRITISH WILDLIFE
PHOTOGRAPHY AWARDS

DAVID BENNETT
CATEGORY WINNER

Goose Barnacles, Sanna Bay, Scotland
(Goose barnacles, *Lepas anatifera*)
Sanna Bay, Highland

We were on holiday in Scotland and the weather was good, so we went to Sanna Bay, which is a place we know and love. While walking and exploring the coast we noticed a very large piece of unusual-looking driftwood. On close inspection we noticed it was covered with goose barnacles, which were moving and pulsating like an alien species. The wood was stranded from the tide and we tried in vain to move it back to the water, but it was too heavy and wedged in – hopefully the barnacles survived until the next tide.

Camera: Nikon D500 | Lens: 200-500mm | Shutter speed: 1/500 sec. | Aperture: f/11 | ISO: 1100

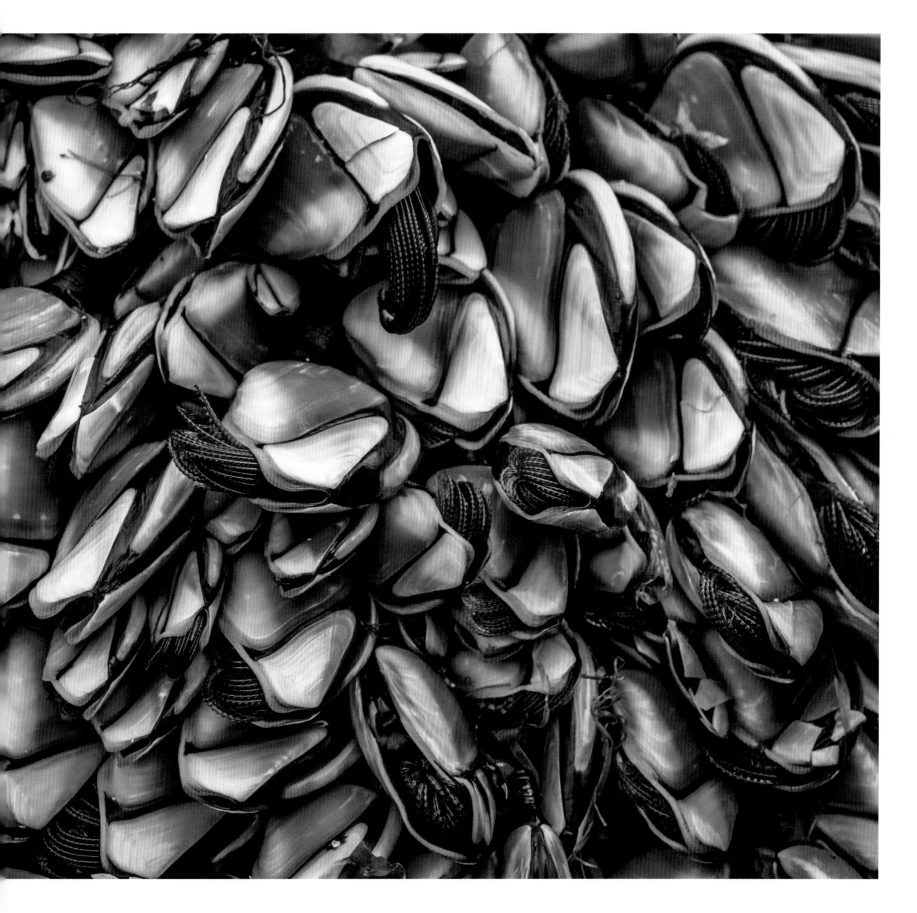

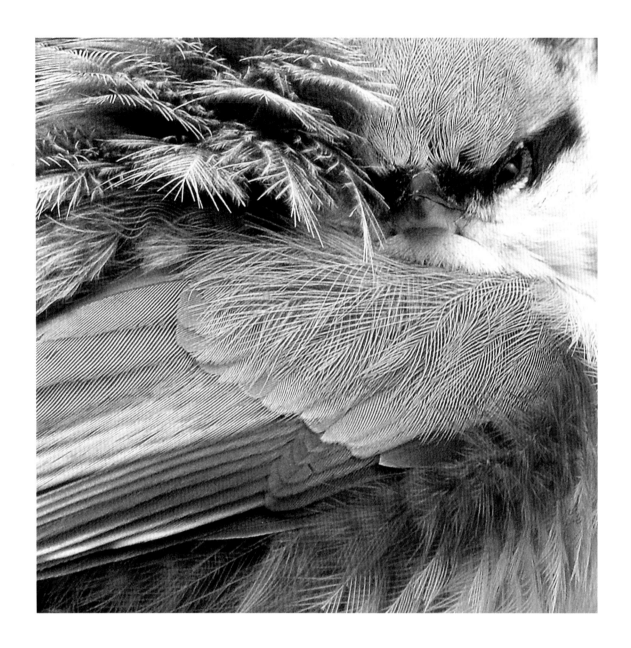

ALAN PRICE
HIGHLY COMMENDED

Resting Fluffy Nuthatch
(Eurasian nuthatch, *Sitta europaea*)
Pentrefelin, Gwynedd

I have many species of birds in my garden and have erected my hide close to the bird table, resulting in excellent close-up studies. A nuthatch flew in, and after feeding settled down in the sunshine for a short break. As I began to focus on the bird a light breeze ruffled its feathers and I managed to capture the moment.

Camera: Nikon D7100 | Lens: Nikon 300mm | Shutter speed: 1/1000 sec. | Aperture: f/8 | ISO: 1600 | Monopod
gatehousestudio.co.uk

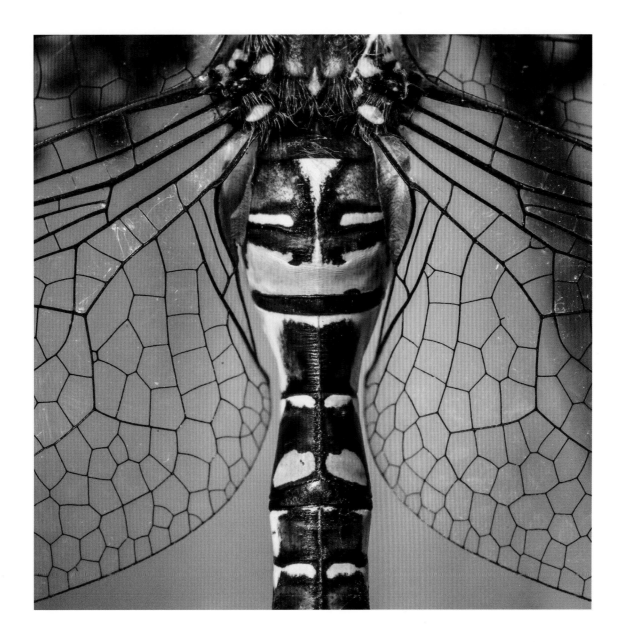

STEPHEN DARLINGTON
HIGHLY COMMENDED

Tee Shot
(Migrant hawker, *Aeshna mixta*)
West End Common, Surrey

The yellow T-shaped mark at the top of the abdomen is a very distinct feature of a migrant hawker. I wanted to get a close-up of this mark and the other markings of the dragonfly to show their beauty, but getting close with a macro lens took a lot of patience and a lot of failed attempts. On this particular morning I had watched a lone individual patrol the pond looking for females. When it perched at head height, I approached slowly, keeping low to avoid spooking it, and taking shots as I got closer and closer. Eventually I got this frame-filling shot.

Camera: Canon EOS 7D | Lens: 100mm | Shutter speed: 1/400 sec. | Aperture: f/13 | ISO: 1600
stephendarlington.com

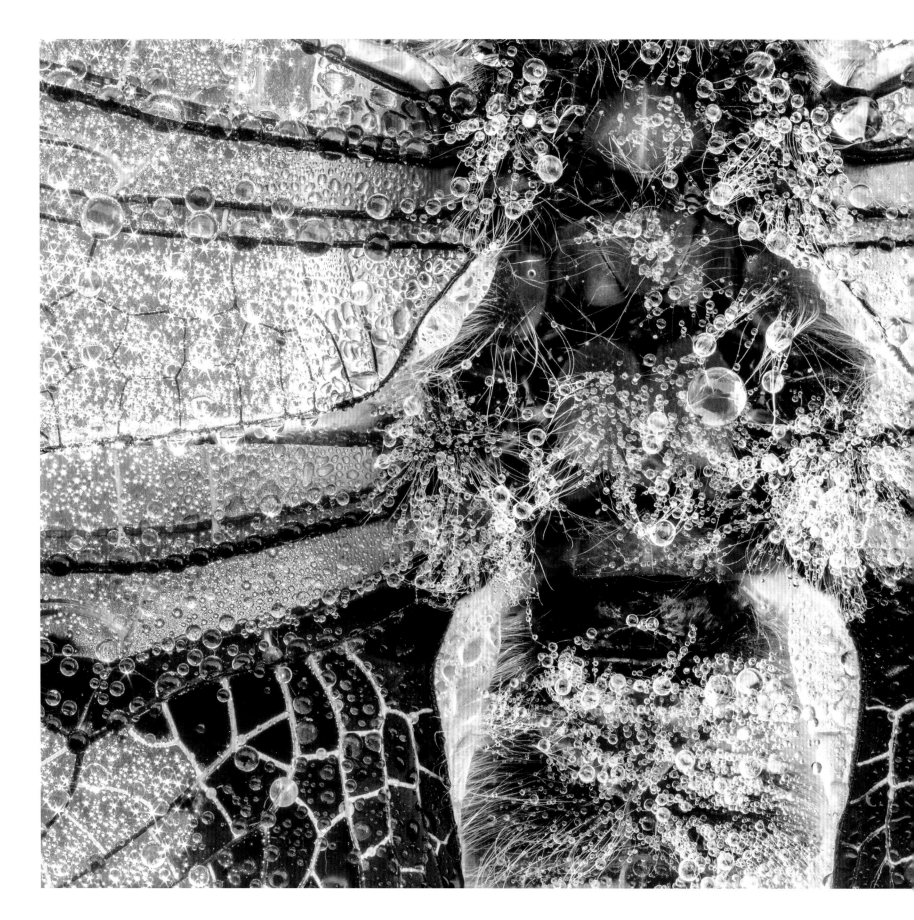

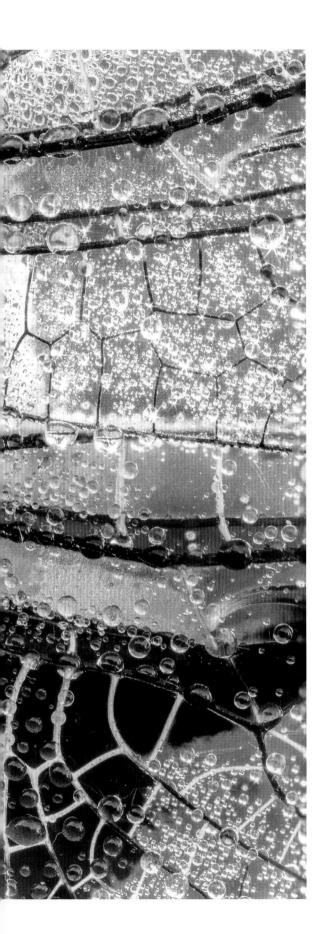

OLIVER WRIGHT
HIGHLY COMMENDED

Dragonfly Stained Glass Window
(Four-spotted chaser, *Libellula quadrimaculata*)
Skipwith, Yorkshire

The image was taken early in the morning, while the dragonfly was torpid and covered in dew. I positioned myself so the sun was behind the dragonfly and effectively lit the wings like stained glass windows in a church. I used focus-stacking to create a greater effective depth of field in the final image.

Camera: Canon EOS 5D MkIV | Lens: 65mm macro | Shutter speed: 1/2 sec. | Aperture: f/13 | ISO: 200 | Tripod, remote release
oliverwrightphotography.com

BLACK
AND WHITE

BRITISH WILDLIFE
PHOTOGRAPHY AWARDS

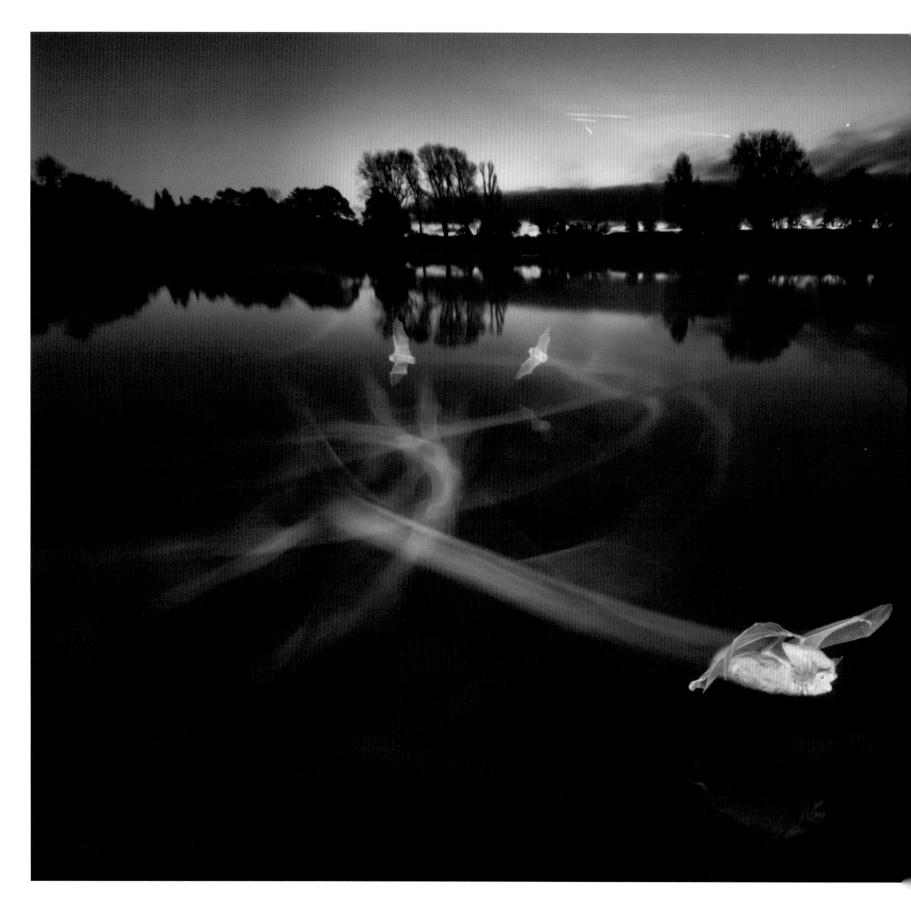

PAUL COLLEY
OVERALL & CATEGORY WINNER

Contrails at Dawn
(Daubenton's bats, *Myotis daubentonii*)
Coate Water Country Park, Wiltshire

Ghostly contrails reveal the flight paths and wingbeats of Daubenton's bats. An infrared camera and lighting system that were 14 months in development overcame the challenge of photographing the high-speed flight of these small mammals in the dark. The in-camera double exposure caught the foreground bat milliseconds before insect intercept. As these bats are a protected species they were photographed in the wild following advice from the Bat Conservation Trust and Natural England.

Camera: Nikon D750 modified to 830nm wavelength infrared | Lens: 12-24mm at 12mm | Shutter speed: 4 sec. | Aperture: f/8 | ISO: 400
Own-design high-speed camera trap using Pluto laser trigger, modified Nikon Speedlights (infrared) and constant infrared floodlight
mpcolley.com

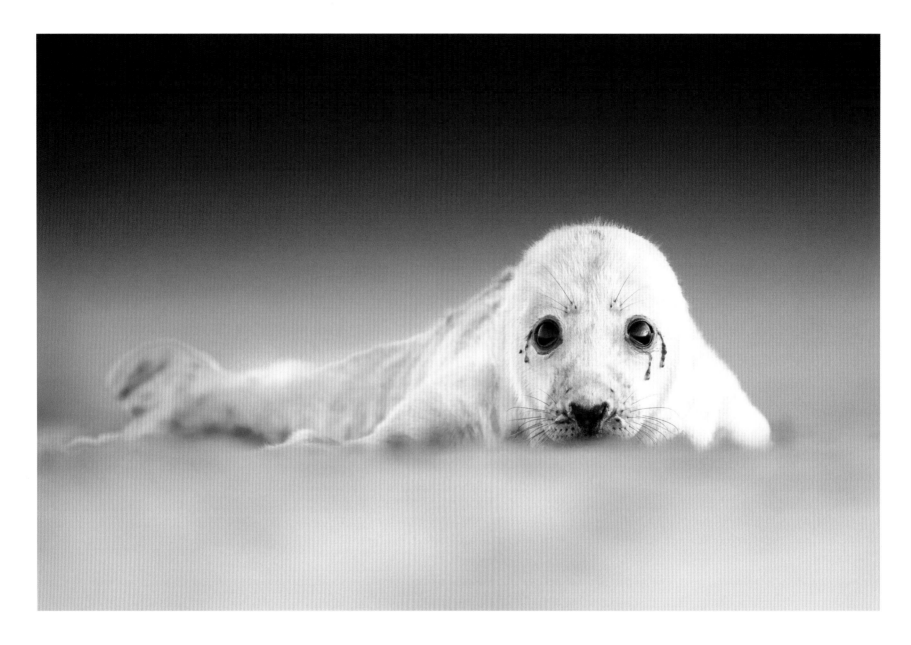

SEAN WEEKLY
HIGHLY COMMENDED

Tears in the Eyes
(Grey seal, *Halichoerus grypus*)
North Somercotes, Lincolnshire

A simple, but cute portrait of a young seal pup being nosey. It was the pup's eyes that drew me in; I loved how they had been weeping due to the strong winds, which gave the impression it was crying. I converted the image to monochrome to give it a more emotional feel.

Camera: Canon EOS 5D MkIV | Lens: 300mm with 1.4x teleconverter | Shutter speed: 1/400 sec. | Aperture: f/4 | ISO: 1250

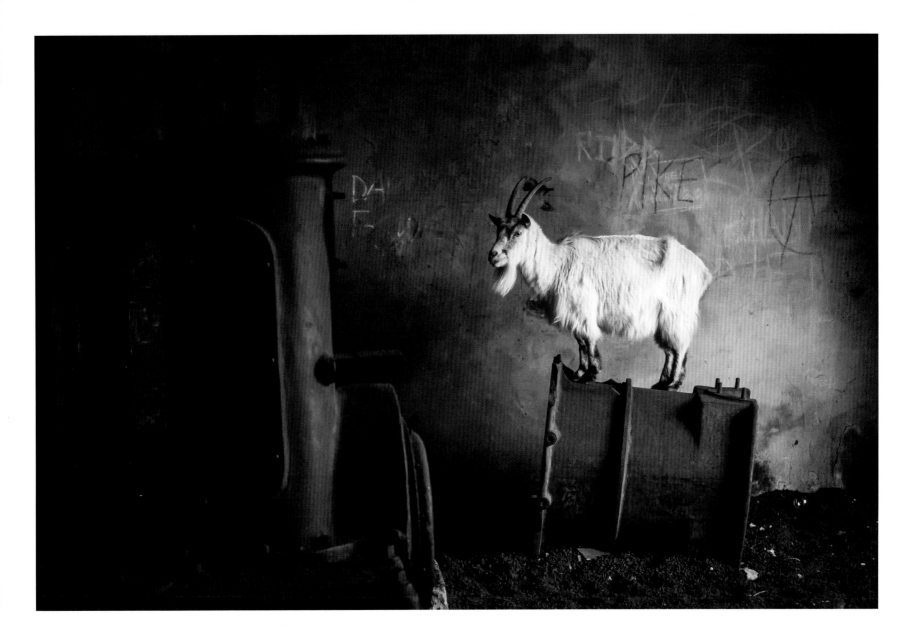

KEVIN MORGANS
HIGHLY COMMENDED

The Boiler Room
(Welsh mountain goat, *Capra aegagrus hircus*)
Snowdonia National Park, Gwynedd

Over the past year I have spent a lot of time photographing the Welsh mountain goats and over time you begin
to learn about their behavioural habits and cycles. This particular group lives high up in an old abandoned mining
quarry and when it is a wet day the group takes shelter in one of the old buildings. This can make for some unique
photographic opportunities as they move around the old mining equipment.

Camera: Canon EOS 1DX | Lens: 70–200mm | Shutter speed: 1/125 sec. | Aperture: f/2.8 | ISO: 8000
kevinmorgans.com

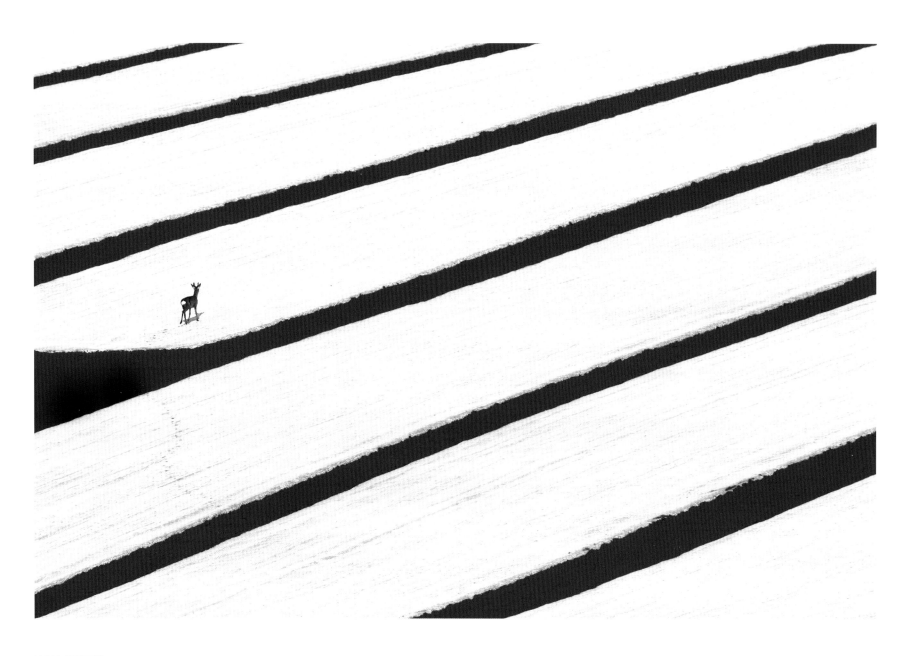

ROY CURTIS
HIGHLY COMMENDED

A Roe Deer Crossing a Plastic Desert
(Roe deer, *Capreolus capreolus*)
Truro, Cornwall

This was an opportunistic photo taken from an upstairs window of my house. When I spotted a deer in the field I was struck by the incongruity of the scene with a wild animal crossing a mainly plastic field. Originally shot in colour, I converted it to black and white to emphasise the diagonal stripes, so the deer looks as if it is isolated in an alien world.

Camera: Nikon D800 | Lens: 80-400mm at 400mm | Shutter speed: 1/500 sec. | Aperture: f/6.3 | ISO: 100

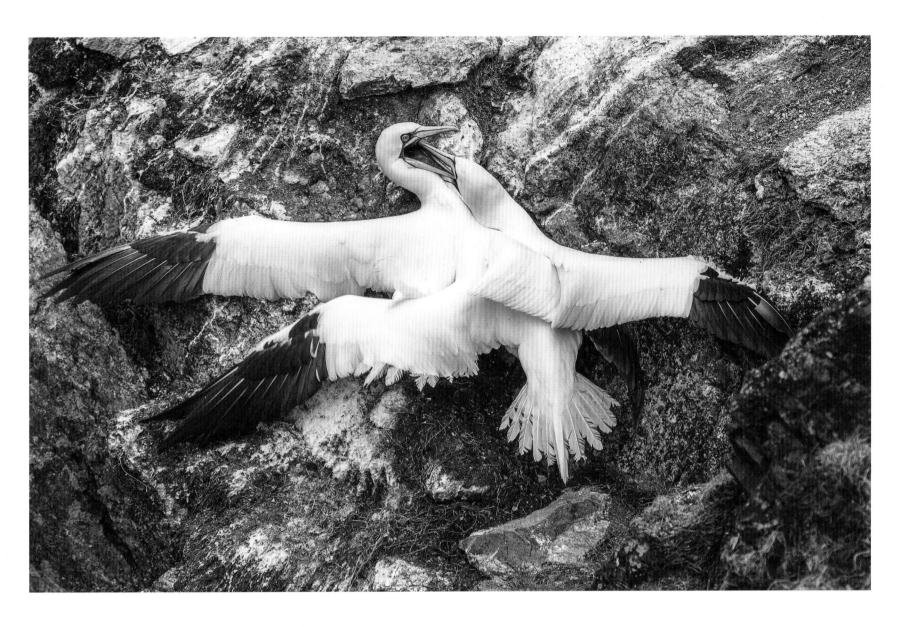

WENDY BALL

Fighting Gannets
(Northern gannet, *Morus bassanus*)
Hermaness, Shetland

Over a period of two days I watched this pair of gannets fighting over a nesting site on
the vertiginous cliffs of Hermaness, on the island of Unst. The fights were long and furious,
with neither bird prepared to give up the tiny ledge. Two adjacent gannets, which were both
sitting on eggs, would sometimes join the fray and grab intruding wings or tails.

Camera: Canon EOS 5D MkIII | Lens: 100–400mm | Shutter speed: 1/400 sec. | Aperture: f/5.6 | ISO: 100
flickr.com/photos/wendy_ball/

BRITISH SEASONS

BRITISH WILDLIFE
PHOTOGRAPHY AWARDS

SPONSORED BY
PARAMO

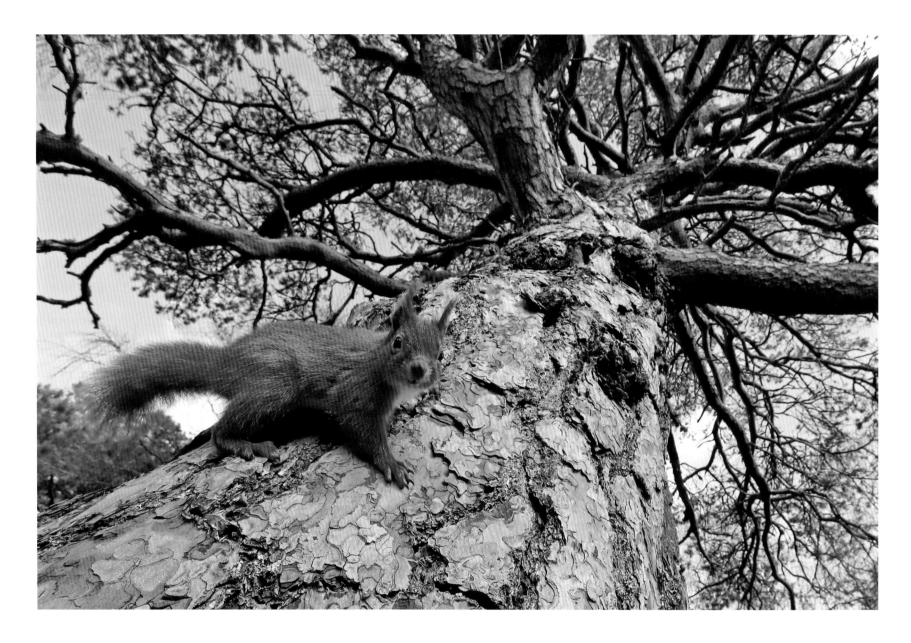

NEIL MCINTYRE
CATEGORY WINNER

Seasonal Scottish Squirrels
(Red squirrel, *Sciurus vulgaris*)
Rothiemurchus Forest, Highland
neilmcintyre.com

SPRING

Spring Red Squirrel on Old Caledonian Pine Tree
With spring in full flow I didn't have much time to get this image before the squirrels changed to their summer coats. With a forecast of blue sky – which I desperately needed for this image – I could now give it a go. After three six-hour shifts I finally managed to get the perfect combination of light and the squirrel's pose and position.

Camera: Canon EOS 1DX MkII | Lens: 16–35mm | Shutter speed: 1/250 sec. | Aperture: f/16 | ISO: 2000 | Tripod, camera triggered with infrared remote control

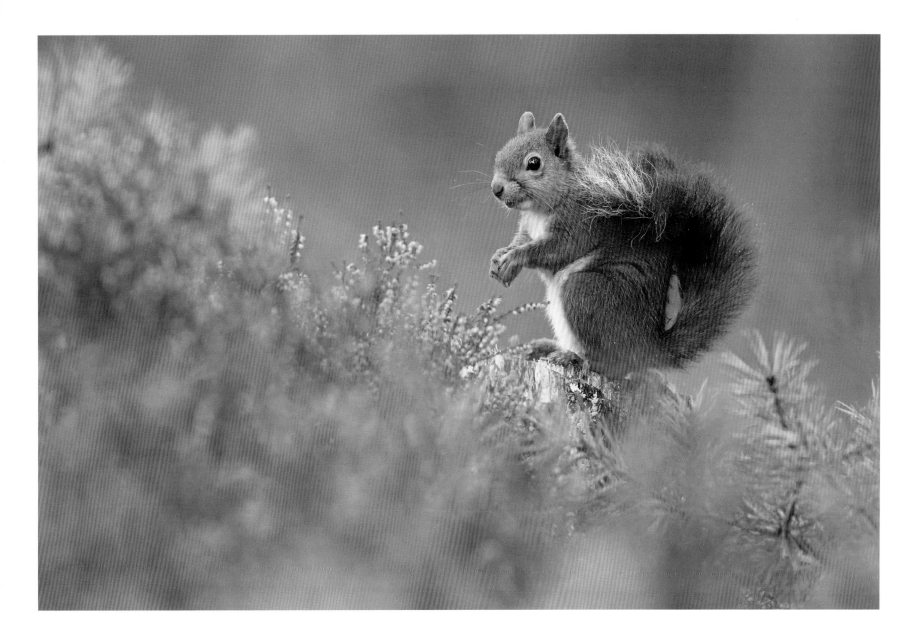

SUMMER

Summer Red Squirrel in Purple Heather

In August, when the heather is in full purple bloom, the pine forests are a colourful delight. With this array of colour in mind, I wanted to show off this season in its full glory. I positioned myself low among a thick bed of heather that surrounded an old tree stump that I knew the squirrels liked to sit on to feed. Eventually one obliged and here the squirrel glances around just before it starts foraging again.

Camera: Canon EOS 1DX | Lens: 500mm | Shutter speed: 1/1000 sec. | Aperture: f/5.6 | ISO: 1600 | Tripod

AUTUMN

Autumn Red Squirrel Silhouette

With its magical golden colours, this season has to be my favourite. It was the sheer vibrancy of the colours that drew me to this scene, and the silhouette of the squirrel tucked in below a beech tree with a background of autumnal glory was perfect – I could not believe my luck!

Camera: Canon EOS 1DX | Lens: 100-400mm at 270mm | Shutter speed: 1/2000 sec. | Aperture: f/5.6 | ISO: 1250

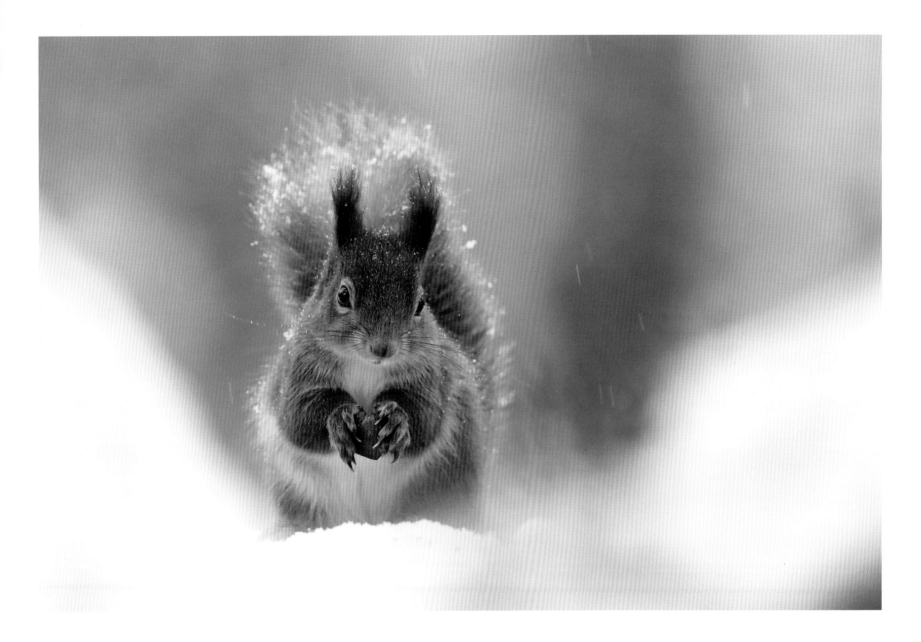

WINTER

Winter Red Squirrel

Red squirrels in snow look very appealing, but they are not overly keen on the colder weather, so visits can be shorter than normal. This fellow had ventured out for some food and I managed to find a lovely low angle that let me position it against a slightly darker background so the snowflakes on its tail were more noticeable.

Camera: Canon EOS 1DX MkII | Lens: 500mm | Shutter speed: 1/160 sec. | Aperture: f/5.6 | ISO: 3200 | Hide, tripod

DOCUMENTARY SERIES AND EVERYDAY NATURE

BRITISH WILDLIFE PHOTOGRAPHY AWARDS

SPONSORED BY
THE WILDLIFE TRUSTS

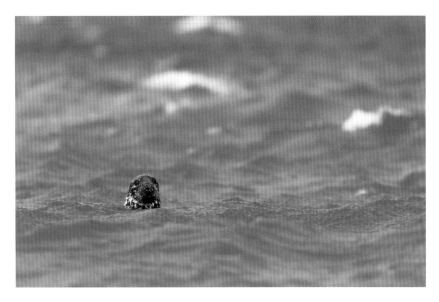

A wild grey seal in stormy waters
Camera: Nikon D7200 | Lens: 300mm | Shutter speed: 1/2500 sec. | Aperture: f/2.8 | ISO: 320

Monitoring seal haul-out sites using technology
Camera: Nikon D7200 | Lens: 10–20mm | Shutter speed: 1/160 sec. | Aperture: f/4.5 | ISO: 100

BEN WATKINS
CATEGORY WINNER

Rehabilitated Seals Being Released into the Wild
(Grey seal, *Hailchoerus grypus*)
Various locations, Cornwall

Based on pup production, the UK is home to 38% of the world's entire population of grey seals. In Cornwall there are numerous organisations and charities working together with the common goal of conserving this iconic species. Their work mainly consists of non-invasive techniques that keep human interaction with the seals to a minimum, only ever stepping in when it is necessary for the seals' survival.

Public coastal survey to monitor marine life
Camera: Nikon D7200 | Lens: 10–20mm | Shutter speed: 1/80 sec. | Aperture: f/8 | ISO: 250 | Tripod

A rescued grey seal pup being transferred for rehabilitation
Camera: Nikon D810 | Lens: 24–70mm | Shutter speed: 1/250 sec. | Aperture: f/2.8 | ISO: 400

Rehabilitated grey seals being released back into the wild
Camera: Nikon D7200 | Lens: 10–20mm | Shutter speed: 1/640 sec. | Aperture: f/3.5 | ISO: 100

Post-mortem examination
Camera: Nikon D810 | Lens: 24–70mm | Shutter speed: 1/400 sec. | Aperture: f/2.8 | ISO: 800

WILDLIFE IN HD VIDEO

BRITISH WILDLIFE PHOTOGRAPHY AWARDS

The glowing lights of Teesside: this vast conurbation is far wilder than meets the eye.

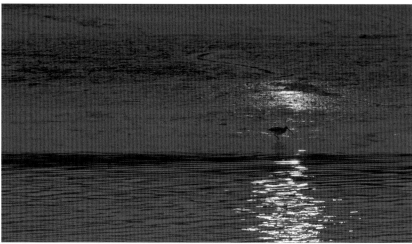

A curlew forages at dusk. Light pollution allows waders to feed well after dark.

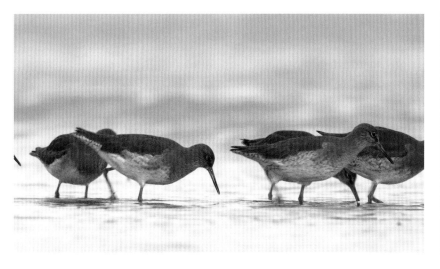

Redshank forage through shallow waters, searching for prey on this surprisingly bountiful coastline.

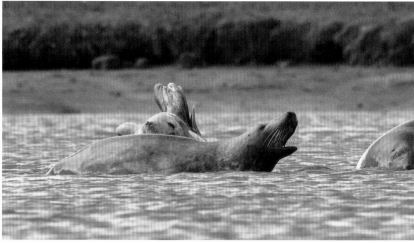

Grey seals disappeared from the Tees estuary in the 19th century, but have returned over a century later.

SAM OAKES
CATEGORY WINNER

Industrial Evolution
Teesside, north-east England

Industrial areas might not spring immediately to mind when searching for a wild encounter, but while Teesside in the north-east of England is best known for towering factories and vast steelworks, something stirs in the shadows. Nature is creeping back and finding a foothold between the smoking chimneys and bustling ports. Waders forage through healthy mudflats, grey seals have returned to their daily roost, and foxes and raptors stalk prey between iconic landmarks and relics of the industrial revolution that in the past claimed so much of this estuarine habitat for man.

The sun rises over a steel graveyard, where oil rigs and ships are broken down for scrap.

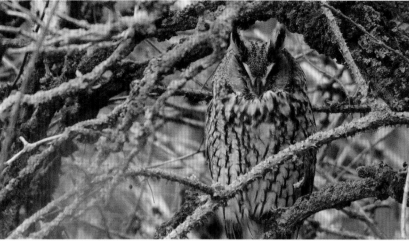

A regular visitor to Teesside in winter, this particular long-eared owl is a famous attraction.

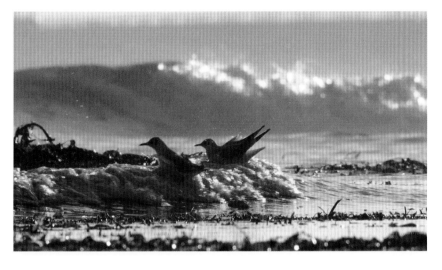

Black-headed gulls battle the waves at sunrise.

Night falls over the Tees transporter bridge, the heart of wild Teesside.

Industrial Evolution aimed to capture the resilience of nature in this unexpected location, and in the process of filming I experienced some of the wildest encounters of my life. The story of Teesside's wildlife is one of hope; of animals fighting back against the tides of change and urban pressure. With a resurgent seal colony and expansion of marshland habitats the future looks bright for the wildlife in this corner of England.

Filmed, edited and produced by Sam Oakes, with special thanks to Teesmouth NNR & RSPB Saltholme.

WATCH THE WINNING VIDEO AT:
bwpawards.org/videowinners2018

BEN ANDREW
EDITOR'S CHOICE: FEBRUARY

Cryptic Cricket
(Great green bush-cricket, *Tettigonia viridissima*)
Stevenage, Hertfordshire

Many years ago a population of these fantastic invertebrates was re-introduced locally to a small grassland meadow. They have since thrived and each year I visit the site just to hear their loud calls: if I can see one, creep up to it and get a photograph, that's a bonus!

Camera: Nikon D800 | Lens: 105mm macro | Shutter speed: 1/400 sec. | Aperture: f/3.2 | ISO: 400

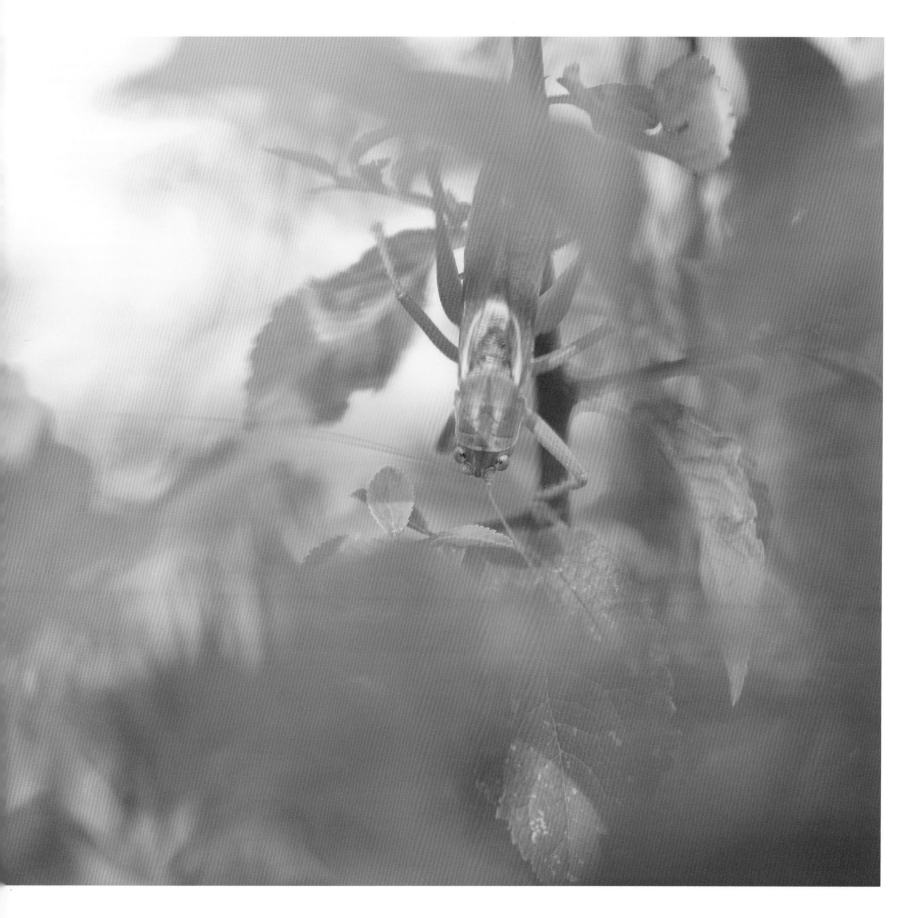

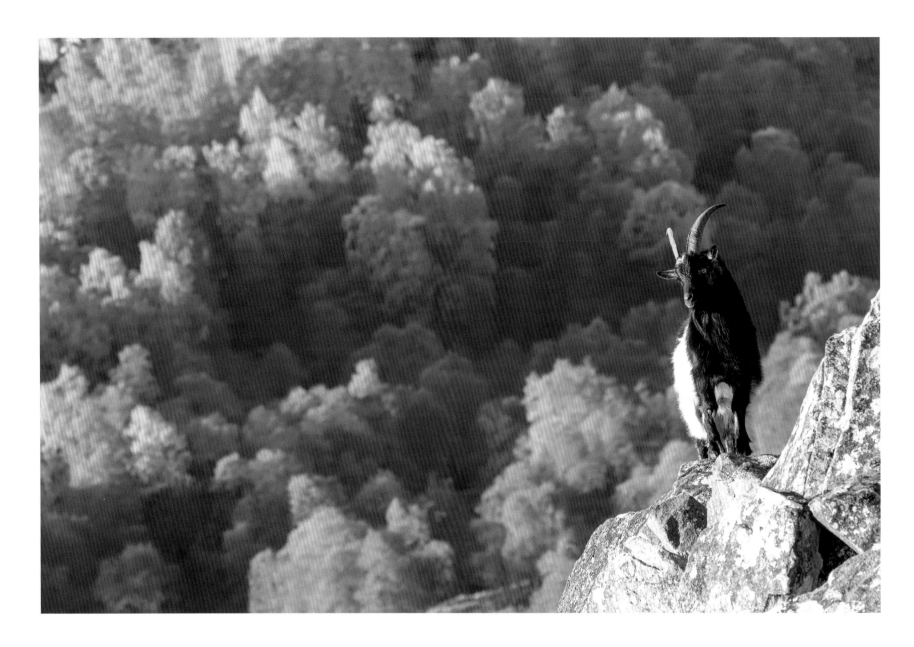

PAUL CARPENTER
EDITOR'S CHOICE: MARCH

Feral Goat Surveying his Slope
(Feral Goat, *Capra hircus*)
Newtonmore, Highland

Now and again I go looking for wildlife that does not involve a hard walk (or crawling for that matter).
I have taken images of this small herd from my car before, which illustrates just how close to the road they
will approach, although they live on a boulder scree coming off a steep cliff. On this occasion I climbed up
the slope and just waited until they drifted my way.

Camera: Canon EOS 7D MkII | Lens: 150–600mm | Shutter speed: 1/160 sec. | Aperture: f/8 | ISO: 400

IAN WADE
EDITOR'S CHOICE: APRIL

Midnight Snail
(Common garden snail, *Cornu aspersum*)
Stokes Croft, Bristol

After heavy downpours during the night I noticed that snails would appear and slowly negotiate Bristol's urban environment. In an area called Stokes Croft there is a street that turns a golden colour from the light reflecting back off the wet concrete and I thought this would be the perfect setting for the snails. However, I had to contend with people heading out to nightclubs and bars seeing me lying on the floor photographing snails! It was an interesting evening and I was glad to get home afterwards!

Camera: Canon EOS 5D MkII | Lens: 105mm macro | Shutter speed: 1/60 sec. | Aperture: f/2.8 | ISO: 3200
ianwadewildlife.com

SARAH DARNELL
EDITOR'S CHOICE: MAY

Roe Row
(Roe deer, *Capreolus capreolus*)
Bintree, Norfolk

Getting this shot was a game of chance and learned study. It meant getting into a position and selecting a row
of asparagus where the action might happen, with regular 4am starts necessary to get there ahead of the deer.
I had been following this young roe buck's progress since March and while he was cautious, he was also very
curious, to the extent that he would often seek me out among the asparagus rows.

Camera: Canon EOS 1DX MkII | Lens: 600mm with 1.4x teleconverter | Shutter speed: 1/1000 sec. | Aperture: f/5.6 | ISO: 800 | Tripod
sarahdarnellphotography.co.uk

CHAITANYA DESHPANDE
EDITOR'S CHOICE: JUNE

A Vision in the Mist
(Red deer, *Cervus elaphus*)
Richmond, Greater London

This scene came out of nowhere, and I still can't believe I witnessed it in person. I was transfixed and it felt like the deer were too, as they held their poses perfectly. Being able to get this image required one key ingredient: knowing my subject and its environment well enough to be able to foresee that this could be possible.

Camera: Canon EOS 5DS | Lens: 70-200mm | Shutter speed: 1/250 sec. | Aperture: f/5.6 | ISO: 320
flickr.com/photos/chaitanyadphotography/

YOUNG PEOPLE'S AWARDS

BRITISH WILDLIFE PHOTOGRAPHY AWARDS

SPONSORED BY
RSPB WILDLIFE EXPLORERS

IVAN CARTER (AGE 17)
CATEGORY WINNER 12–18 YEARS

Eye of the Spawn
(Tadpole of common frog, *Rana temporaria*)
Walmer Castle, Kent

I was visiting Walmer Castle taking photos of the wildlife. I went into The Queen Mother's Garden to take some photos of the flowers and noticed three tadpoles trapped in a small pool of water on top of one of the water lily leaves in the ornamental pond. I realised that this tiny water scene would create the special shot I was looking for that day.

LUCY FARRELL (AGE 9)
CATEGORY WINNER UNDER 12 YEARS

Who Says Bugs Aren't Cute?
(Cockchafer, *Melolontha melolontha*)
Borrowdale, Cumbria

I took this at a caravan site in Borrowdale, in woodland on the shores of Derwentwater.
I found this with five other cockchafers in my moth trap — it was amazing!

THEO RUSSELL (AGE 17)
HIGHLY COMMENDED 12–18 YEARS

On the Waterfront
(Cormorants, *Phalacrocorax carbo*)
Bristol Floating Harbour, Bristol

GIDEON KNIGHT (AGE 18)
HIGHLY COMMENDED 12–18 YEARS

Golden Bokeh
(Red fox, *Vulpes vulpes*)
Ilford, East London

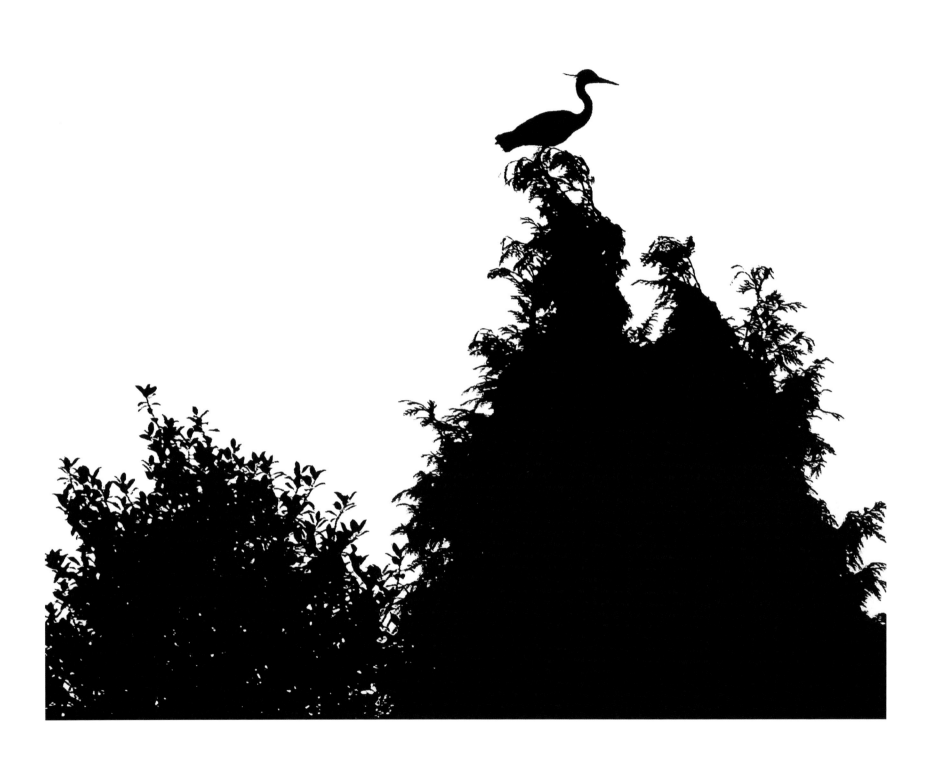

◀ TESS EASTERBROOK (AGE 8)
HIGHLY COMMENDED
UNDER 12 YEARS

Stopping for a Rest
(Grey heron, *Ardea cinerea*)
Beaconsfield, Buckinghamshire

▶ ALICIA LAKIN (AGE 10)
HIGHLY COMMENDED
UNDER 12 YEARS

Summer Mayfly
(Summer mayfly, *Ephemeroptera*)
Near Thrupp, Oxfordshire

▲ JAKE KNEALE (AGE 15)

The Long Wait
(Spider, *Arachnida*)
Wilsford, Wiltshire

▶ JOSH CLARK (AGE 18)

Mute Swans
(Mute swan and cygnet, *Cygnus olor*)
River Stour, Dorset

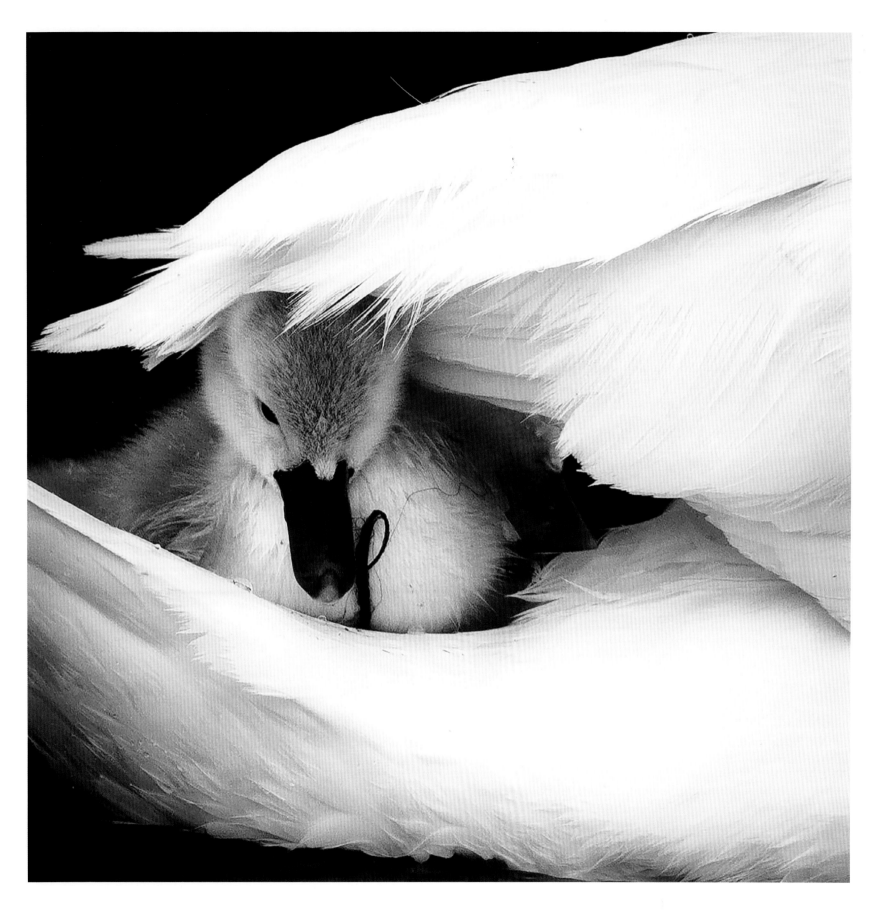

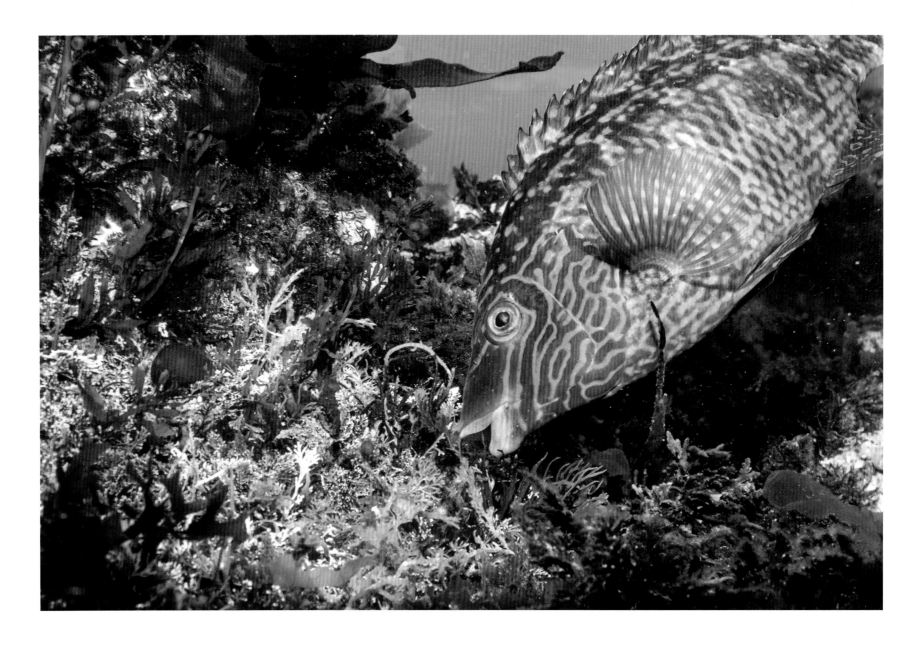

ELLIE STONES (AGE 18)

The Flamboyant Fish
(Corkwing wrasse, *Symphodus melops*)
Pendennis Point, Falmouth, Cornwall

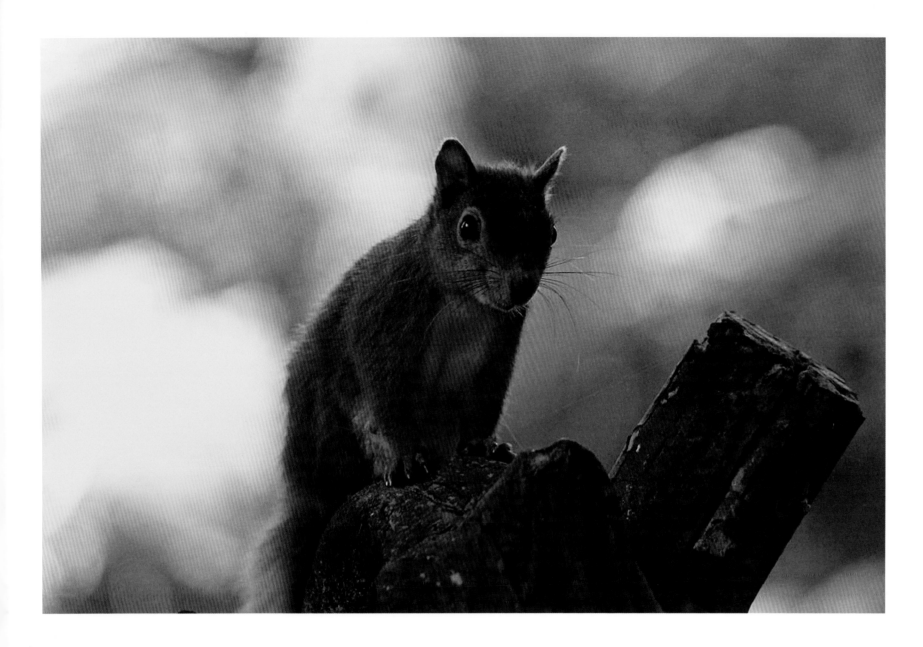

JOEL OSBORN (AGE 10)

Brownsea Red
(Red squirrel, *Sciurus vulgaris*)
Brownsea Island, Dorset

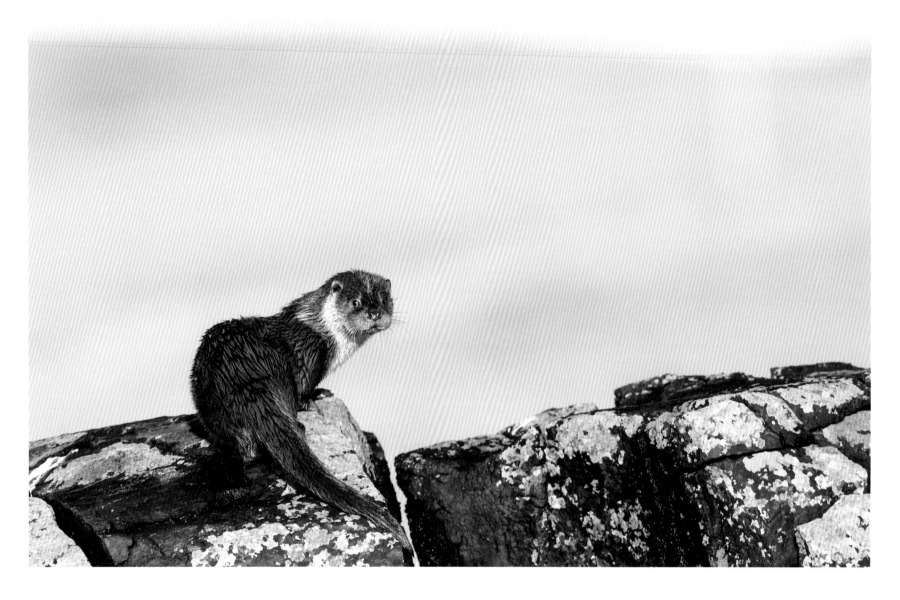

CASEY HUNTER THOMASON (AGE 7)

Top of the Rock
(Otter, *Lutra lutra*)
Shetland

CASEY HUNTER THOMASON (AGE 7)

The Skerries Wally
(Walrus, *Odobenus rosmarus*)
Shetland

First published 2018 by Ammonite Press
an imprint of Guild of Master Craftsman Publications Ltd, Castle Place,
166 High Street, Lewes, East Sussex, BN7 1XU, United Kingdom

Copyright in the Work © GMC Publications Ltd, 2018

ISBN 978 1 78145 344 5

A catalogue record for this book is available from the British Library.

Publisher: Jason Hook • Designer: Robin Shields • Editor: Chris Gatcum
Colour reproduction by GMC Reprographics
Printed and bound in Turkey
Cover image: Kevin Morgans

SOPHIA DENNETT (AGE 11)

Focused for Flight
(Puffin, *Fratercula arctica*)
Farne Islands, Northumberland

AMMONITE
PRESS

www.ammonitepress.com